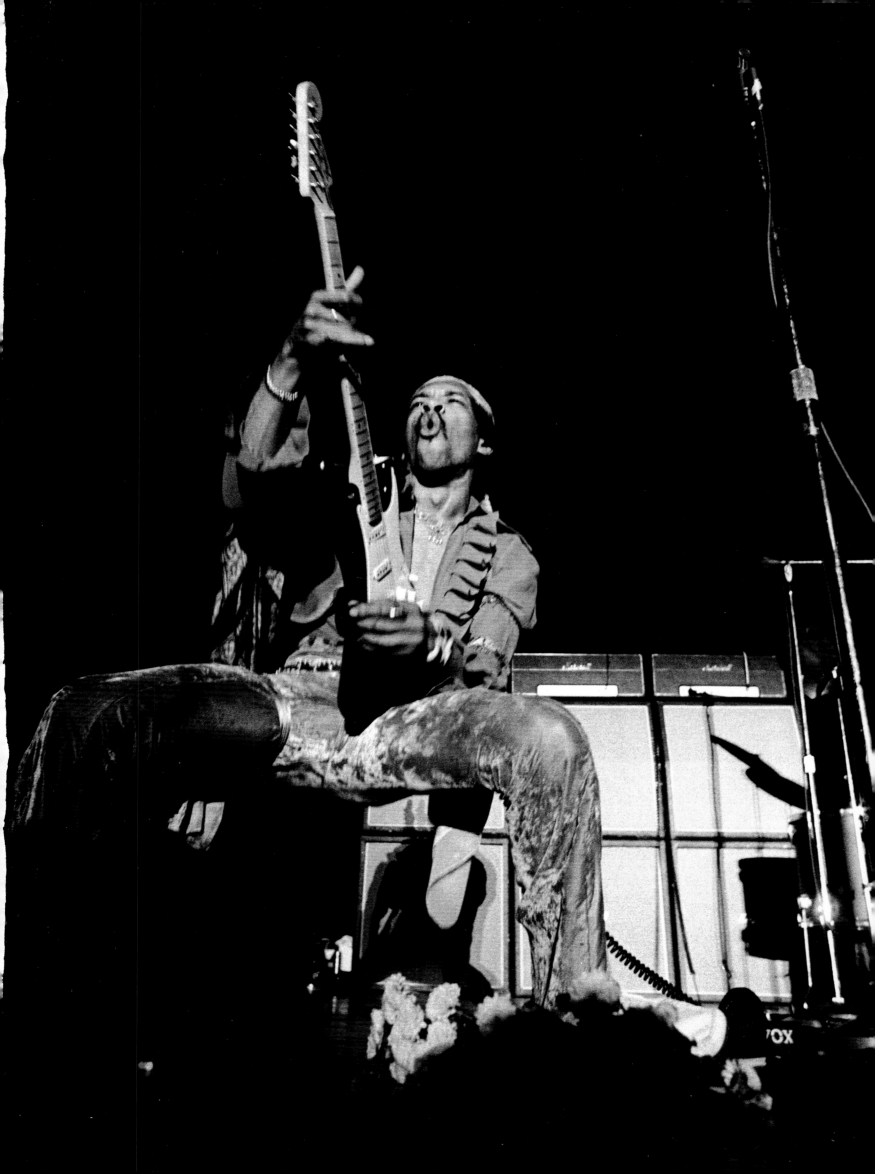

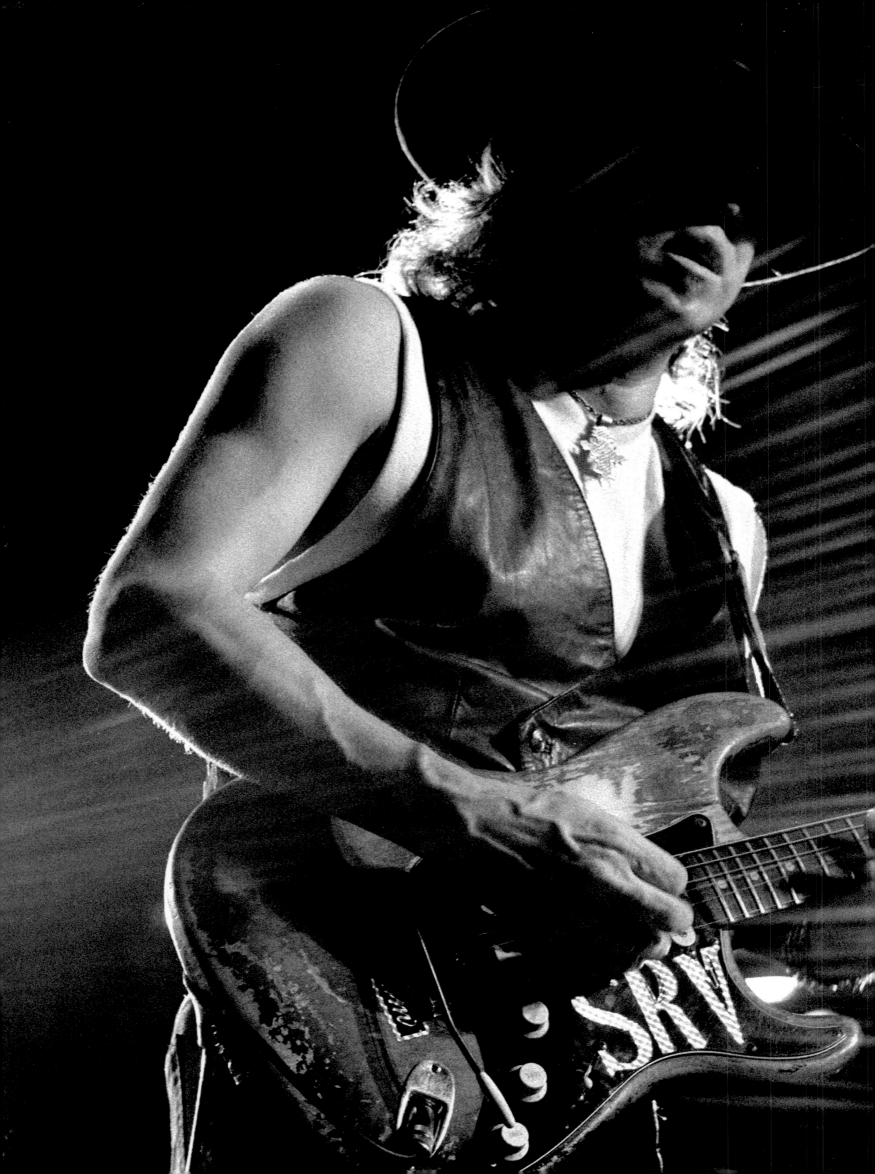

ROCK GODS

FORTY YEARS OF ROCK PHOTOGRAPHY

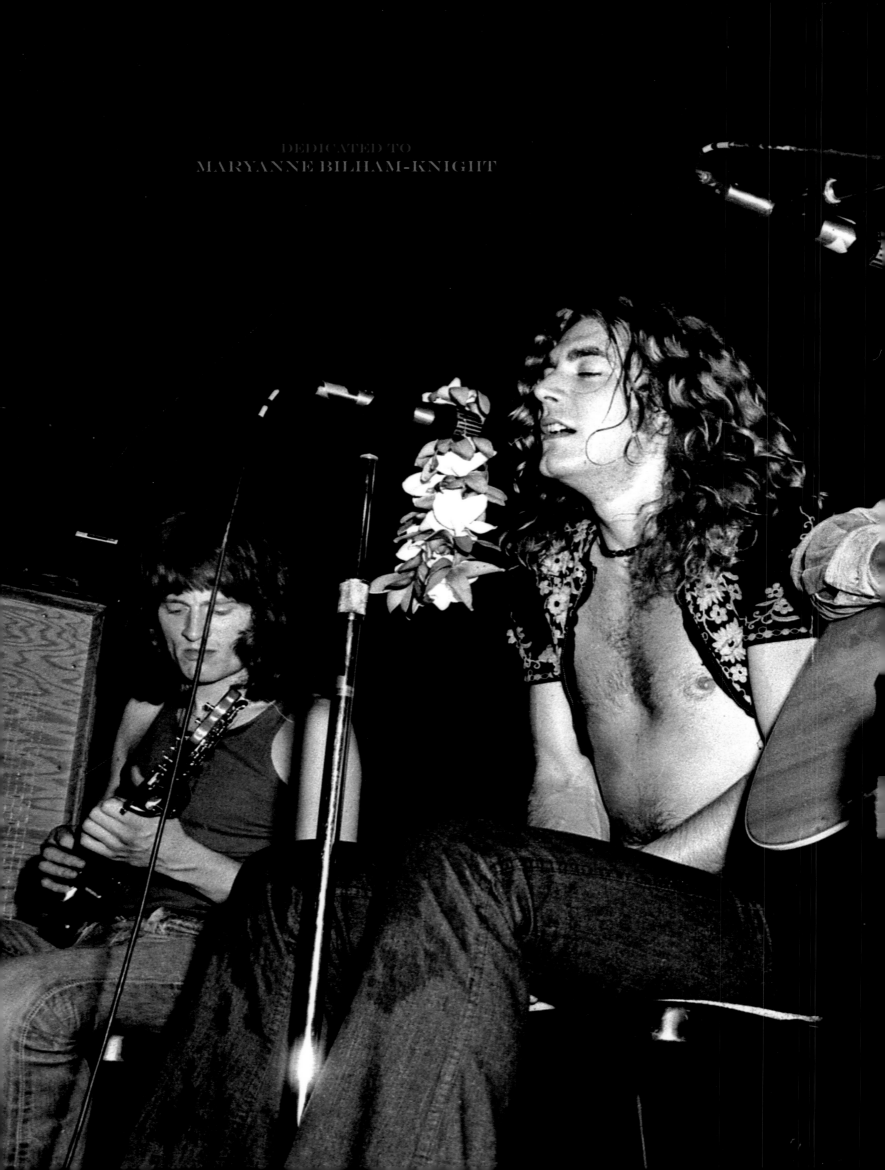

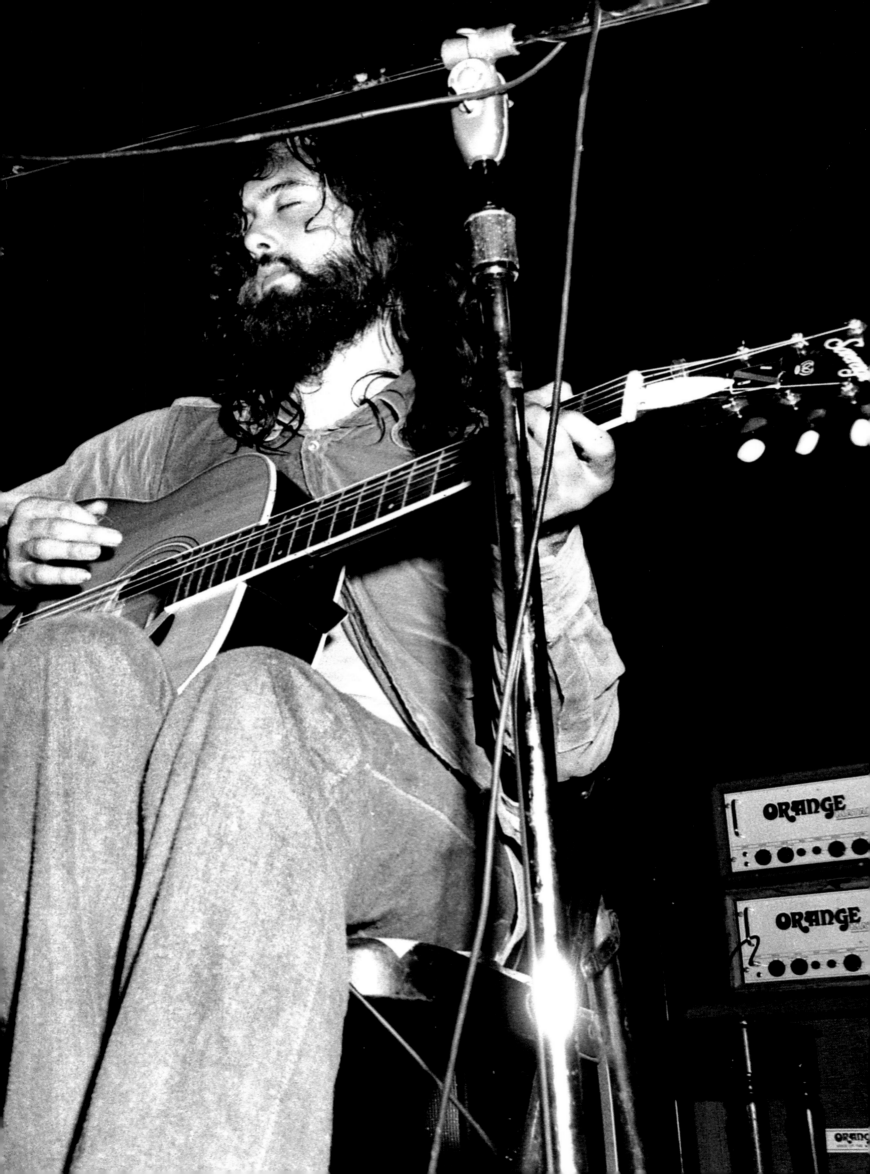

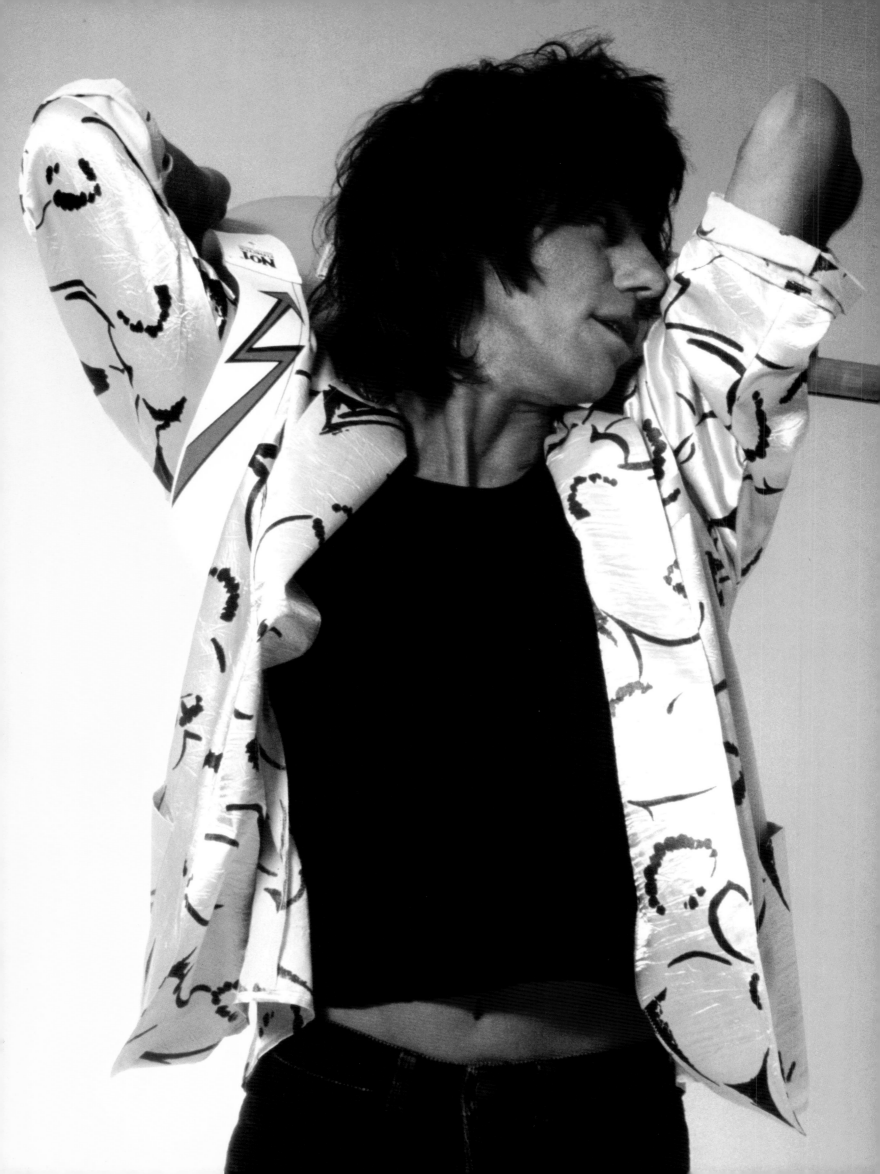

ROCK GODS

FORTY YEARS OF ROCK PHOTOGRAPHY

Robert M. Knight

introduction by Slash
edited by Divina Infusino

INSIGHT EDITIONS

San Rafael, California

CONTENTS

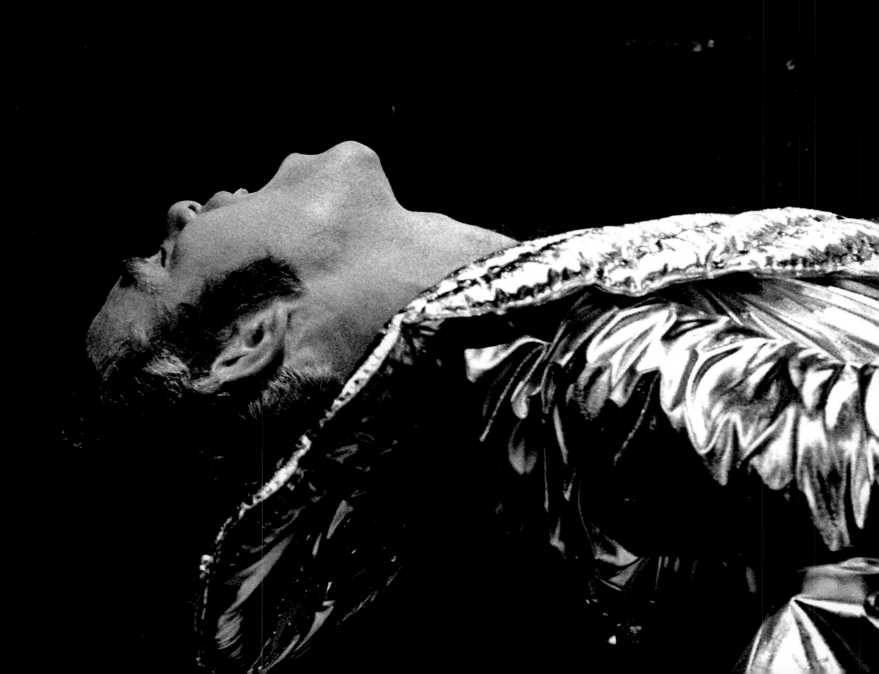

I DON'T REALLY think of Robert as a "rock photographer"—he's just a really good guy I enjoy spending time with. Our professional relationship is more dictated by our personal relationship, but it's all been wound together over the years.

I first met Robert about twenty years ago. We were both hanging around L.A. in the same circles. I was just sort of a punk kid. I remember Robert got me into a Stevie Ray Vaughan gig, so I guess he had taken a liking to me. That was the first time I'd ever met Jeff Beck, Eric Clapton, Chrissie Hynde, Eddie Van Halen and, for that matter, Stevie Ray Vaughan. But they didn't really know who I was back then, because that was when Guns N' Roses was just coming out.

When he's around taking pictures, it's not really like a photo shoot. He just shows up and tries to capture the individual in an artistic kind of way, without being too imposing. We're doing whatever we're doing, and it's not at all regimented, but in the time that we spend together, he always has a camera. He's into capturing the moment and having it either say something as honestly as possible or alluding to what might be happening in the subject's mind, as opposed to trying to get The Rock Pose, the quintessential Rock God Photo, which is what most other photographers are doing.

It's hard for me to pigeonhole him by giving him one sort of identifiable description. He's just completely different from all the other rock photographers, and not because he tries to set himself apart. He just has such a different approach to the whole thing. It's so casual and he's so unassuming that he manages to capture our human side, which gives his pictures poignancy, texture and depth.

Robert is very, very candid, even when we're doing a setup shoot. When he needs to do these shots we lock down together, talk about what needs to happen and then go in, I just do what I do, he shoots and it's over in ten minutes. He's like a really, really good dentist.

Robert has shot me with Guns N' Roses, Snakepit, and Velvet Revolver, but also taken some casual and relaxed photographs with just me and my guitar, with just my cars and another shoot with my wife and kids. He's the go-to guy for formal things as well, like openings at the Guitar Center's Hollywood RockWalk, or the Hard Rock Hotel in Las Vegas, where they put up a glass case last year with my guitar and some other

FOREWORD

memorabilia. They also had a slide-show loop of about ten or fifteen minutes worth of pictures Robert has taken of me over the years. There's a certain kind of tension that usually goes along with those kinds of formal events, but he manages to slip in seamlessly and get his shots without being overbearing.

We recently did an interview for Tim Kaiser and John Chester's upcoming documentary on Robert's life and work. The time that we put into that was very special because I got to know him even more as a person and a little bit more about his lifelong quest. I realized then that he had put me into the company of some major guitar heroes that he had worked with over the years. I'd never really asked him who he had shot before, and I'm not the most talkative individual. We' just have such an easygoing relationship and enjoyed each other's company, no questions asked. I knew he had shot some of the most iconic rock guitar players of all time, and knowing that he put me in that category was a little humbling—being included in a portfolio alongside Jeff Beck and Jimi Hendrix.

One time, Robert asked me for an interview. I normally don't like doing interviews, but I actually had a good time doing this one. It didn't feel like a forced situation. I had just gotten finished doing a production rehearsal, and I was trying to squeeze him in at the tail end so we could get it done, not knowing

how eager he was to really get under the surface of me as an individual personality. So I gave him a typical interview like I would do with anybody else, but later he came back to me and said, "I want to get the *real* you." That's when I really started to understand where he was coming from.

The part that's really hard to put into words is what a genuinely sweet and amazing individual he is. He's very conscientious and—what's the word I'm looking for?—a very considerate person. Robert's not like

SLASH

the usual people that you hang around with in this business—he has a spirituality, a Zen-like quality, about him.

I haven't seen the book you're holding in your hands, but I have seen a lot of his portfolio from his archives and looked at the stuff that he has lying around, and his photos are just awesome and kind of eclectic, like Robert. It must be kind of a wild place. Welcome to his jungle.

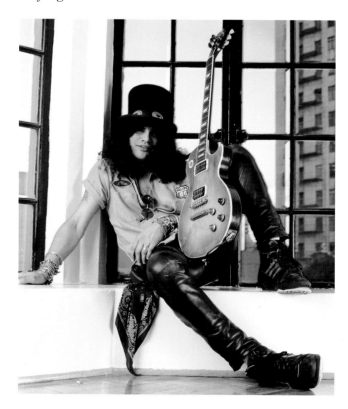

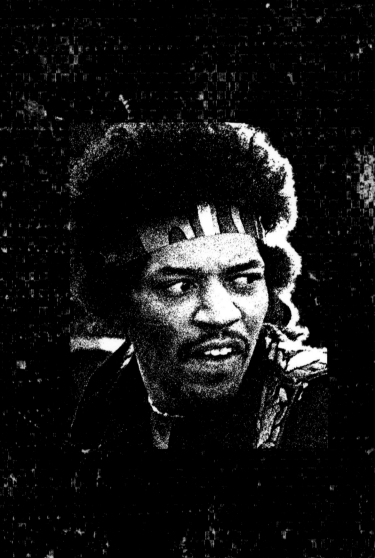

1

IN THE BEGINNING

HOW DID I GET STARTED as a rock photographer? How did I accumulate one of the largest rock photography archives in the world?

How did I become friends with Jeff Beck, Carlos Santana, Jimi Hendrix, Ron Wood, Jimmy Page, Elton John, Eric Clapton, Rod Stewart, Slash, Steve Vai, Eddie and Alex Van Halen? Why was I the only photographer who shot Stevie Ray Vaughan's last performance on the night of his death?

How did I meet and photograph nearly every musician I have ever admired and turn my heroes into my friends?

ROCK GODS

I've been asked these questions for forty years. The answer to all of them is really the same. And the technical dimesions of photography—cameras, lens, lighting, etc.—as well as magazine or record company assignments are really only a small part of it.

A good friend of mine, Ingo Swann, the father of remote viewing and an expert in psychic phenomena, once told me that life consists of two things: the signal and the noise.

The signal points to your path or destiny—what you contribute, the part you are meant to play in life. The noise is all the interferences that distracts you from that signal.

Ingo contends that when synchronistic events—like chance encounters or seemingly random coincidences—frequently occur in life, you are probably on the signal line. When they stop, you have probably drifted away.

The collection of photographs in this book exists because I've paid attention to the signal and the synchronistic events that have popped up on my radar throughout my life. I have visualized what

I have wanted and then gone after it. When I have done that, strange and amazing doors have opened, taking me in directions and on adventures that I can only describe as magical, and bringing people into my life that I never could have was anticipated meeting when I was growing up the son of a Baptist minister in Hawaii.

Destiny, I found, does not necessarily declare itself by putting things directly in front of you. Sometimes you need to look to your left and right, and in your peripheral vision.

My whole career as a photographer started accidentally when I found some British music magazines left behind by English tourists in an alleyway in Waikiki.

ROBERT M. KNIGHT

Because of The Beatles and the Rolling Stones, London was at the eye of the coming rock and roll hurricane that was about to transform music forever. At the time, American bands bored me. I gravitated toward the British groups. So when I saw an ad for a catalog of British records in one of the magazines, I subscribed. Soon, I was receiving copies of the Yardbirds and Jimi Hendrix albums before they were released in the U.S. These import albums arrived with exotic covers, different than their U.S. versions, with fantastic photography.

This was pretty exciting stuff for a kid like me who lived with his family in the parsonage and had to go to church three or four times a week. I grew up pretty sheltered. Hawaii is paradise to a lot of people, but if you're a teenager and don't like water sports and sun, you're doomed. Since I don't, I didn't have much to do or anywhere to go. Plus, as the preacher's son, I had to be "the good kid," and a model for the parishioners, who were mostly Japanese. As you can probably imagine, I was ready to rebel.

14

In high school, I convinced the administration to let me play my British records on the intercom system during the lunch hour. Through this primitive DJing, I met a group of artists and musicians. We bonded over the music. Eventually, though, I felt ostracized. I wasn't a musician, painter or writer. My parents didn't encourage that kind of thing and I suffered emotionally from the lack of a defined artistic pursuit.

That changed when I first traveled to England.

At fifteen, I became a travel agent, mostly so I could get off the island. After seven months of selling tickets to my dad's church members and the high school basketball team, I qualified as an official travel agent and was eligible for an agent's discount pass.

One day, my friends and I decided to check out London during a school break. They sat in the back of the plane while I rode first class on an agent upgrade, sitting next to Noel Coward, no less, who was the first celebrity I ever met.

In London, we stayed with a working class family who looked after a photographer's studio. They mentioned that someone was making a movie and invited us to the shoot. The movie was *Blowup*, the legendary Antonioni film about a swinging London photographer with girls, models and the band, the Yardbirds. It was like a bell went off in my head. At that moment, I knew I wanted to photograph album covers. Specifically, I decided that I was going to work with the Yardbirds which had, at various stages of the band, Eric Clapton, Jimmy Page and Jeff Beck

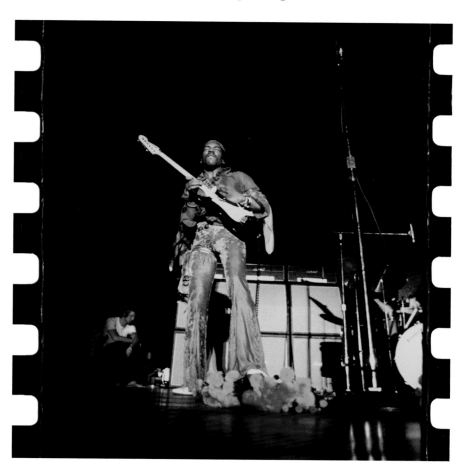

as guitarists. In fact, the Yardbirds' scene in *Blowup* captured the brief period where Page and Beck played in the band at the same time. But the film really kicked off my affinity for Jeff Beck, who is one of the most under-recognized guitar innovators—the best of the best in my opinion. He eventually became a true friend—and is definitely someone who has functioned as a "signal" throughout much of my life.

As soon as I returned to Hawaii, I began to caddy at an exclusive golf course. After months of lugging four golf bags twice a day around eighteen holes, I earned enough money to buy cameras and lenses. I was going to be rock photographer.

But how was I going to meet these bands since they rarely toured in Hawaii? In the summer of 1968, Bill Graham was booking Jimi Hendrix, the Yardbirds, Jeff Beck and other British groups in San Francisco. Since I realized I needed to attend photography school, I

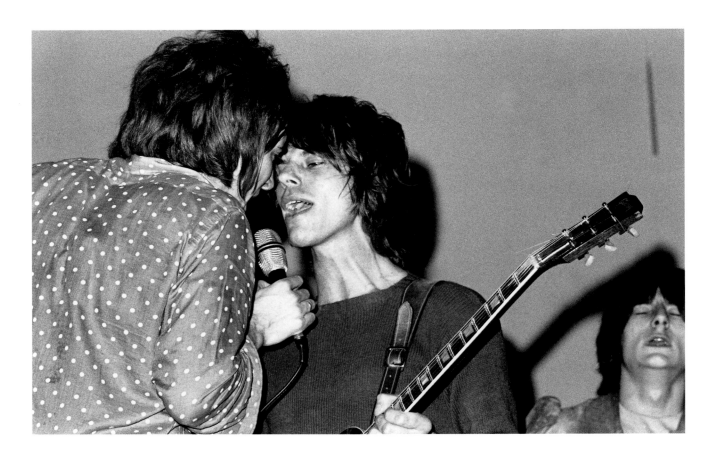

convinced my parents to send me to the San Francisco Art Institute. Not that I had any interest in what the school could offer me. But it got me to San Francisco where the bands I loved were performing.

A friend and I landed an apartment in the city, right in the middle of all the hippie nonsense, which I absolutely hated. I've never had anything to do with drugs—not then, not ever. Nor did I like the San Francisco bands. I never really got the Grateful Dead. I was quite arrogant about whom I would photograph and I have pretty much stayed that way. I've mostly avoided working with or seeing musicians that I don't like. I have followed my passion and my passion has been for guitar bands.

I spent about six months in San Francisco. In that time, I shot some of the most significant photographs of my entire career and met and befriended what I consider to be the archetypes of rock music, the people who forged the sound and style for decades to come— Jeff Beck, Led Zeppelin, Jimi Hendrix. A little later, I added Carlos Santana to that list.

FIRST ROCK SHOW

The first rock concert I ever photographed was The Jeff Beck Group in the summer of '68 at the Fillmore in San Francisco. I was the first person through the door. I sat below the stage, and captured these amazing photos of Jeff and Rod Stewart and a very young Ronnie Wood. Those photos from my first night as a rock photographer came full circle in 2007, when they all appeared in a reissue of one of Jeff's first records, *Beck-Ola*.

The Jeff Beck Group played San Francisco several times while I lived there and I attended every performance, hoping I could finagle my way backstage to meet Jeff. I never did at that time; I'd have to wait to make contact. At one of the shows, though, Jeff announced that Jimmy Page's new group, the New Yardbirds, would be touring the U.S. I immediately called Jann Wenner at *Rolling Stone* magazine and convinced him that I needed to travel to Los Angeles to photograph the band's debut.

I headed to the Whisky A Go Go the afternoon

of the show and announced: "I'm here from *Rolling Stone* magazine, and I want to shoot this band playing tonight." By that time, the group had changed its name—to Led Zeppelin. The woman at the door studied me for a couple of seconds, then asked: "How old are you?" I was twenty and she said, "I'm sorry. You can't come in. It's California. It's a bar. You have to be twenty-one years old." "You're kidding me. What am I going to do?" The panic on my face must have spoke volumes, because she immediately called the Chateau Marmont hotel, got Jimmy Page on the phone and said: "Jimmy, there's this young boy here who's a photographer. He wants to shoot the band." Jimmy said, "Have him come to the hotel." So I went and it was like a dream come true. I finally met a Yardbird.

Jimmy treated me like some long lost relative. "Use the hotel phone to call anybody you want. Order anything you'd like from room service," he told me with a big grin. So I called everybody I knew in Hawaii and put them on the phone with Jimmy Page. Then, he introduced me to John Paul Jones and Robert Plant. That night I rode with the band to the Whisky. Since I arrived with the group, the Whisky had to let me in. I was right there on the side of the stage, photographing Led Zeppelin's first major show in the U.S. Some 175 people witnessed Led Zeppelin in their full glory and

power that night and I got the photographs. The next day, I called a promoter in Hawaii, Tom Moffatt, who was a friend of mine, and told him, "You've got to book this band. They're going to be huge." He did. The next day, I traveled with the group to San Francisco and I shot them at the Fillmore West. That was it for me. I knew I was on the right track.

JIMI HENDRIX

My first big break in rock photography, even before Zeppelin, was shooting Jimi Hendrix at Winterland in San Francisco in '68. I brought exactly one roll of film with me. With that one roll in my camera, I walked to the front of the stage, and nobody stopped me— because I had a camera in my hand. No assignment. No pass. Right then, I knew that the camera was my crowbar, my passcode for getting and fitting into the music world.

As for Hendrix's performance that night, I had never heard anything that loud, weird or aggressive before in my life. It hit me in the stomach. It kicked me in the head. I shot my one roll of film, and then I just stood there, dumbfounded, with my mouth open, watching him.

17

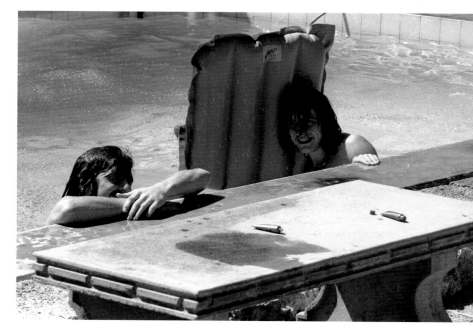

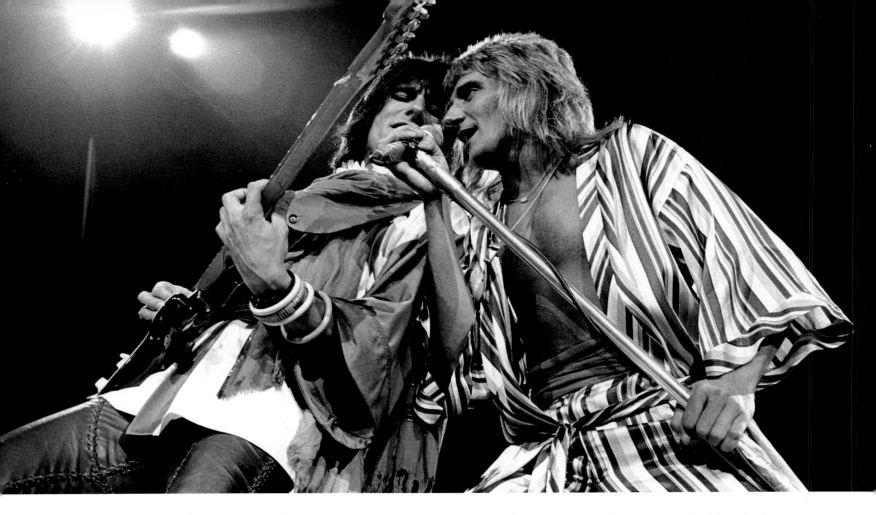

Rock photography has never generated a lot of financial gain for me. Rock photography was my passion, not my job. But I have made the most money, by far, on those first shots of Jimi in 1968. Almost forty years later, I sold the rights to my photos to Jimi Hendrix's sister so I could pay for my mother's nursing home. My parents used to ask me why I was taking photos of Jimi Hendrix, implying that I'd never get anywhere doing it. Ironically, in the end, those photos helped take care of my mother.

HAWAIIAN SON

When winter hit in San Francisco, the British bands stopped touring the area and I returned to Hawaii. I already knew what I wanted to do. I convinced the promoters in Hawaii to give me access to all the shows. So when Zeppelin came to Hawaii, the promoter asked me to meet them at the airport. Because of that, I have this photo of Led Zeppelin arriving on the runway in Waikiki, carrying the master tapes to their next album, *Led Zeppelin II*.

I got to know Elton John and Rod Stewart in much the same way. Eventually, I functioned as the British rock musician's go-to guy in Hawaii. I met Jimi Hendrix, however, through a friend. Jimi stayed on for a couple weeks after his show and rented a house at the bottom of Diamond Head. I spent days with Jimi. He was incredibly friendly, likable, shy, but warm. We all would hang out, swim in the pool and just relax. But I never took my camera out. Jimi was in his swimming suit, not his full regalia, and he didn't want pictures of himself circulating that way. Looking back, I am amazed how much I kept my camera in the bag over the years. I spent a lot of time with Bob Marley and the Wailers when they were in Hawaii. Why didn't I take out my camera? I wonder now. But the truth is, the camera can act like a barrier. Some artists are fine with it. With others, it completely alters the dynamic. That was certainly true with Jeff Beck. I guess I valued the friendship more than the photos. But in the long run, I had lots of opportunity to shoot.

Eventually, the hip weekly newspaper in Honolulu, the *Sun Bums*, appointed me its concert photographer. I had access to every show that played in Hawaii and got to know all the promoters and the security

people. I would just drive to the back of the arena, and they'd let me in. I never needed tickets. I would always go into the pit. Through the *Sun Bums*, I met all kinds of musicians. I photographed Long John Baldry, who asked me if he could crash at my house for a night because the rest of the band was returning to England and he wanted to see Hawaii. The guy ended up staying with me for a month before I was able to push him out the door. I was the big fish in a little pond.

JEFF BECK

Even though I was coming into contact with all these incredible musicians, I still hadn't met Jeff Beck. I would ask Jimmy Page so much about Jeff and how I could meet him that eventually Jimmy said, "Look, if you don't stop asking me questions about Jeff Beck, I'm not going to let you hang out."

Finally, I convinced the promoters in Hawaii to bring Jeff to the islands, which is where I met him and spent a lot of time with him. Slowly, I started to take photographs of him. Eventually, he became the centerpiece of my photography. I absolutely thought Jeff was the best of all the guitar players I'd ever seen. I probably have ten thousand photos of Jeff taken over forty years—more than any other artist. He means the most to me. He's considered to be one of the most reclusive, private people, and yet, honestly, I can say that Jeff Beck is my friend, and I think he feels the same way. When I first met him, he asked me, "Are you a guitar player?" No, I said. " Do you want to be a guitar player?" No I said. "I think we are going to be great friends," he laughed. He was right.

THE GAP

Working with the promoters, I created much of the rock and roll concert scene in Hawaii. Over the course of twelve years, I acquired a huge library of images because everyone eventually toured there.

Since I wasn't on assignment for record companies or major magazines, I owned all my work. But because I didn't know about syndication and couldn't make any money with rock photography, I became a commercial advertising photographer and flew all over the world on assignment, visiting places like Japan, England and Australia. When I traveled, I sought out bands and began working on a more global level.

Eventually, Hawaii came to feel limiting. In 1981, I moved to Dallas for one year and then to Los Angeles. Unfortunately, the whole music industry spiraled down for me around that time. Led Zeppelin stopped touring the U.S. in '77. Many bands were suffering from drugs and they weren't really up to par. Disco music was happening and simply grossed me out. So there's a gap there in my work. I just wasn't interested.

But here's the thing about the signal: Just when you

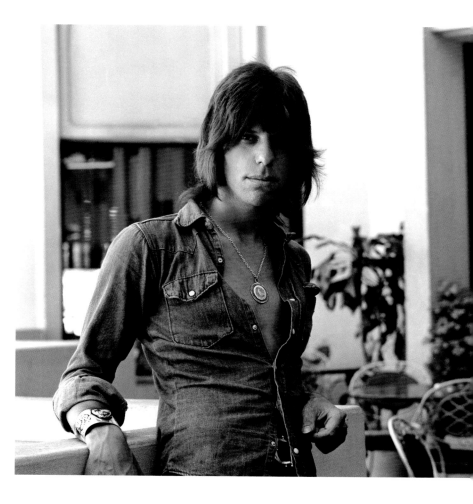

think it is gone for good, some synchronistic event pops up to steer you in the right direction. This time, it happened through Guitar Center.

GUITAR CENTER

In 1985, I walked into the Guitar Center on Sunset Boulevard and asked to speak with the manager. I asked if I could trade him some photos for a guitar and an amp that a friend of mine wanted but couldn't afford.

The manager, Dave Weiderman, said, "Yeah, no problem." I showed him the photos and he looked at me and said: "We're doing our first RockWalk tonight. Come back." Hollywood's RockWalk is the equivalent of the Hollywood Walk of Fame, for influential musicians, especially guitarists. So I returned and shot their first inductees, Eddie Van Halen and

magazine. When you call Eddie Van Halen or Steve Vai and ask, "Hey, how would you like to go up on Guitar Center?" Their response is "Cool, man. Come down to my show tonight and shoot or do a studio session." Eventually, I photographed every RockWalk induction. I am now co-director of RockWalk, and help decide who gets inducted.

GUITAR PLAYER FOCUS

Guitar Center and I are obsessed with the same thing—guitar players. Most photographers fixate on lead singers. I have little interest in them. My passion is for lead guitarists. Like someone who collects rare stamps or coins, I track down my favorite guitar players so I can photograph them. I've shot Albert Collins, Albert King—so many of the greats. Eventually, I worked with Fender and Gibson and Taylor guitars

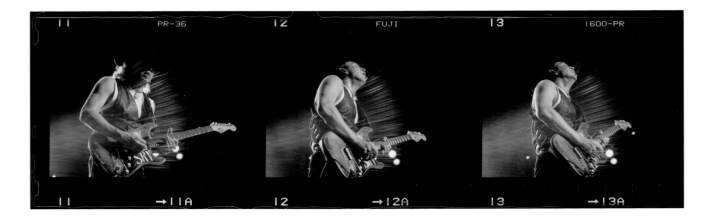

Les Paul. We decided to hang some of the photos on the outside of the Hollywood store. As soon as the photos went up, everyone started coming there. Guitar Center expanded into the largest music retailer in the world, and my photos were plastered on the outside of every one of their stores. Now every single Guitar Center in the U.S. has anywhere from five to twenty of my pictures on the outside of it, or photos by my wife Maryanne Bilham. Guitar Center provided me with a really great entrée to shoot bands without an assignment for a record company or a

and then the drum companies became my clients. Through these contacts, I developed friendships with Eddie and Alex Van Halen, Steve Vai and Slash.

STEVIE RAY VAUGHAN

I met Stevie Ray Vaughan, though, through Jeff Beck, when they toured together as alternating headliners in 1989. I first got together with him during the tour rehearsals at Prince's Paisley Park Studios in Minneapolis. We became really good friends. That relationship put me at Alpine Valley, Wisconsin

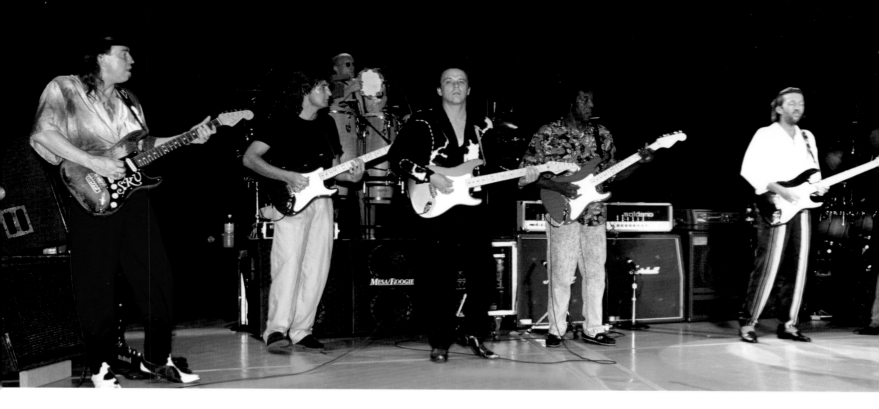

on August 26, 1989. It still constitutes one of the strangest days of my life. I shot one of the eeriest and, in some ways, most beautiful shows I have ever had the privilege to photograph—the last performance Stevie Ray Vaughan gave before he crashed to his death in a helicopter later that evening. I have a very eerie picture that, in a way, foretold Stevie's demise. In it, you can actually see what looks like his life force coming through him. This beam of light hits his back, but then manifests through his solar plexus in luminous rays. It is one of the most important photos that I have ever taken. Stevie used to sign his autographs, "Soul to Soul." That's the bond I felt with him.

STAR-MAKING MACHINERY

Rock photographers, whether conceptual or documentary, are part of the process of creating stardom. When you see a picture of Pete Townshend throwing his arms in a windmill or Jimi Hendrix throttled back, that image defines the artist. The photography creates the image of an artist just as much as the clothing and the guitar. It is part of the making of a rock star or a rock god. Successful musicians know this. They become critics of photographers, and choose the ones they like and the ones they don't. They know who can get them on a magazine cover.

Often, I have been in the right place at the right time and produced the right type of image simply because of the way I shoot. I know my weaknesses and strengths as a photographer. I am not really conceptual. My wife, Maryanne Bilham, who photographed The Go-Gos as saints and Dave Navarro asleep in a church, is a conceptual photographer. She thinks up an idea, figures out how to execute it technically and pulls it off. I do photo shoots that last anywhere from five minutes to as little as ninety seconds, even with major artists. I don't have the time to come up with a set or a story idea or even particularly interesting lighting. I'm quite capable of doing studio work, and I know lighting and printing. But I've usually operated more like a journalist or a documentarian. I really don't care where I'm going to shoot you as long as I can shoot you.

Photography defines the moment. It's a time capsule. It lets you go back and relive that moment. Look at a picture of Mick Jagger from the '60s. You can almost be there again. It's a visceral, gut experience.

Shooting live concerts, especially with film, is probably one of the harder things to do. When you're in a studio, you maintain total control. With a live event, you have no control. The artist is moving. The lighting changes. There's a whole set of variables that you need to anticipate. You have to shoot according to the beat, because certain climactic effects will happen. When Mick Jagger does "Midnight Rambler," the whip will come down, and you have to be ready for

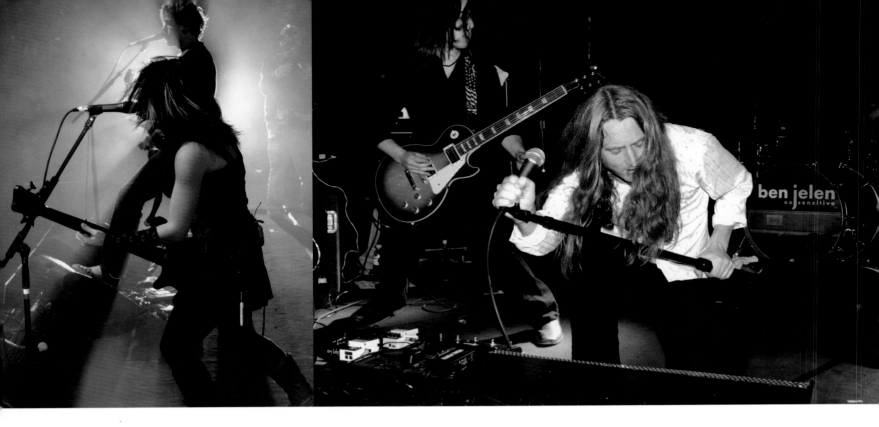

that. The exposures are wild.

Besides the technical awareness, the other key to my photographic approach is that I try not to impose my ego on the band. Some very famous photographers think they are more important than the artists that they shoot. They can be self-serving and self-aggrandizing. I absolutely could care less about that stuff. Yes, I have a little bit of show biz about me. I always wear the beret because that way people can instantly recognize me. But I really don't seek fame. I want my work to be famous. I'm thrilled that multiple galleries show my work. I want my photography to speak for me. But I'm not that comfortable on the other side of the camera, which I discovered during the filming of *Rock Prophecies*, the documentary that Tim Kaiser, a producer on *Seinfeld* and *Will & Grace*, and director John Chester recently completed about my work and the people I have known.

THE FUTURE

The documentary is one of those synchronistic things that I never could have predicted or ever made happen. This book, however, has been a longstanding desire of mine—a milestone. A museum showing my photographs is my next goal.

That said, I am now at a point where I want to reinvent myself, to work with new artists in new ways, such as starting to manage and promote them. Musicians I have in mind include Tyler Dow Bryant, who is a brilliant and talented guitarist, The Answer, the Sick Puppies and Scott McKeon.

All the artists that I've known over forty years have each given me a kernel of knowledge, a piece of the puzzle. So as I approach my sixtieth birthday, I know how to manage bands and guide their careers. This is an exciting time for new artists. And for me in many ways.

I'm like a shark. If I stop moving, I drown. If I had to sum up my personality, it would go like this: I can't wait to leave, and once I get there, I can't wait to leave again. If I am home for three days and eat breakfast and dinner at the same time and watch the same TV show, I get scared. I feel stuck, like I'm starring in the movie *Groundhog Day*.

No artist, no musician, who has enjoyed a long career thinks their best work is behind them. Paul McCartney, Jeff Beck and the Rolling Stones all continue to release albums because they truly believe that their most creative material still lies ahead. You can never rest on your laurels. You have to keep moving forward.

I will always take photos. The summer of 2008 marks my fortieth year as a photographer. This book and the film will come out in my fortieth year. It's just a coincidence, but you and I both know there are no coincidences.

This book is about self-empowerment as much as anything else. If you visualize what you want and go after it, your dreams can come true.

It's all a matter of keeping aware of the signal, the synchronicity. For me, the signal is my love of the music that these musicians create.

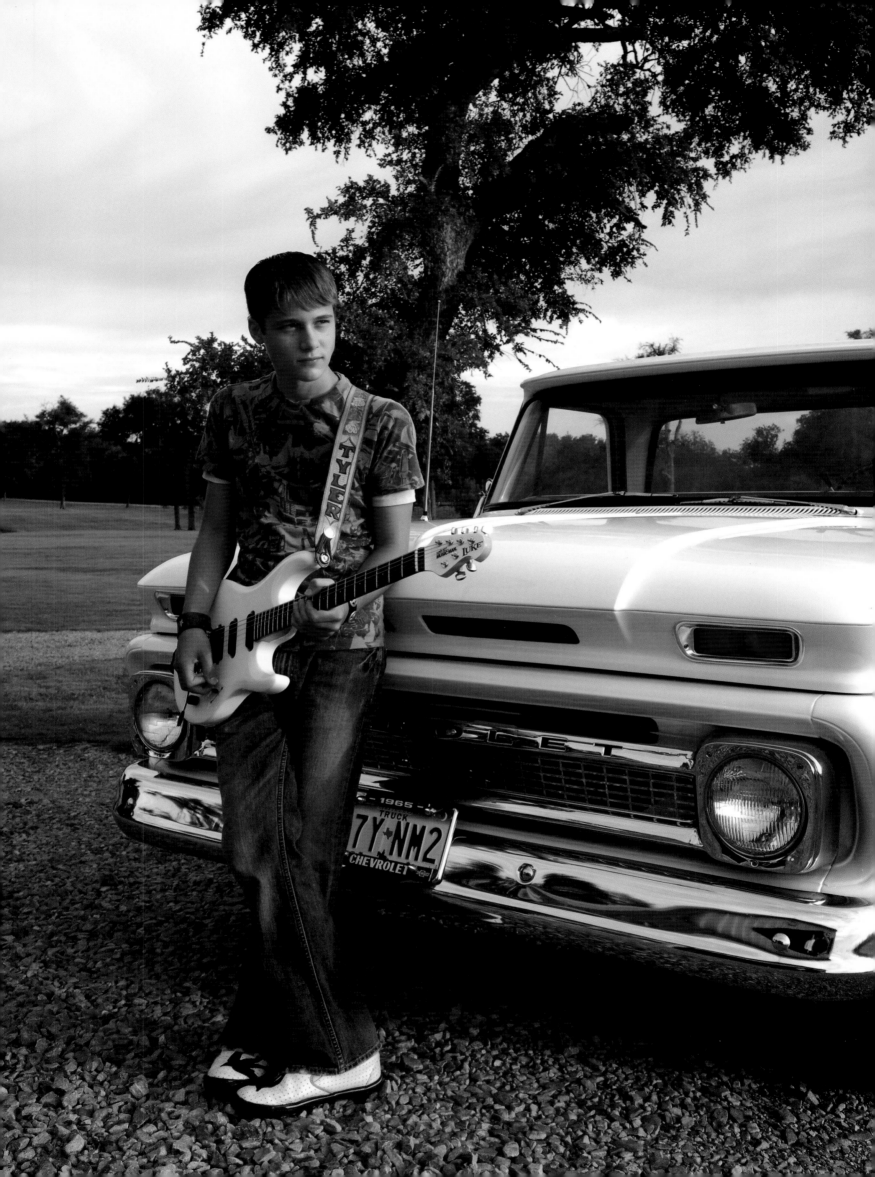

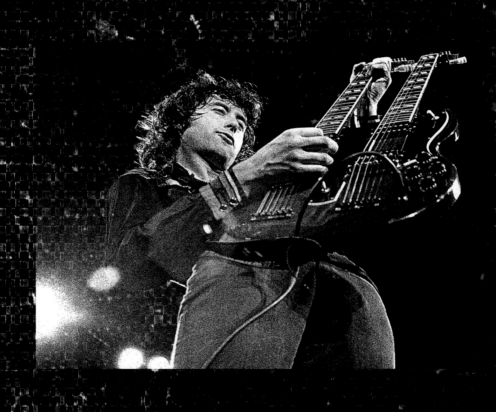

2

INITIATION

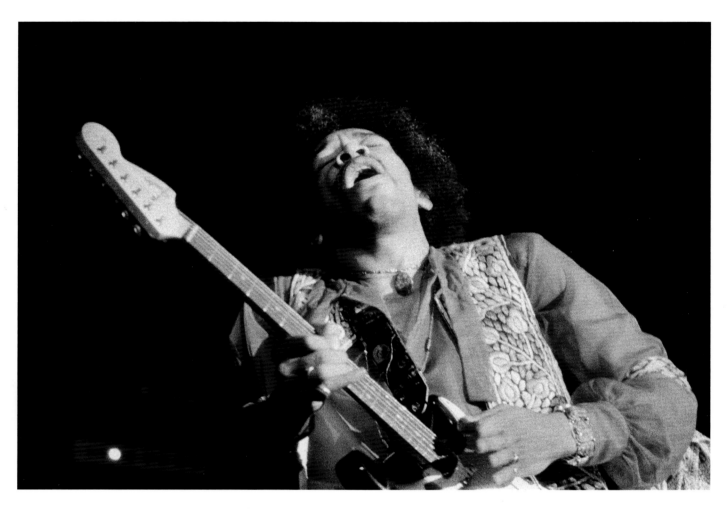

WHEN PEOPLE ATTENDED A CONCERT THEY CAME

JIMI HENDRIX wasn't into the Black Power movement or the Black Panthers or lots of political stuff. He was interested in what he called the "cosmic electric church." Hendrix used to talk to me about concerts being church and that when people attended a concert they came to commune, to worship. Being the son of a Baptist minister, that idea appealed to me. Jimi was interested in other planets and getting off of this one. He was a really sweet guy when I knew him. He used to tell me that his mom was Japanese. I'd think, "Okay, whatever you want to be, Jimi." Years later I met Janie Hendrix, his much younger sister, and she told me that Jimi's mother left early in his life and his father remarried a Japanese woman.

TO COMMUNE, TO WORSHIP

JIMI HENDRIX

| Jimi Hendrix Experience | San Francisco, California | circa 1968 |

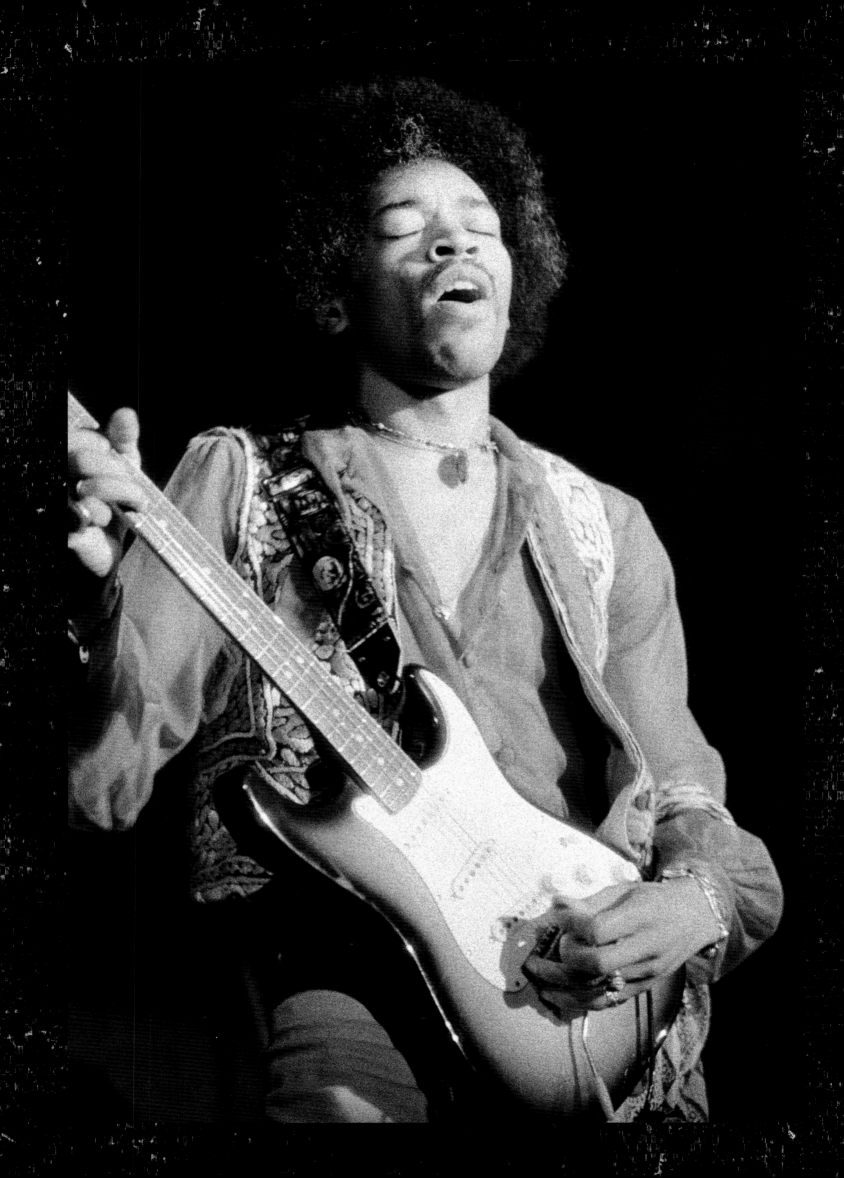

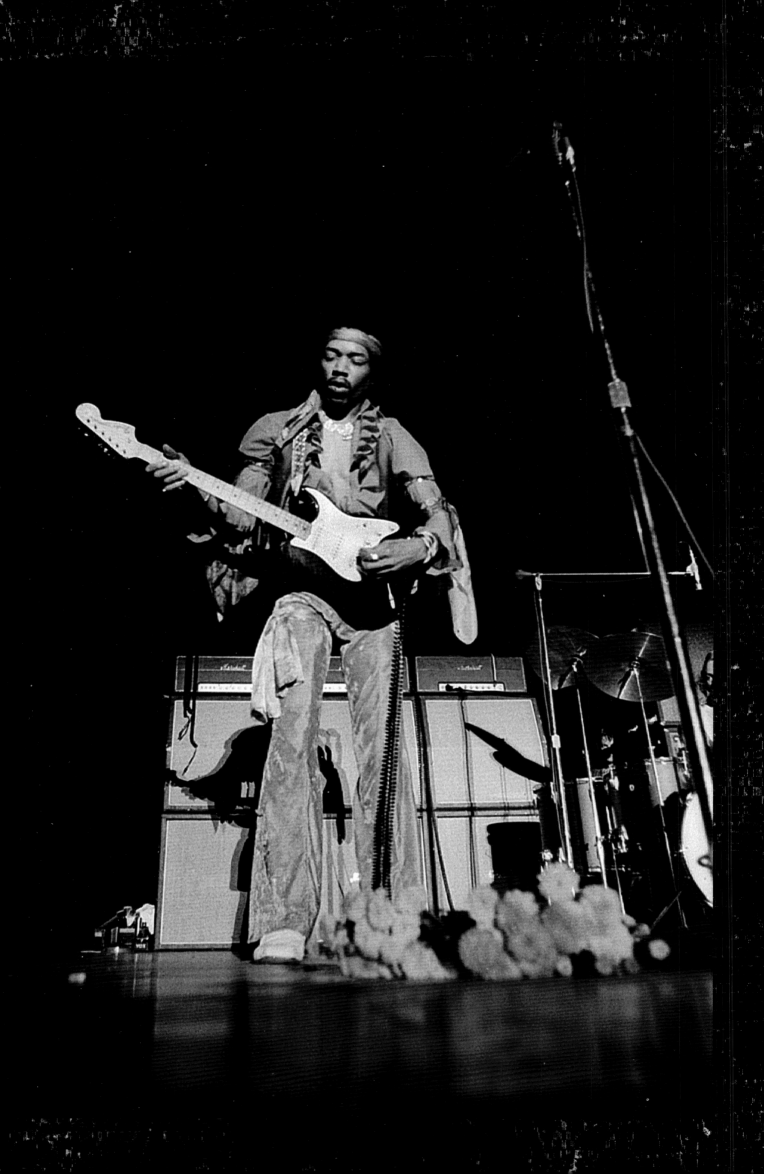

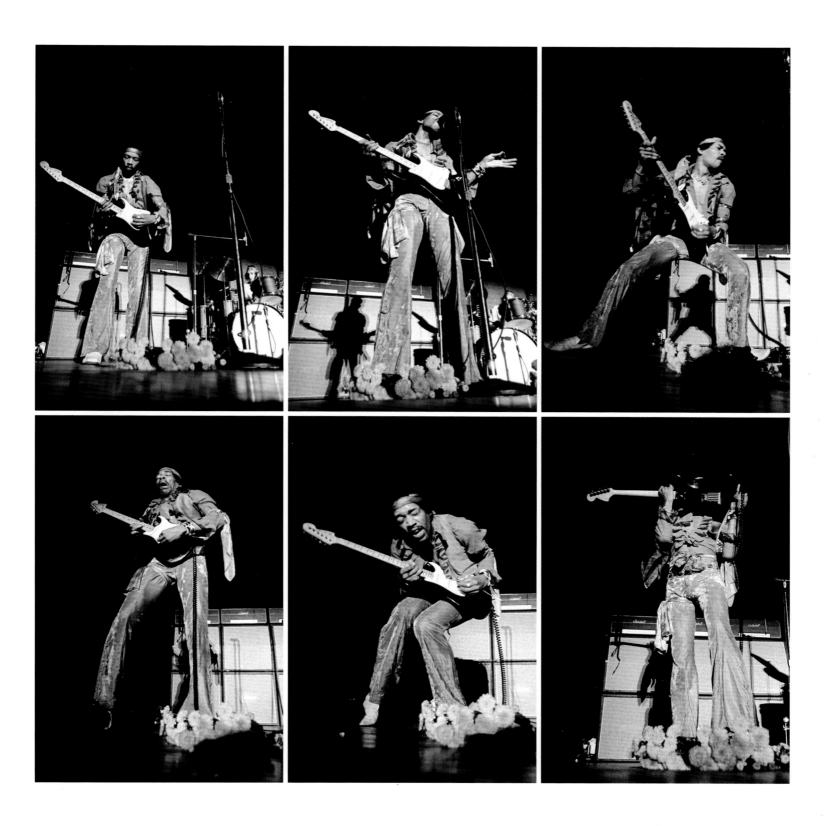

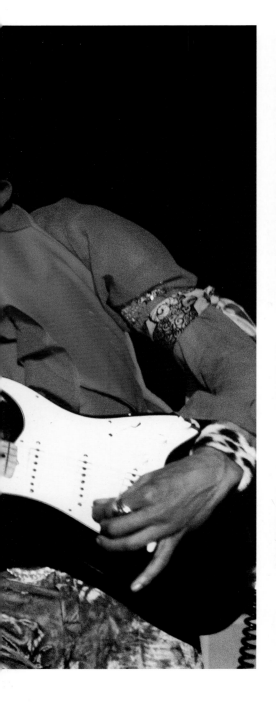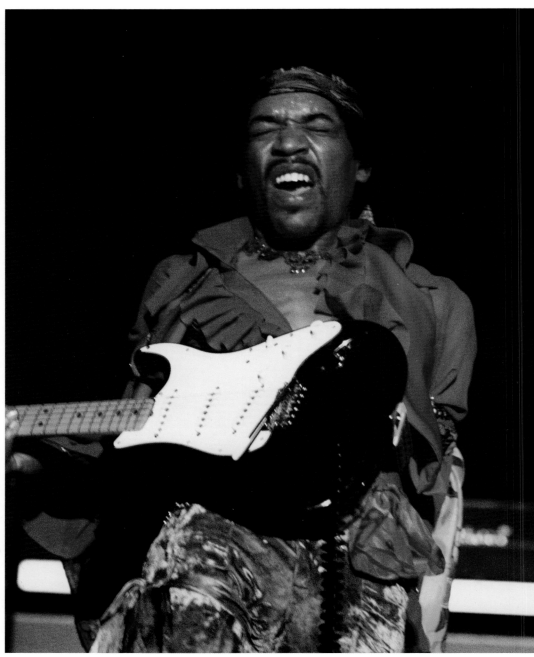

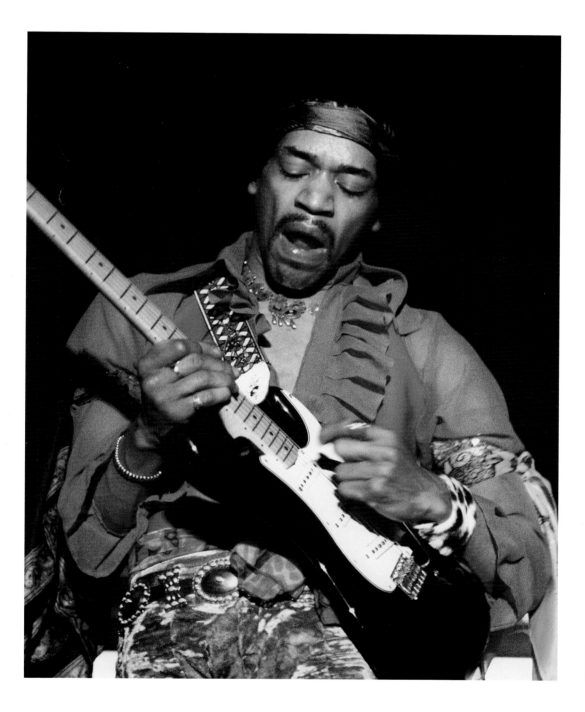
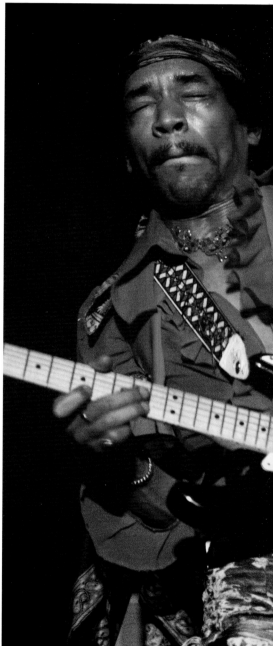

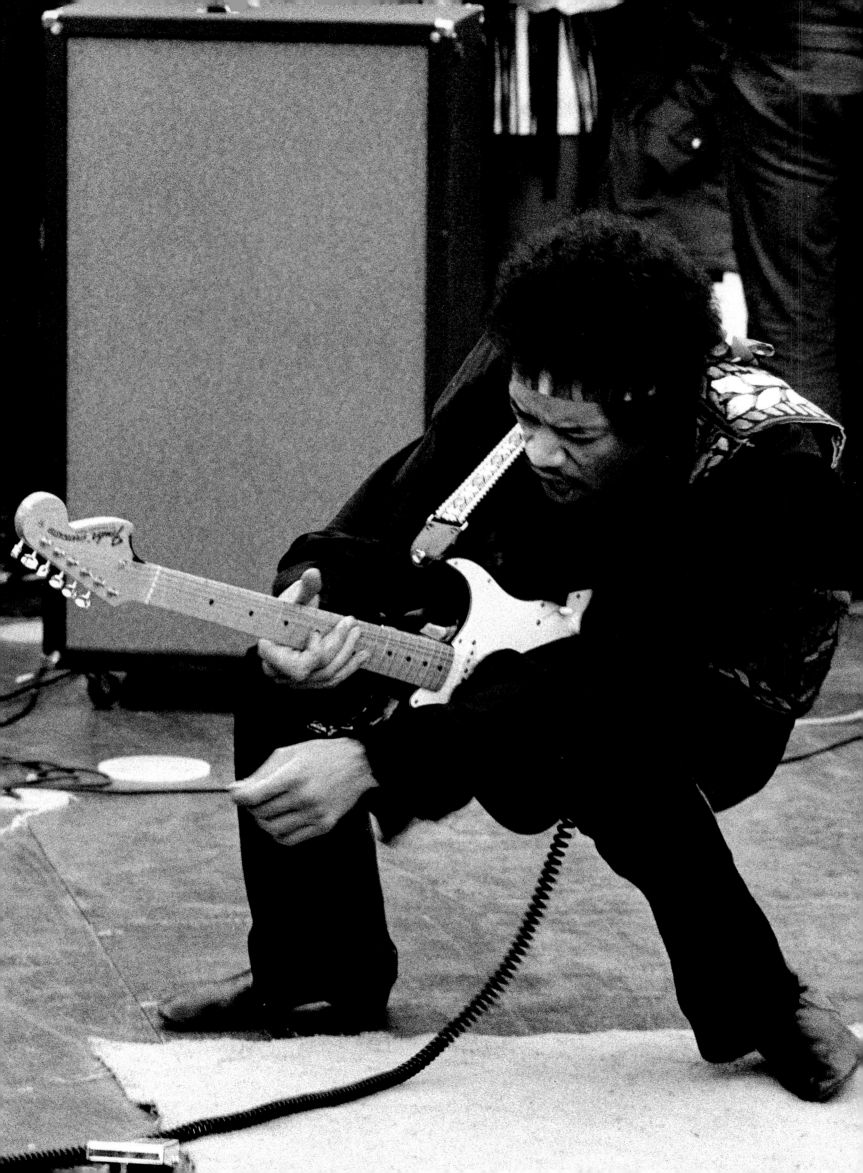

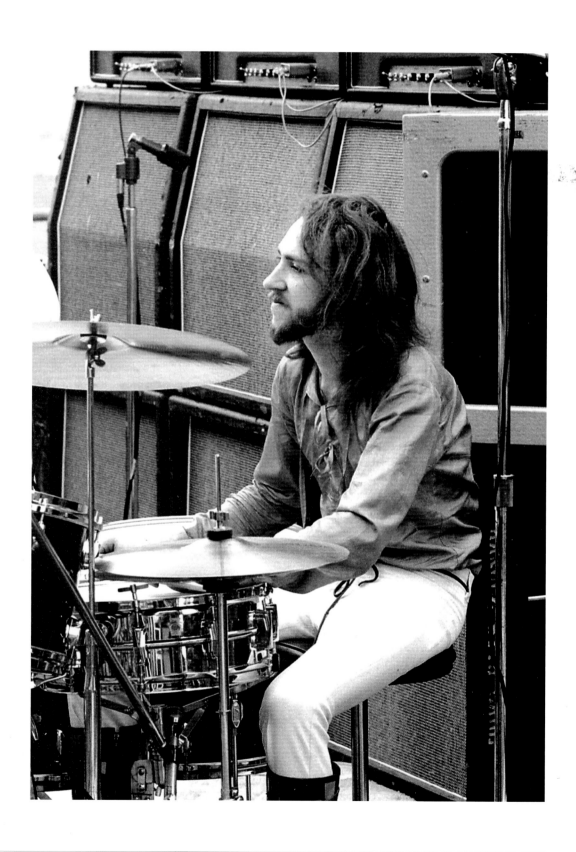

MITCH MITCHELL

WHAT JEFF BECK DID in his two or three years with the Yardbirds established what rock music became many years later. He really defined it, with the amps, the crazy chords, the feedback and the smashing of equipment. And he preceded Hendrix by about three years. Yet, for a well known guitar player, Jeff Beck has never received

the kind of attention or recognition that he deserves, at least compared to someone such as Eric Clapton. Eric is a great guitar player but over the years he hasn't changed much. He sounds pretty much like he did when he was playing with John Mayall back in the day. The same thing is true with Jimmy and Robert (Page and Plant). They basically stopped moving forward in 1977.

Jeff, however, plays better now than he ever has. He never stopped innovating. Every day Jeff wakes up and pretends that he has never picked up the guitar before and that he has to discover how to play it. Every day he tries to approach the guitar in a different way.

One of the reasons Jeff is under recognized is that he has done some of his best work on other people's records. But so many guitar players say that Jeff Beck's "the man," even Jimi Hendrix told me that Jeff was his hero.

JEFF IS PLAYING BETTER NOW THAN HE EVER HAS

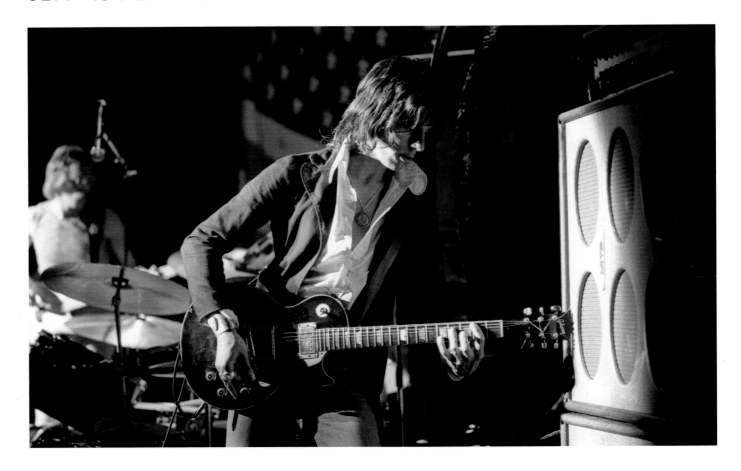

JEFF BECK

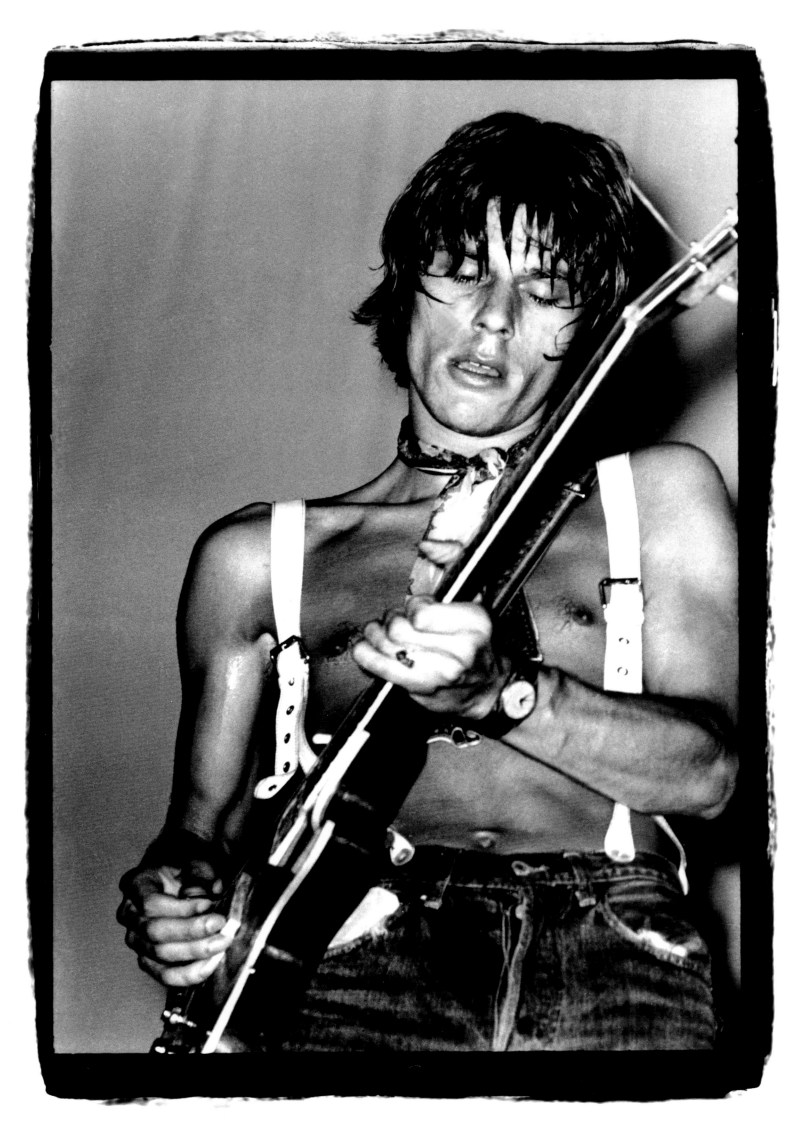

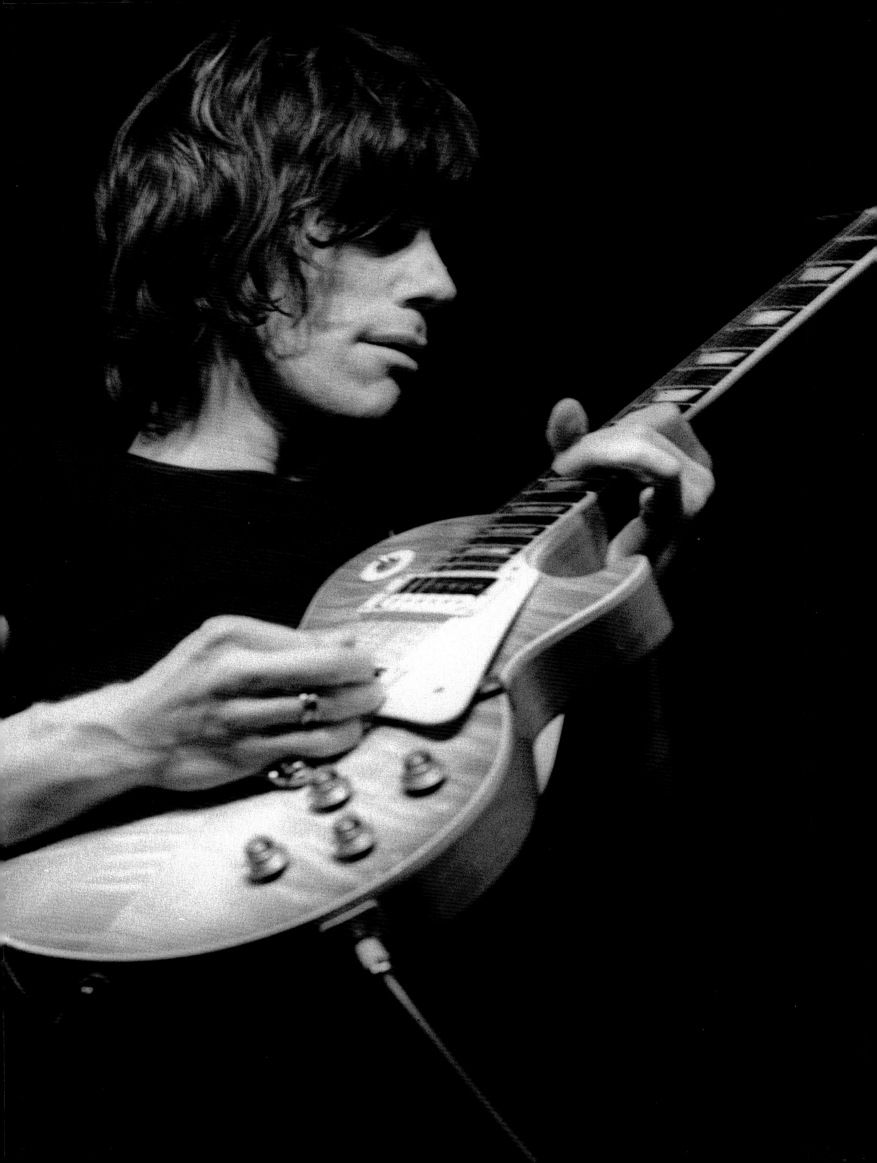

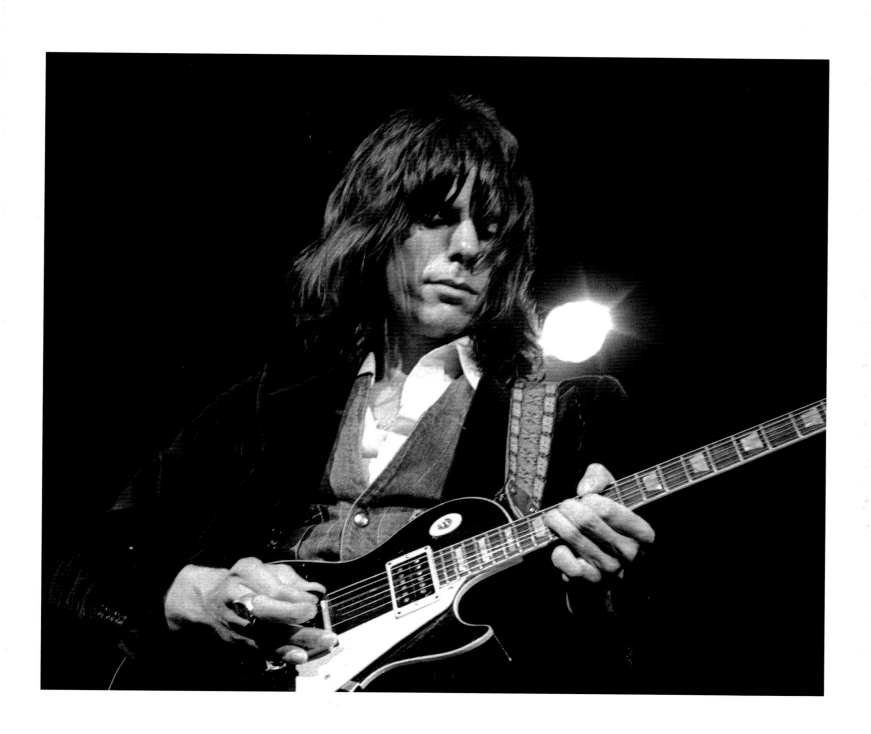

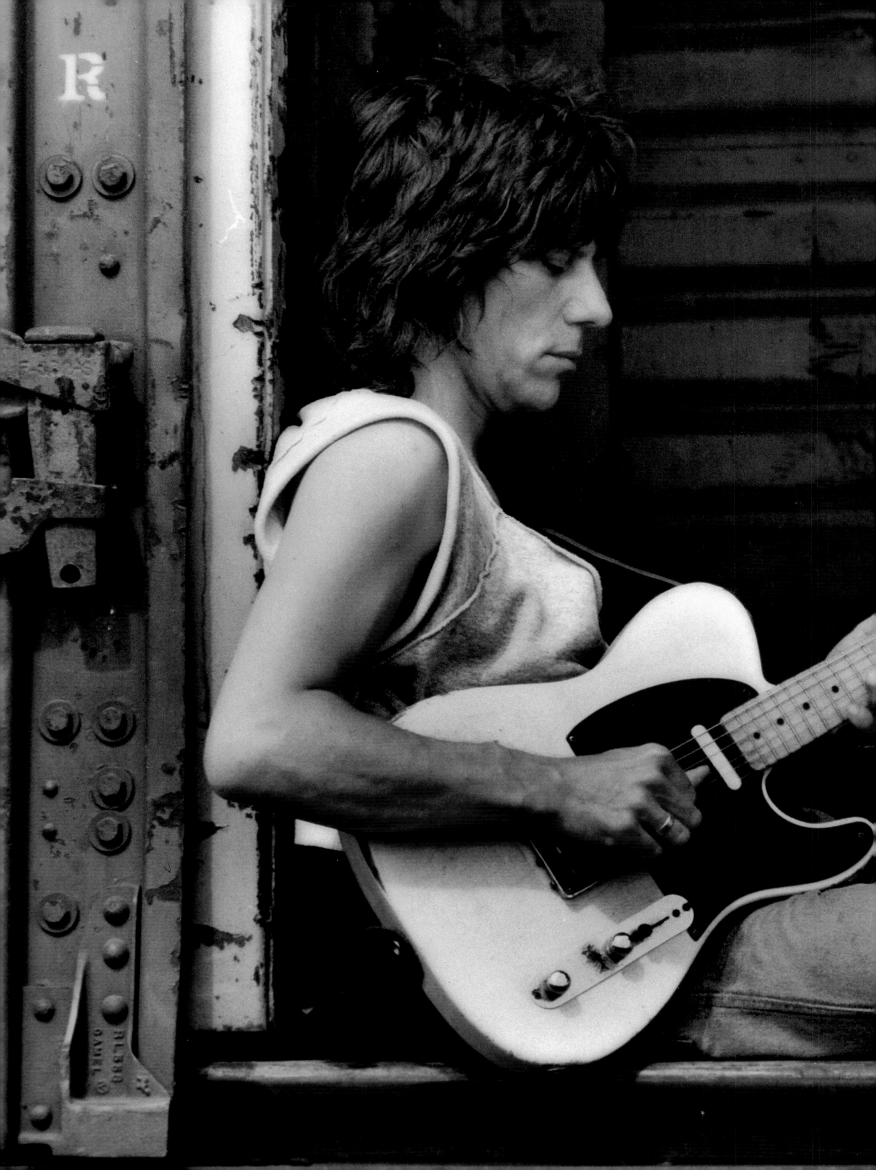

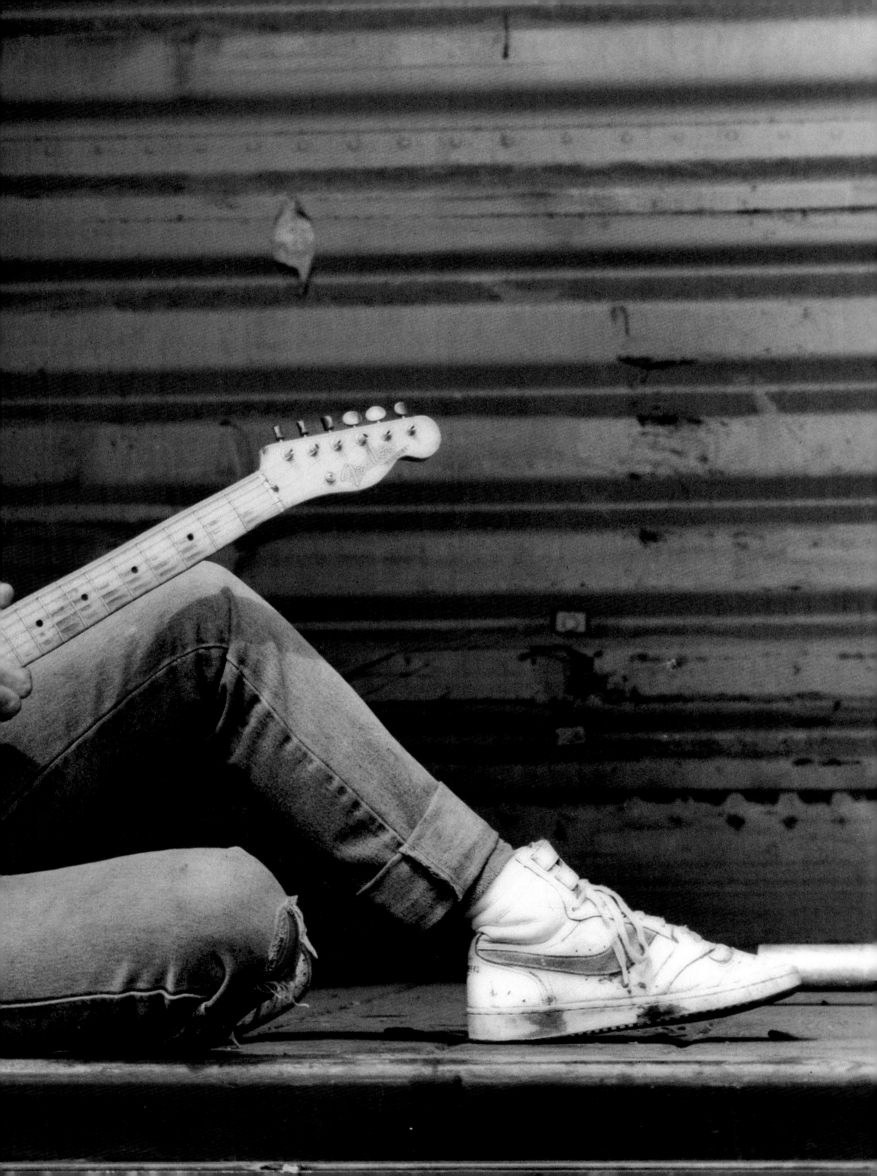

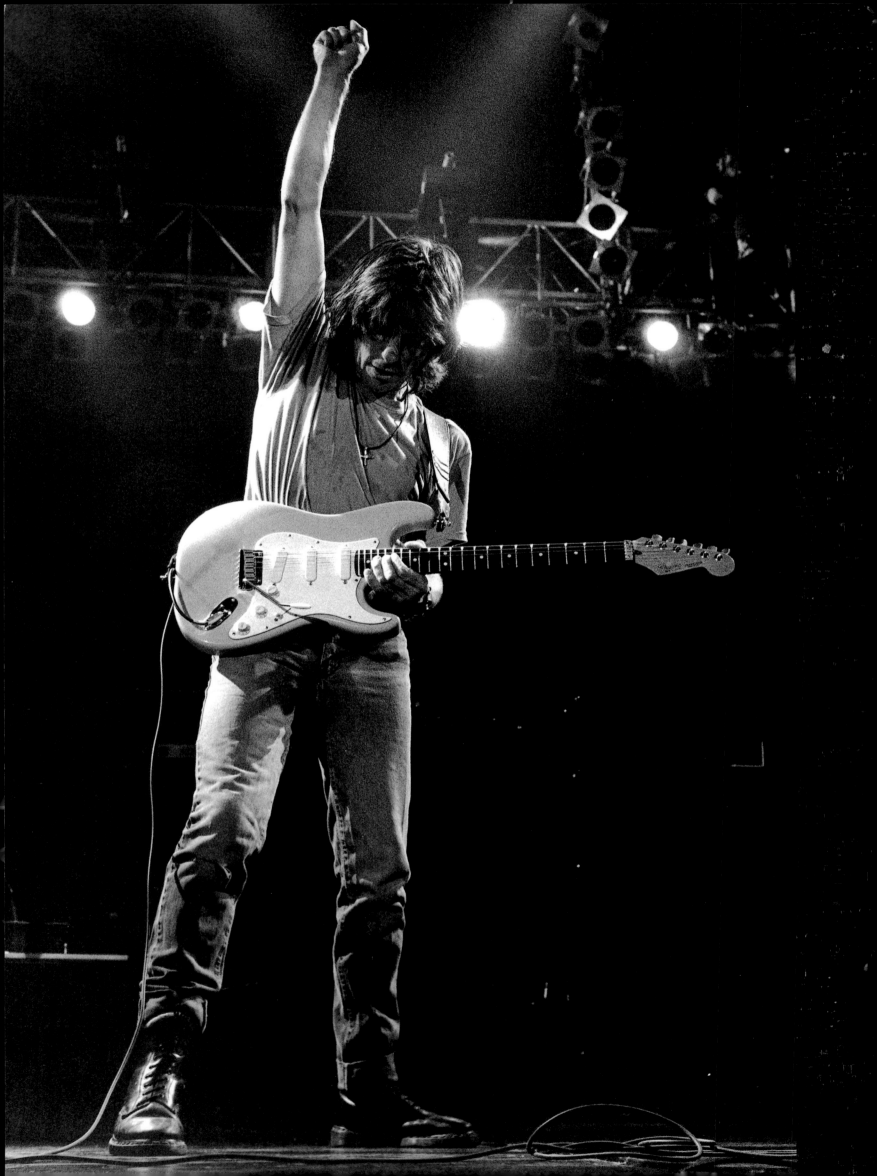

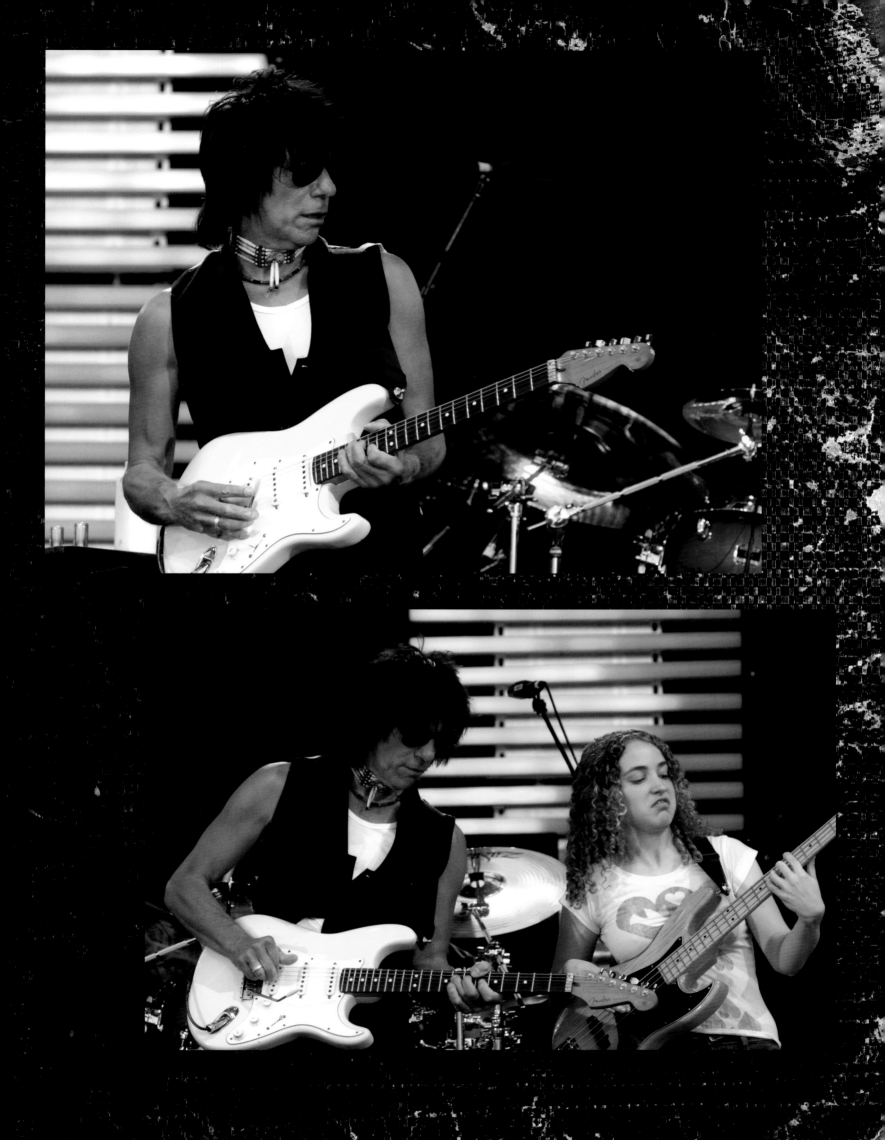

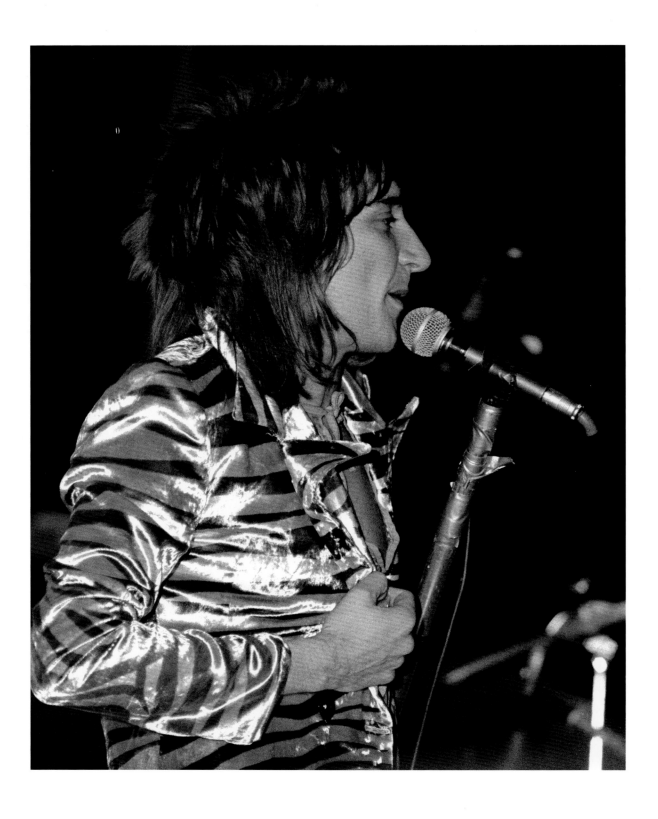

42

ROD STEWART

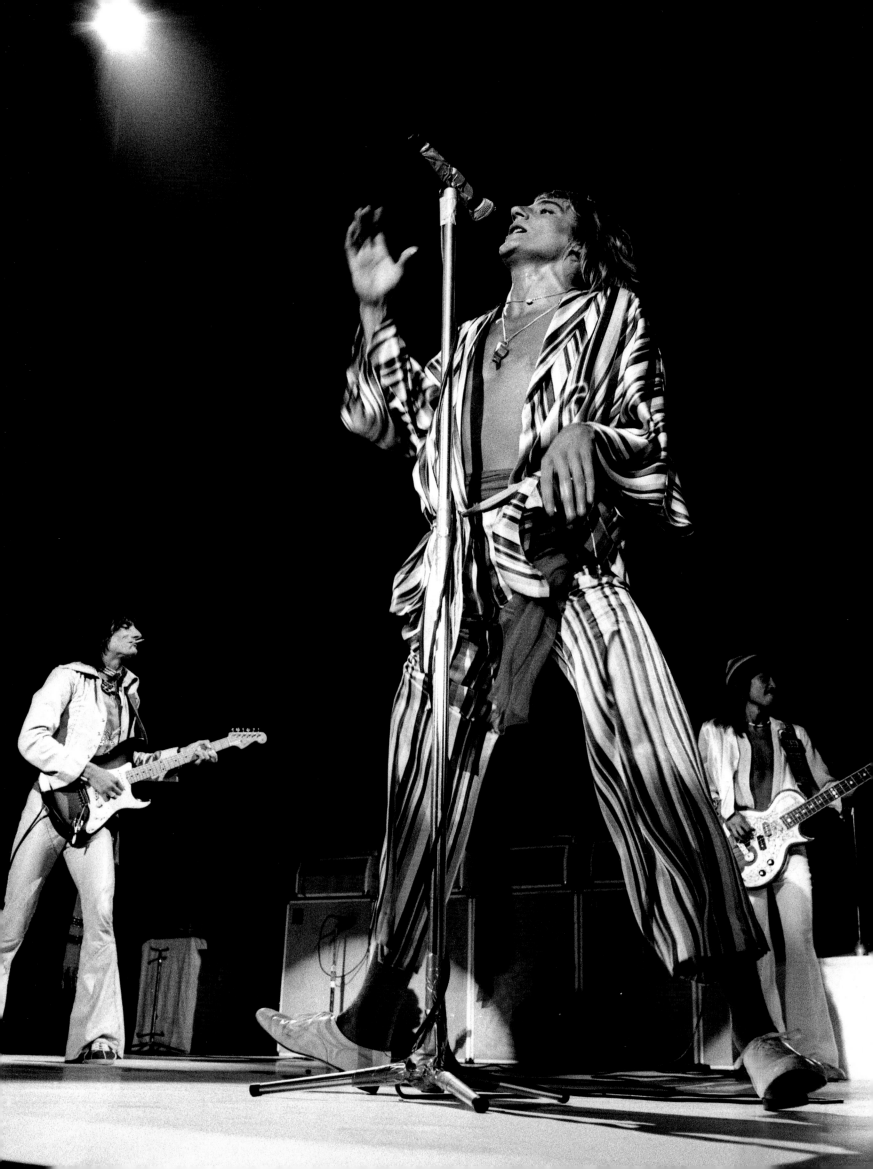

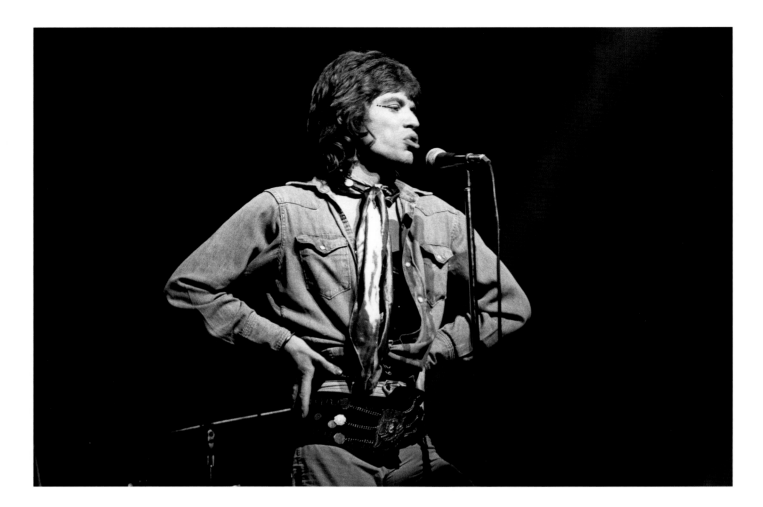

THEY SEEMED WICKED AND THEREFORE

I WAS ALWAYS a Stones guy. I mean, I really, really liked that band. Being a missionary's kid, they seemed wicked and therefore held a lot of appeal to me. While The Beatles wanted to hold your hand, the Rolling Stones wanted to hold another part of your anatomy. They were naughty boys and antisocial. They didn't wear uniforms and they looked unwashed. It's was the kind of stuff that a young, smelly teenage boy would really find appealing. Plus, I loved their music.

I got to know Ron Wood the best. I've been working with him for forty years. He's quite a character, almost like a cartoon character in a way. I think the reason that Ronnie and I became friends is because I'm good friends with Jeff Beck and Slash, who are also two of Ronnie's good friends. I was with Ronnie at one of his gallery shows in Las Vegas when most of the cast of *CSI* walked in. Ron introduced me to the *CSI* cast, "This is Robert Knight. He's worked with Jimi Hendrix. He's good friends with Jeff Beck and Slash." I turned to him and said, "Ronnie, I've worked with you for forty years too." "Oh, yeah, and he's worked with me." That's typical of how he is.

HELD A LOT OF APPEAL

MICK JAGGER

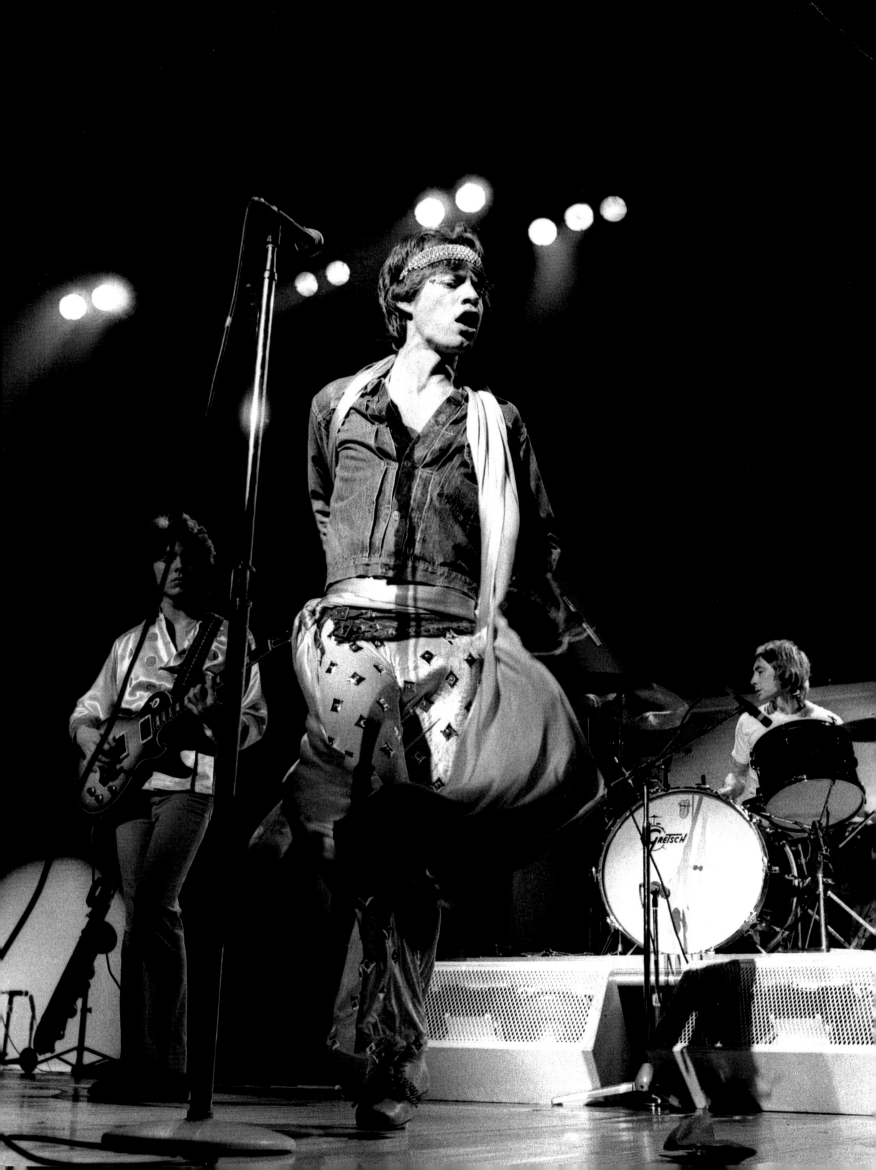

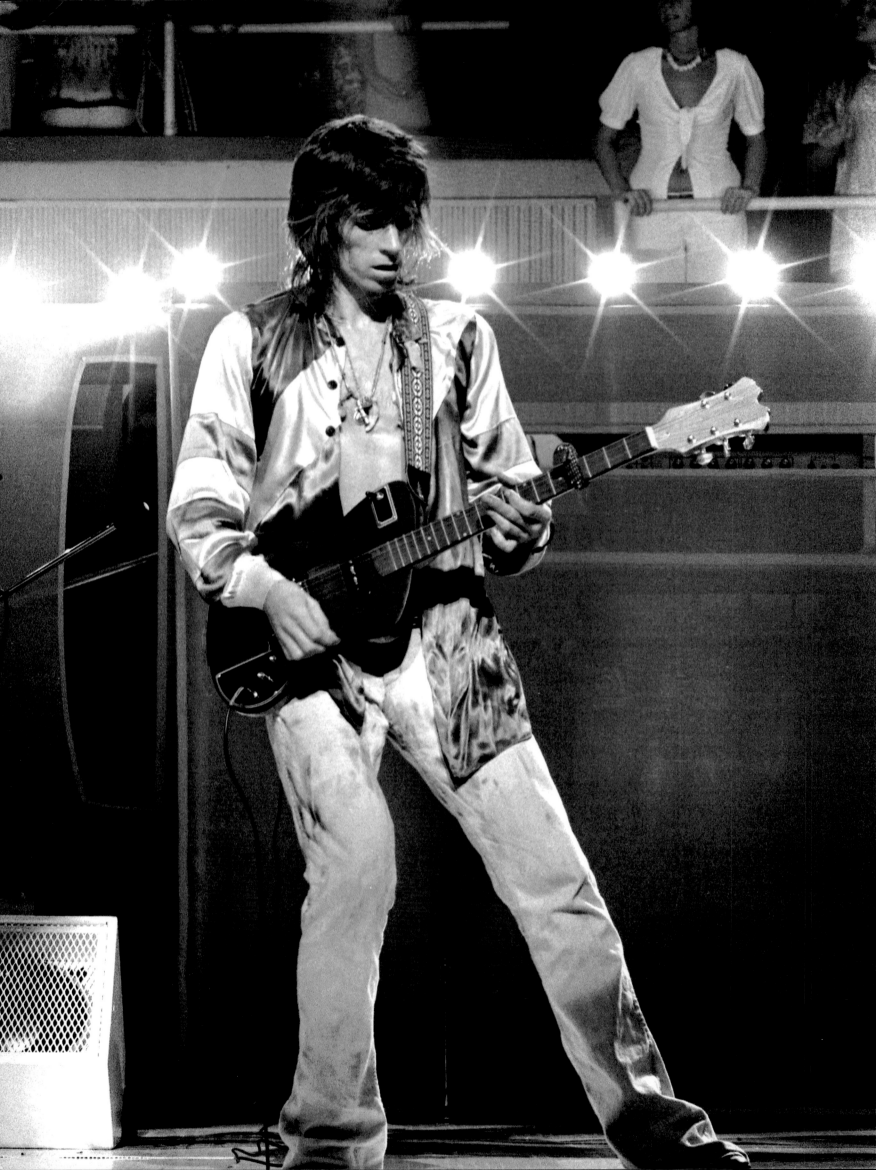

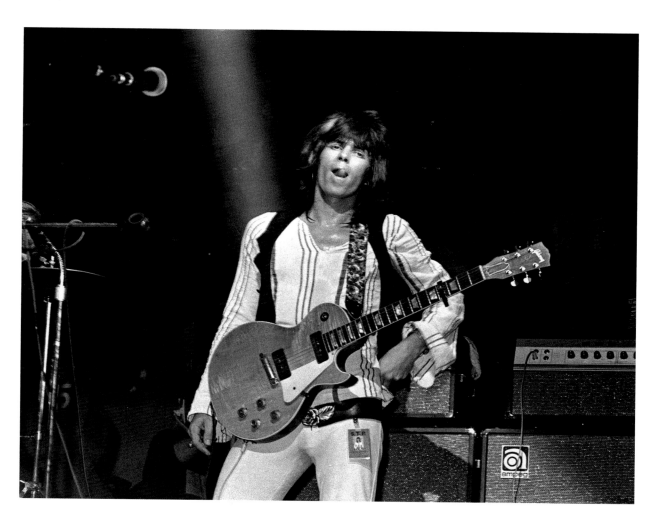

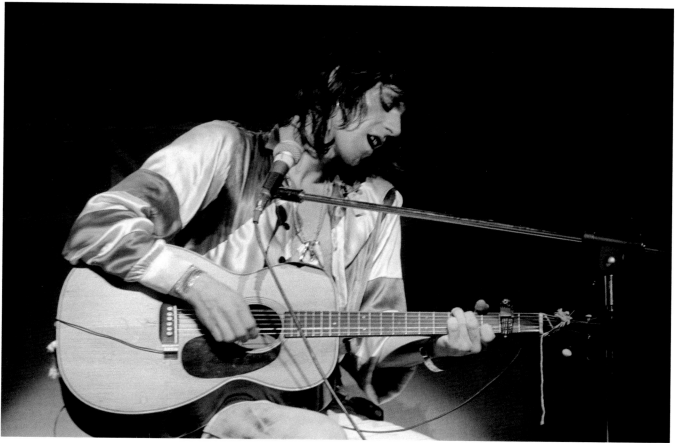

KEITH RICHARDS

The Rolling Stones Honolulu, Hawaii 1972

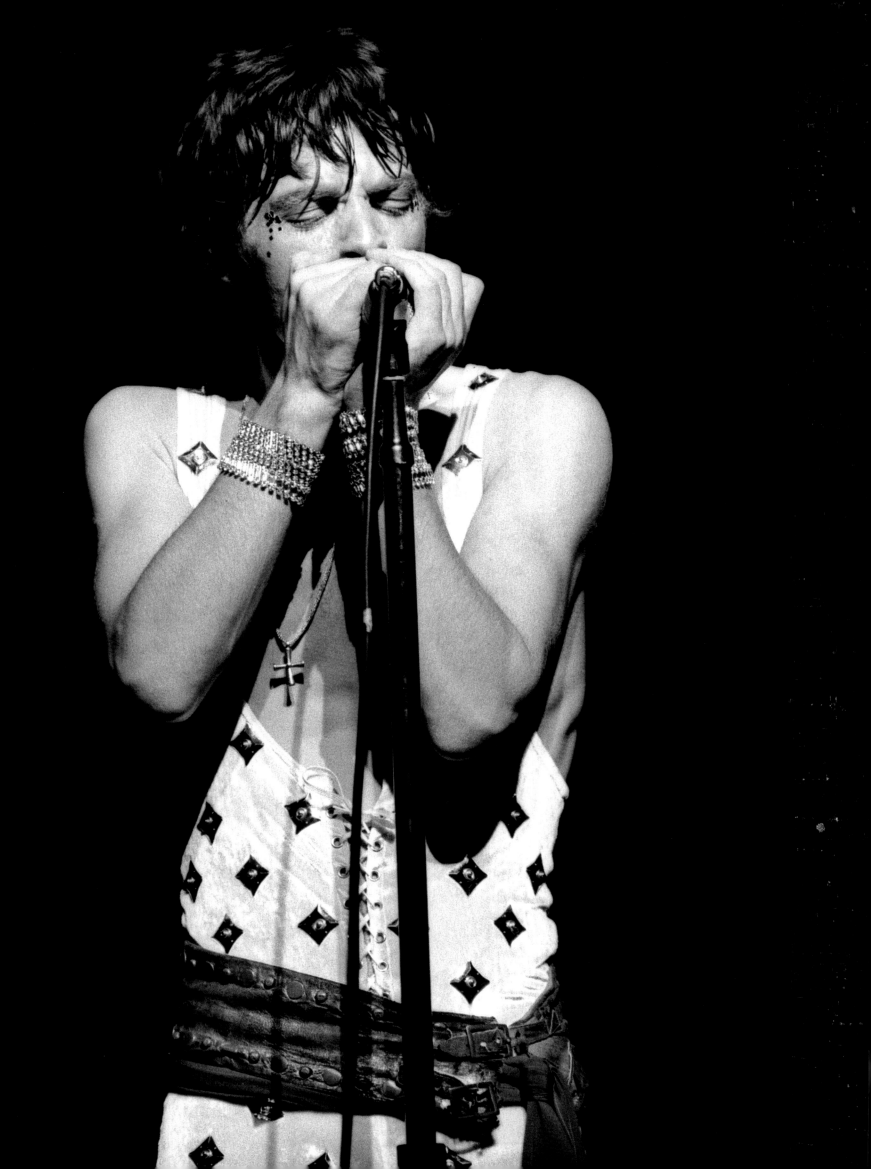

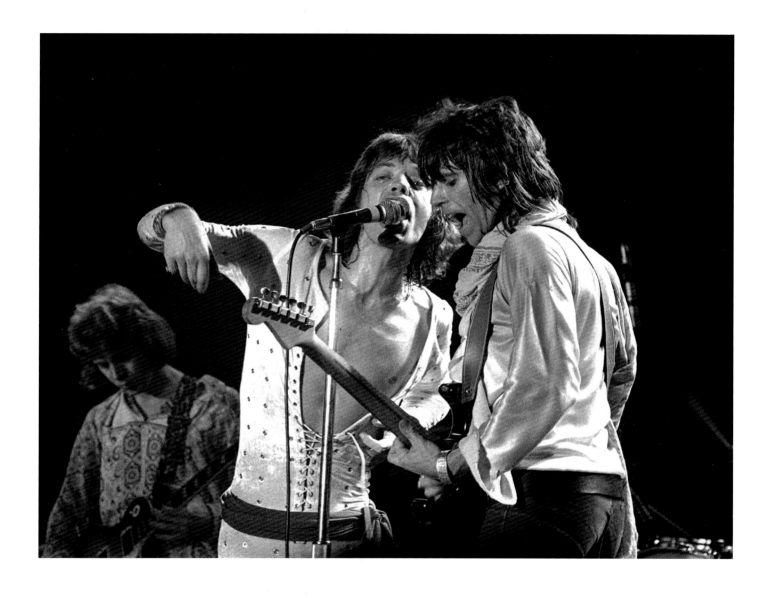

MICK TAYLOR, MICK JAGGER & KEITH RICHARDS

The Rolling Stones Los Angeles, California 1973

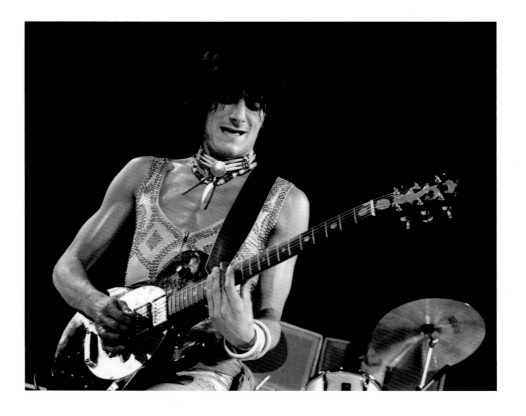

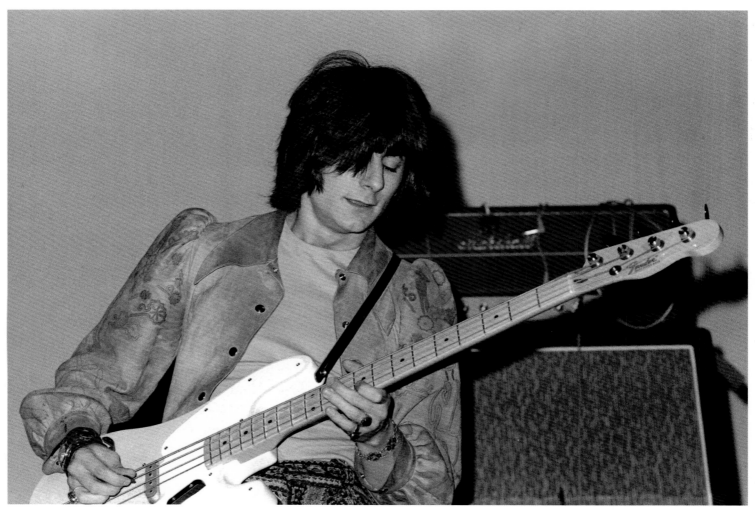

RON WOOD

| Touring with Rod Stewart | Honolulu, Hawaii | 1975 |

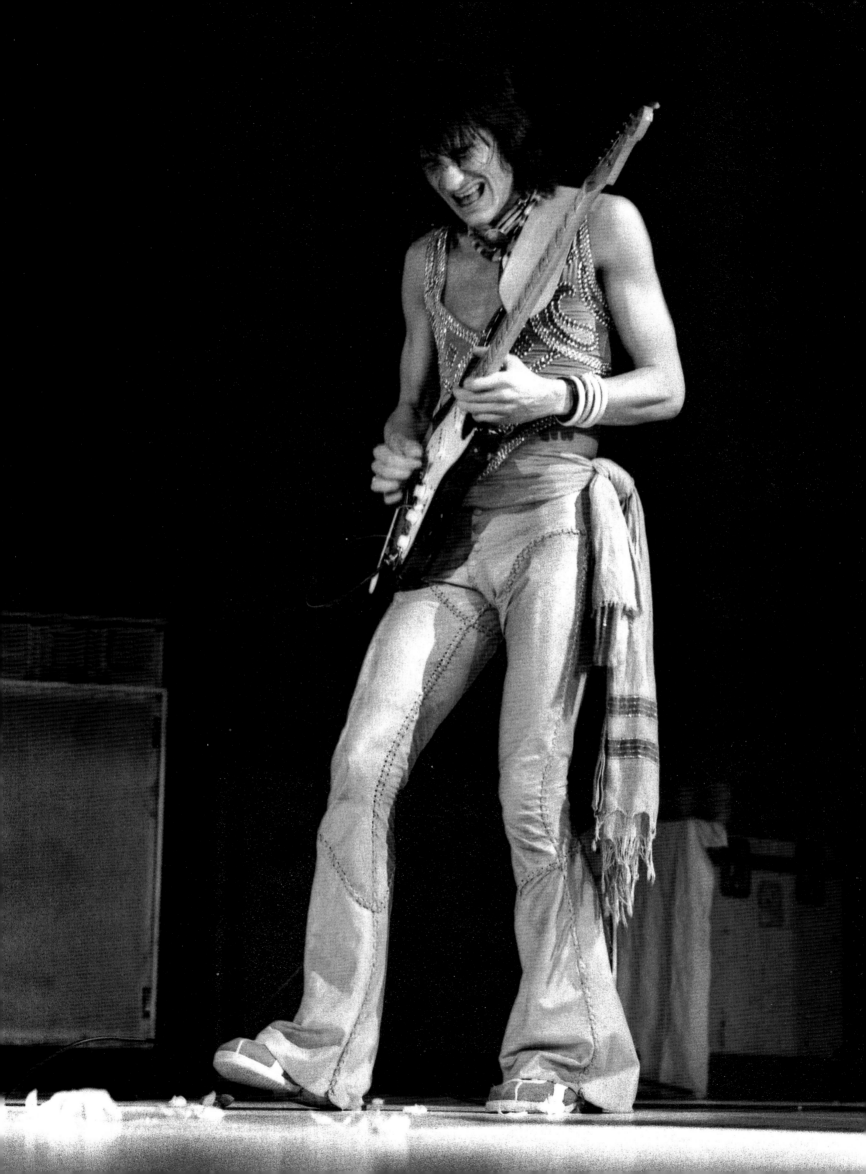

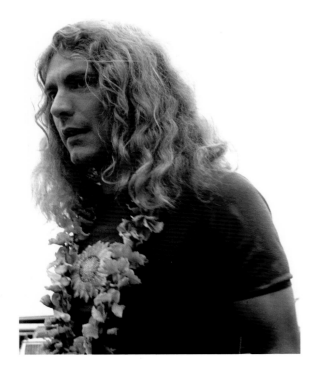

AFTER THE BAND played Hawaii, they stayed on for a week or two after the show and I spent time with them. We went out to dinner, they came over to my house. They had water fights in their pool. I photographed them trying to surf and running up and down the beach. It was quite amazing. But at the time, nobody really had the feeling that Led Zeppelin

A lot of people labeled Jimmy "the dark lord" and satanic. But I actually think he was really far more of an expanded consciousness. He was always looking at all sorts of alternative things. We would talk literally for hours about the use of color, sound and psychology on an audience, and he wanted to do that. He actually wanted to levitate.

54 I KNEW THEM BEFORE THEY WERE LEGEND

would develop into a massive force in music. They weren't in the league of The Beatles or the Rolling Stones yet. The critics didn't particularly care for them at the time. I think *Rolling Stone* actually gave them a bad review. I knew them before they were legend and made friends with Jimmy Page.

Jimmy Page owned one of the largest occult bookstores in Europe back in the day, called Equinox, and he was really a student of the arcane.

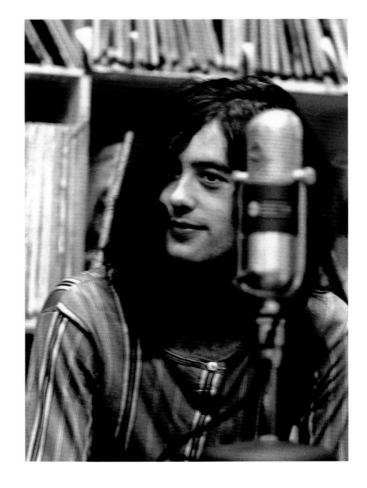

ROBERT PLANT

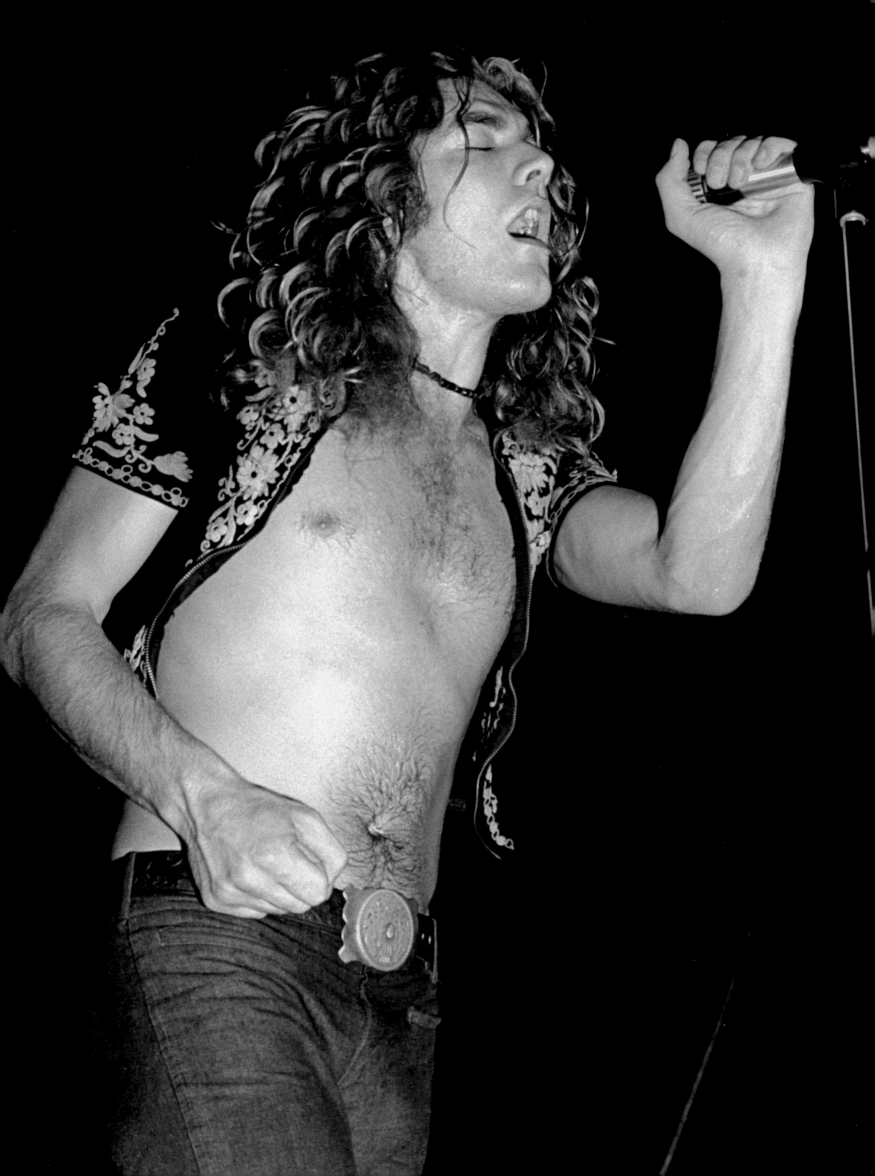

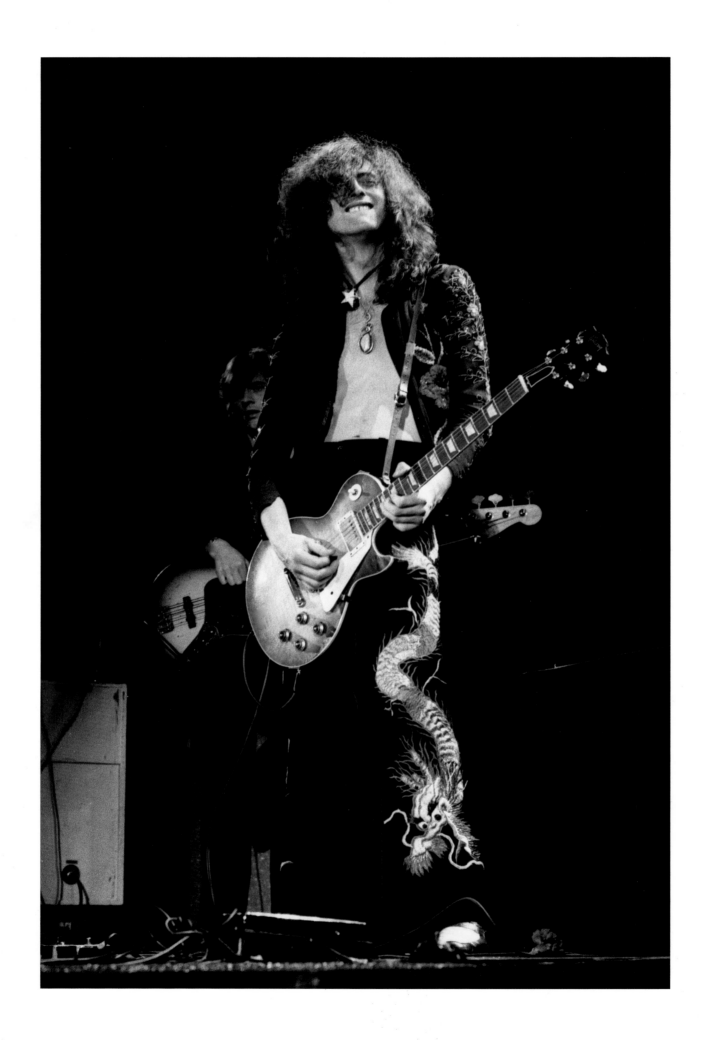

JIMMY PAGE

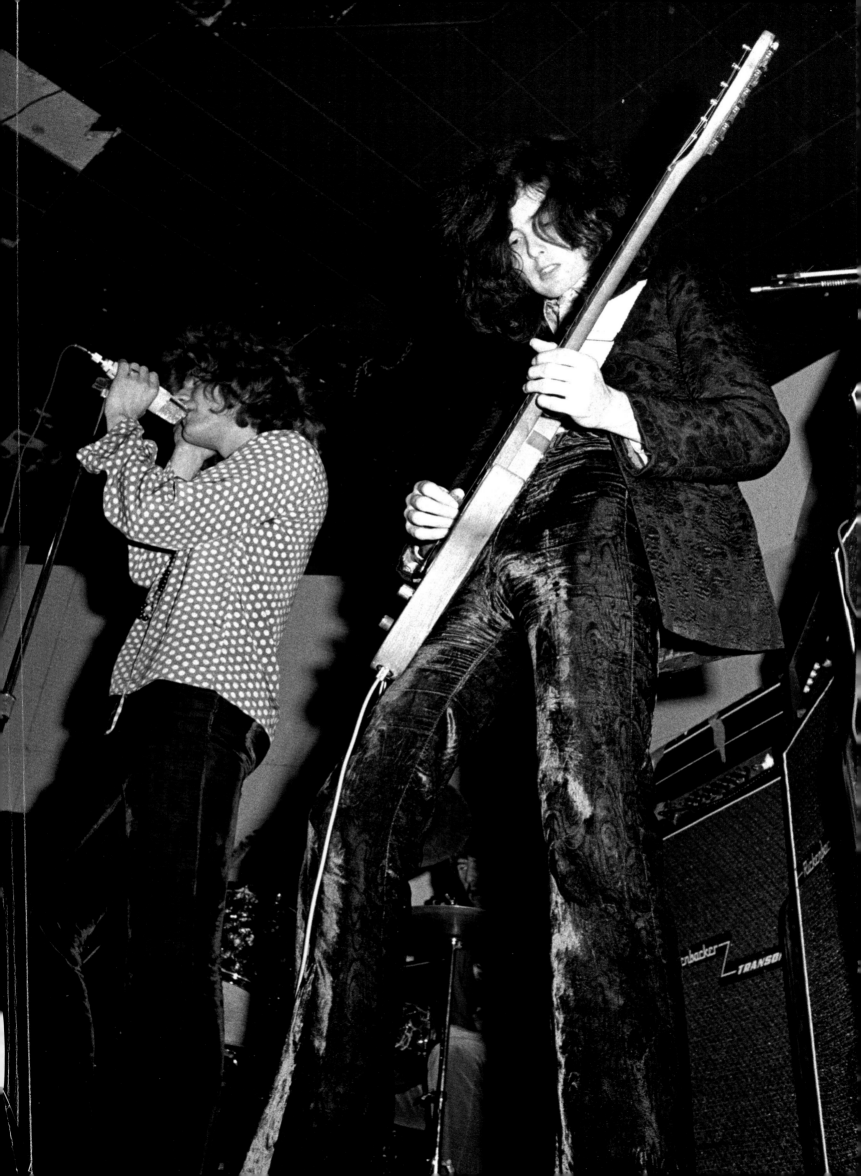

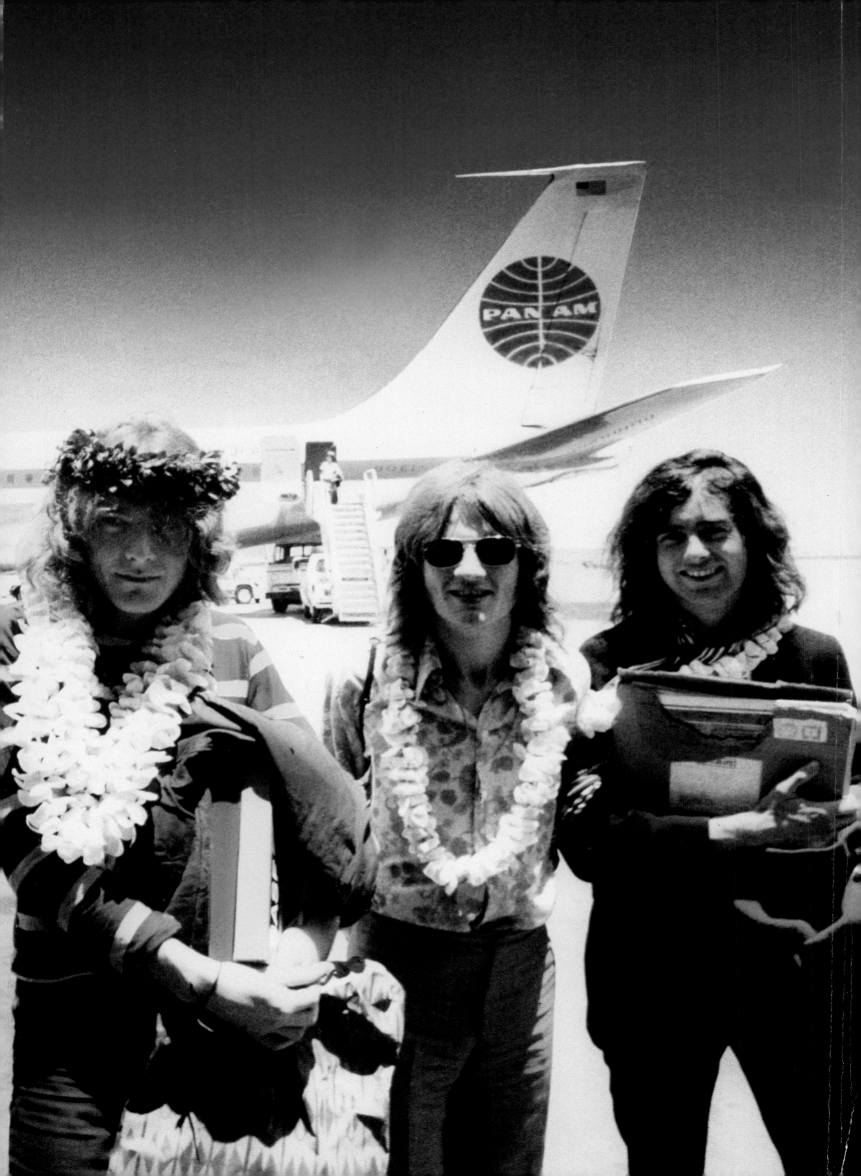

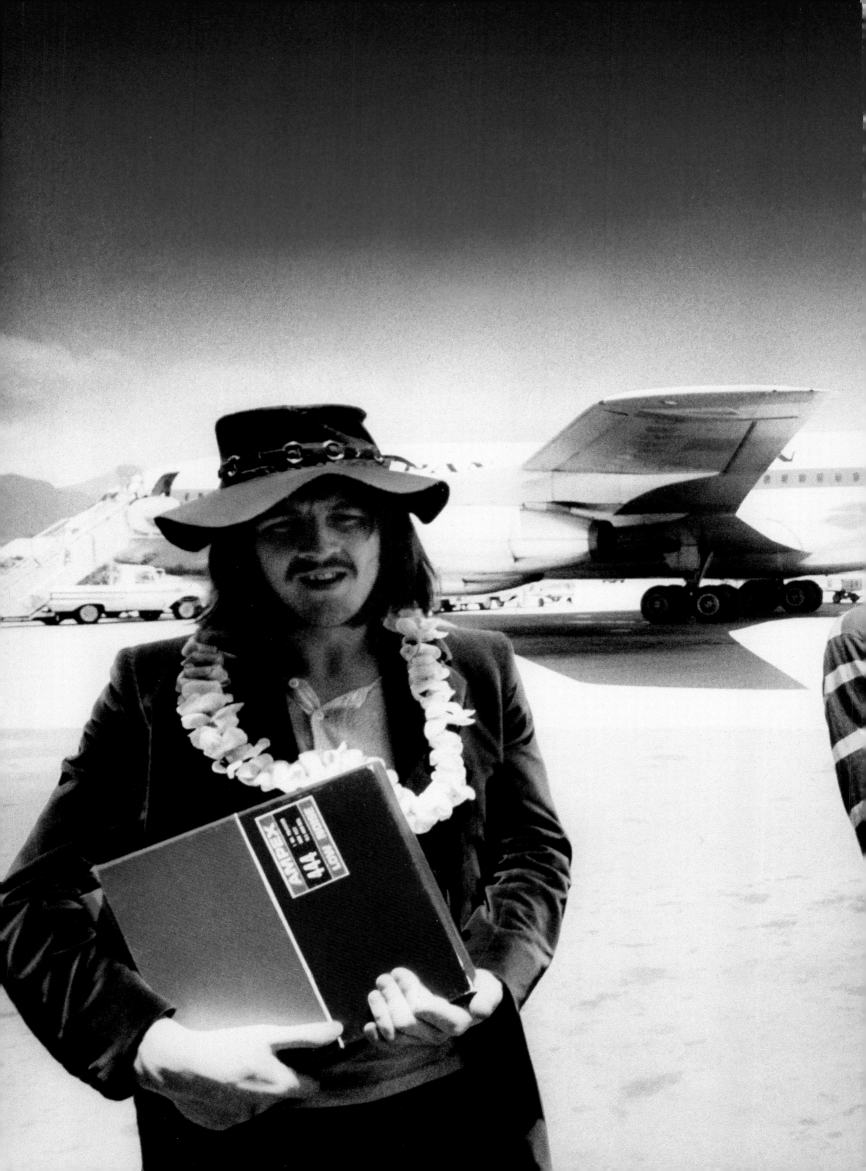

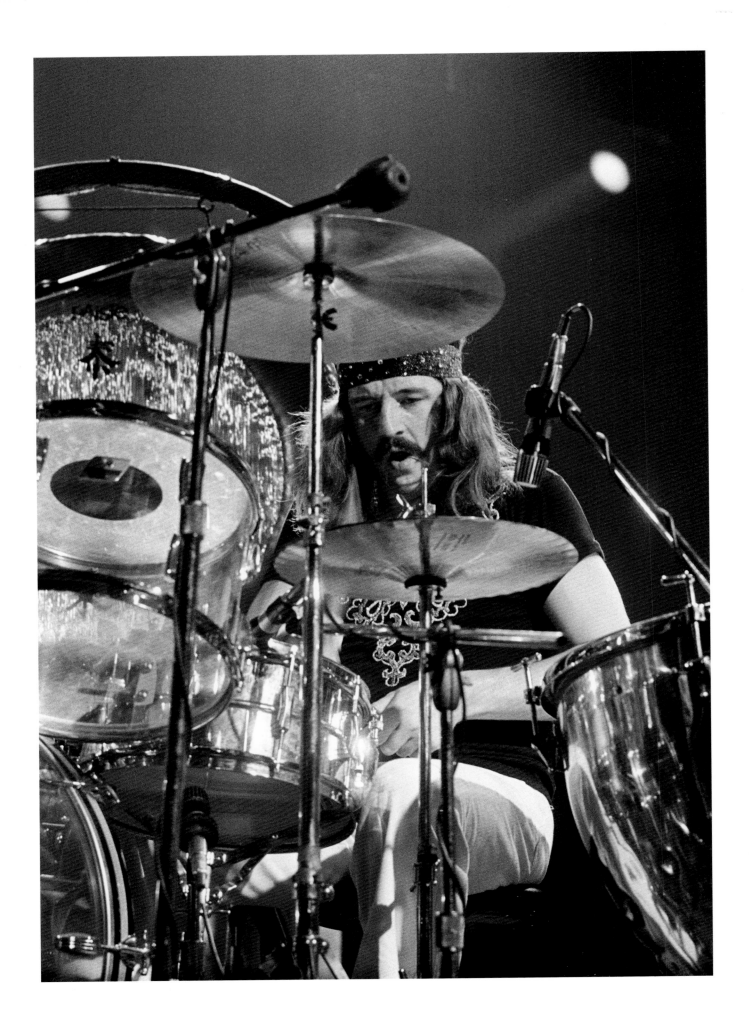

JOHN BONHAM

Led Zeppelin | Seattle, Washington | 1972

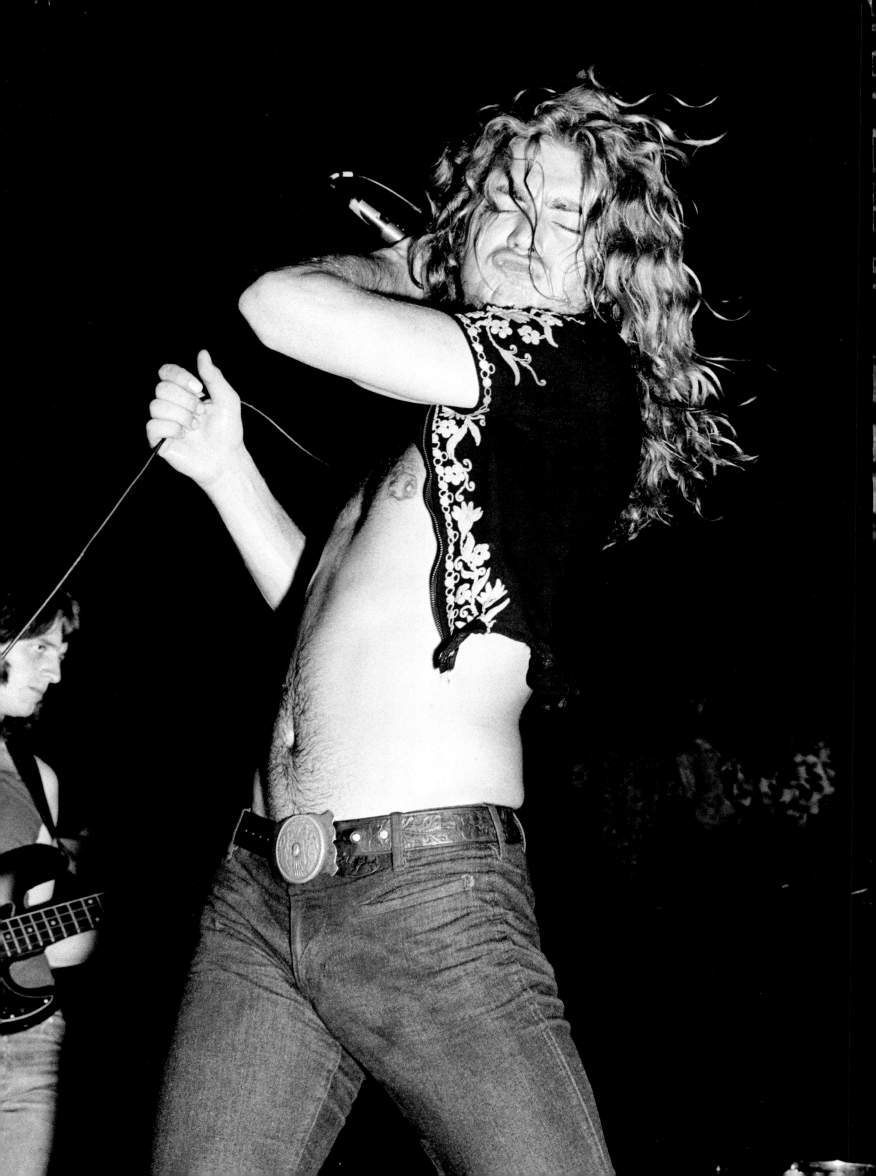

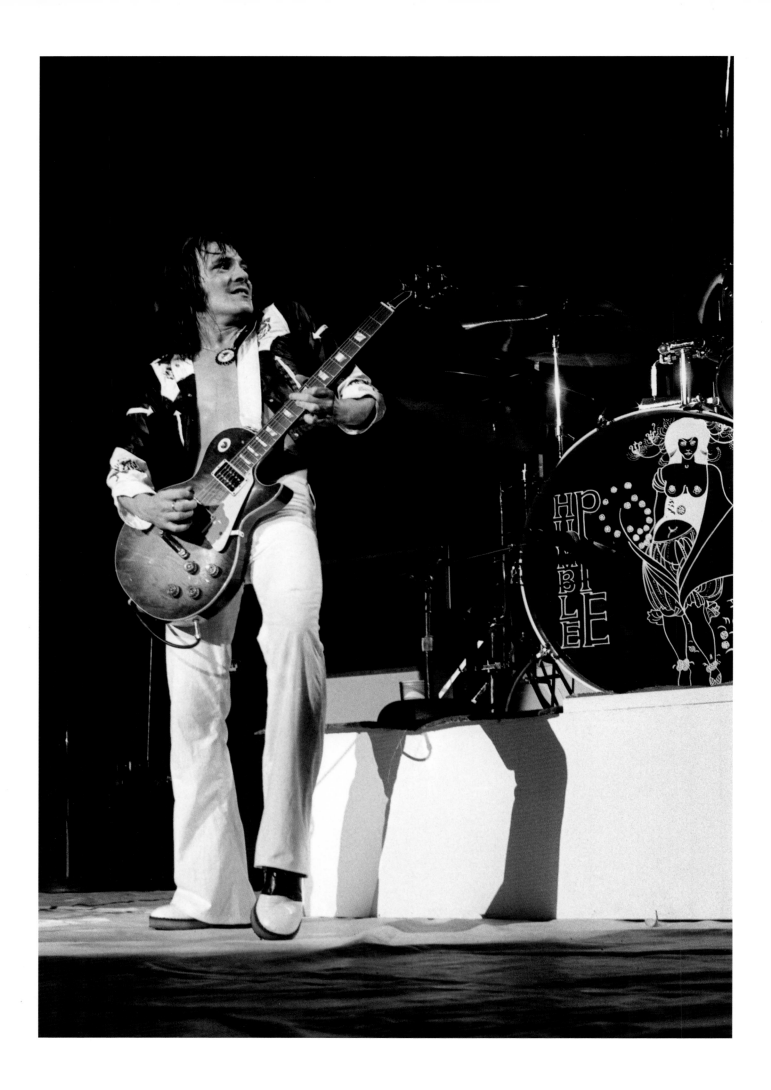

STEVE MARRIOTT

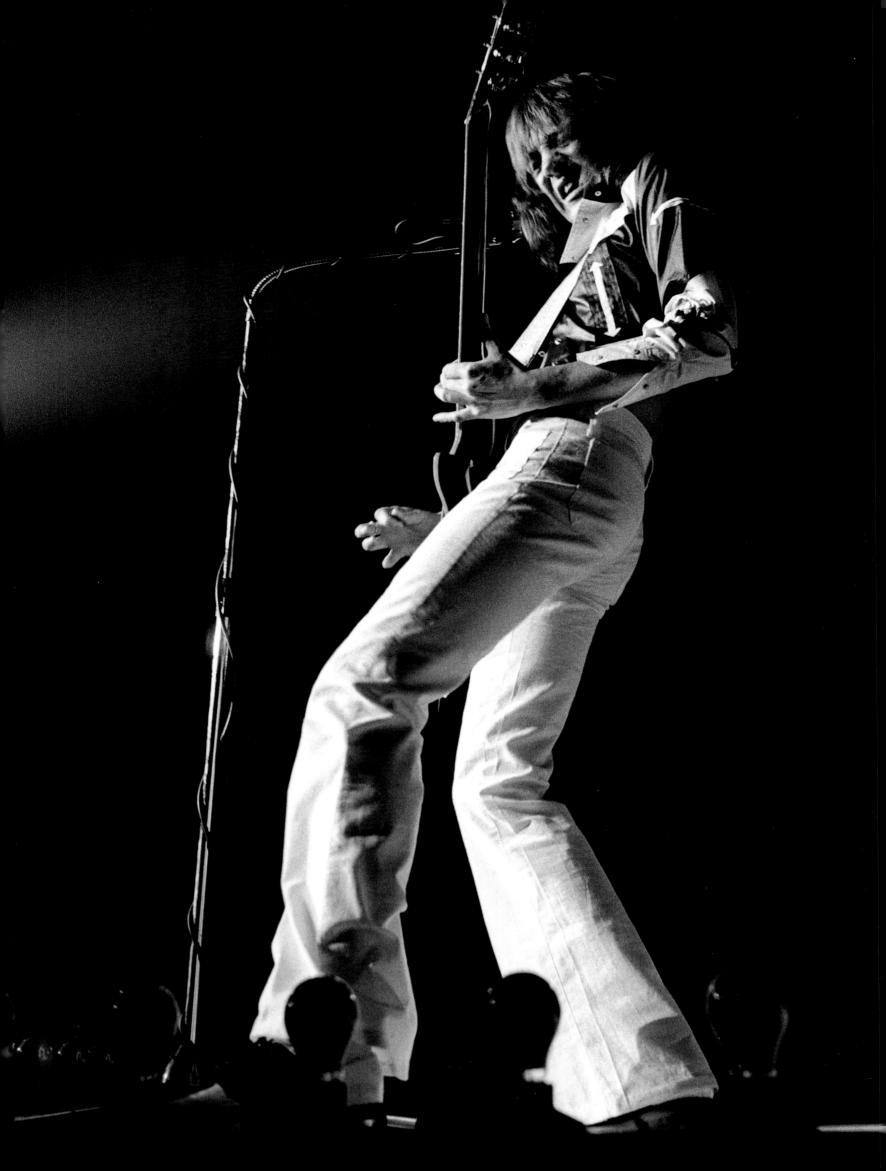

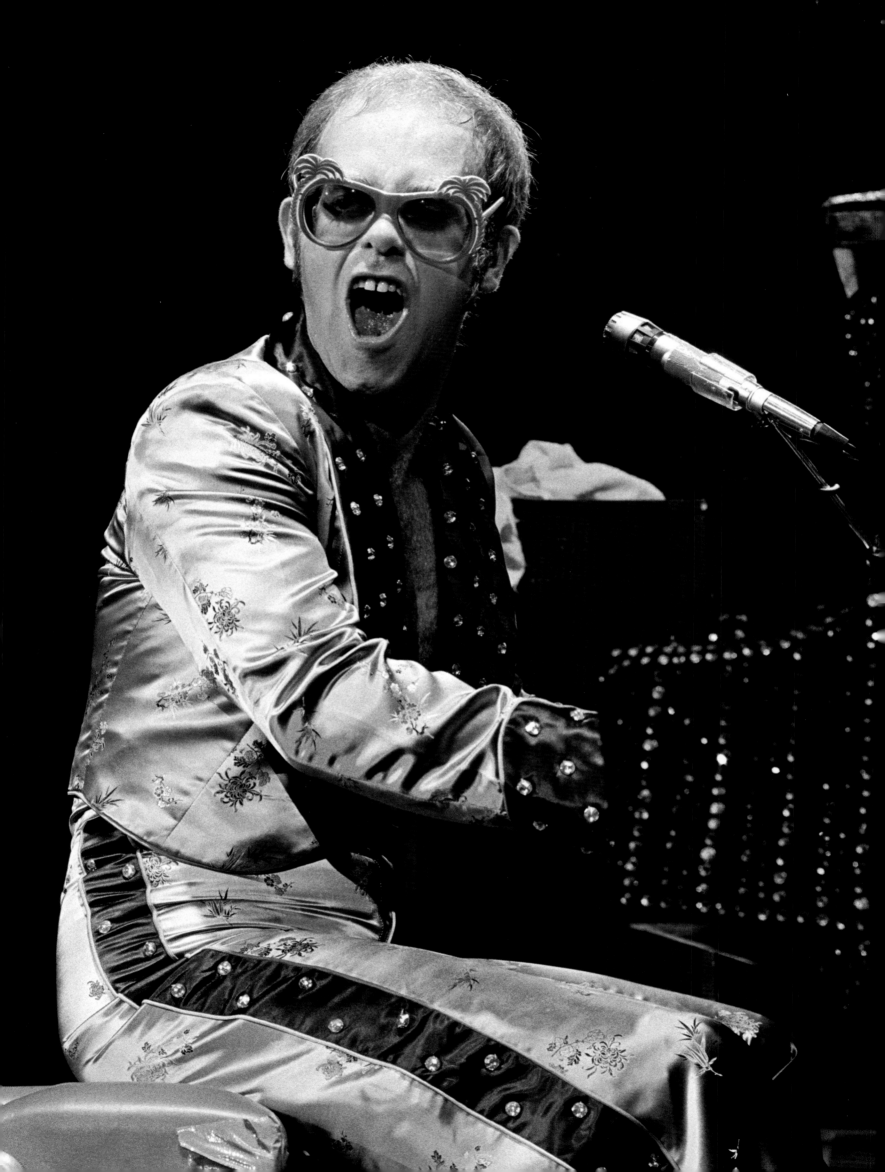

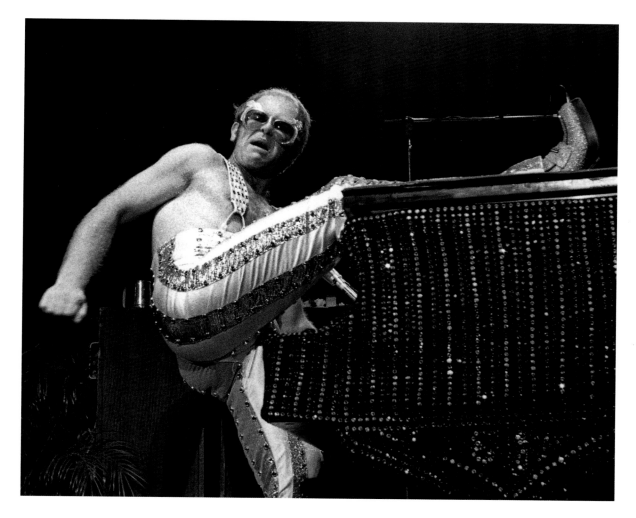

THIS GUY IS GOING TO BE THE NEXT BIG THING

I FIRST MET ELTON in Hawaii when the promoter told me to head to JC Penney where Elton was doing an in-store performance. He said, "This guy is going to be the next big thing." I'd never heard of him. This was probably 1970 or 1971. When I got to the store, I basically saw this guy in a funny costume. I couldn't figure out the clothes. He had on white patent leather shoes and a weird jumpsuit. He stood on a little round white pedestal and signed autographs. He invited me to the show. He put me on the stage and I

shot the whole concert from there. Afterwards, we hung out.

I was really into Monty Python and he was an expert on Monty Python. We both knew all the words so we started doing Monty Python skits. After that, every time Elton came to Hawaii, he would call me. We'd have dinner, rent mopeds, fly to the outer islands and end up in all kinds of adventures. He actually stayed at my house in Hawaii once. After 1980, I didn't see that much of him. The basis of our friendship was that we really enjoyed music.

ELTON JOHN

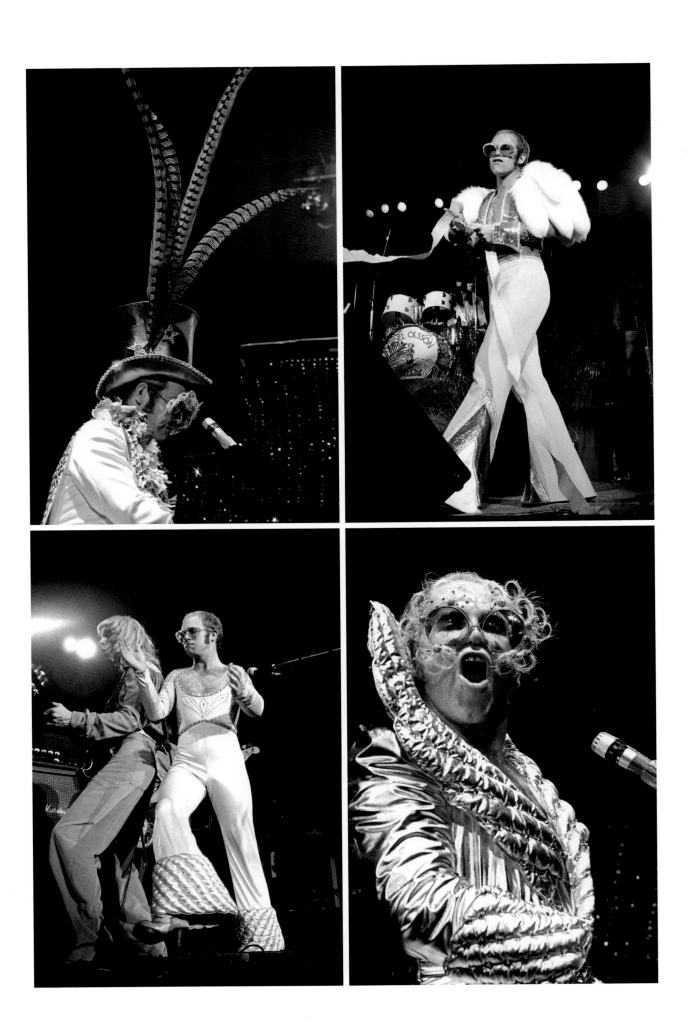

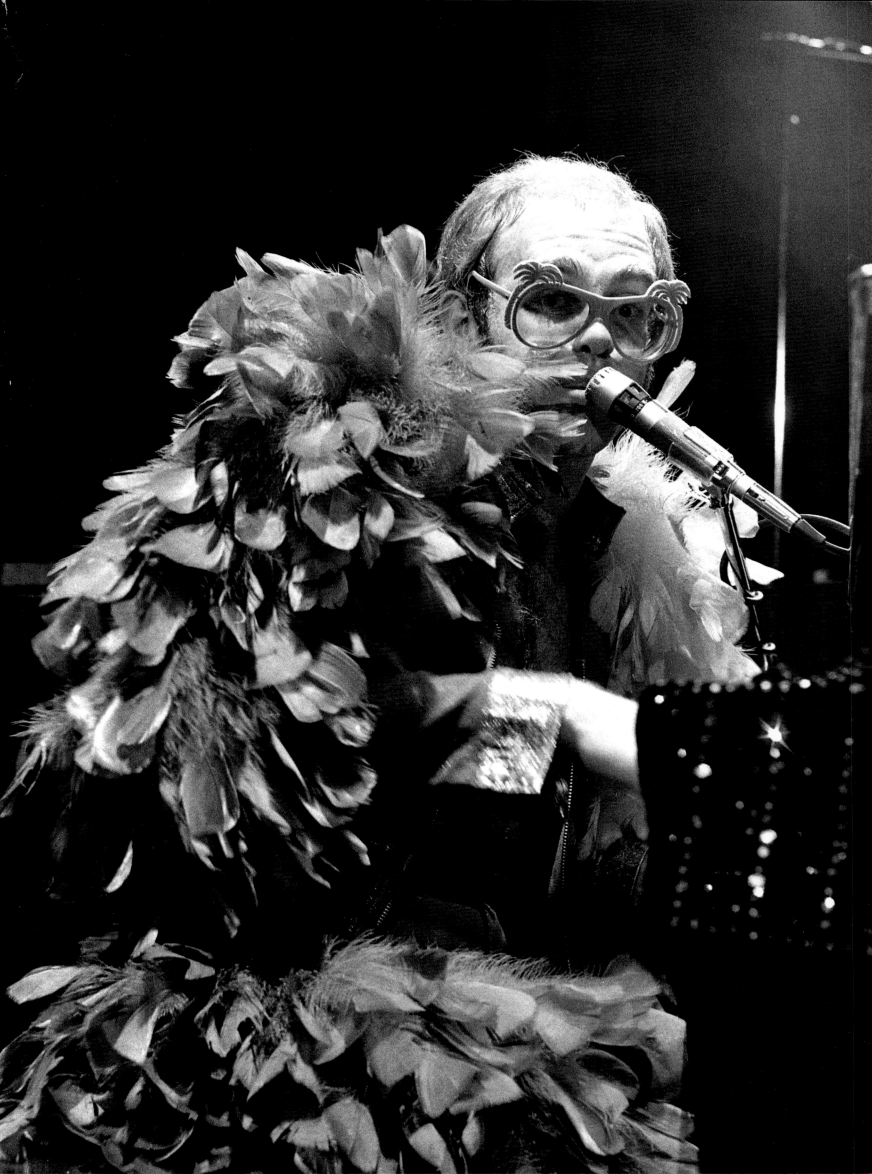

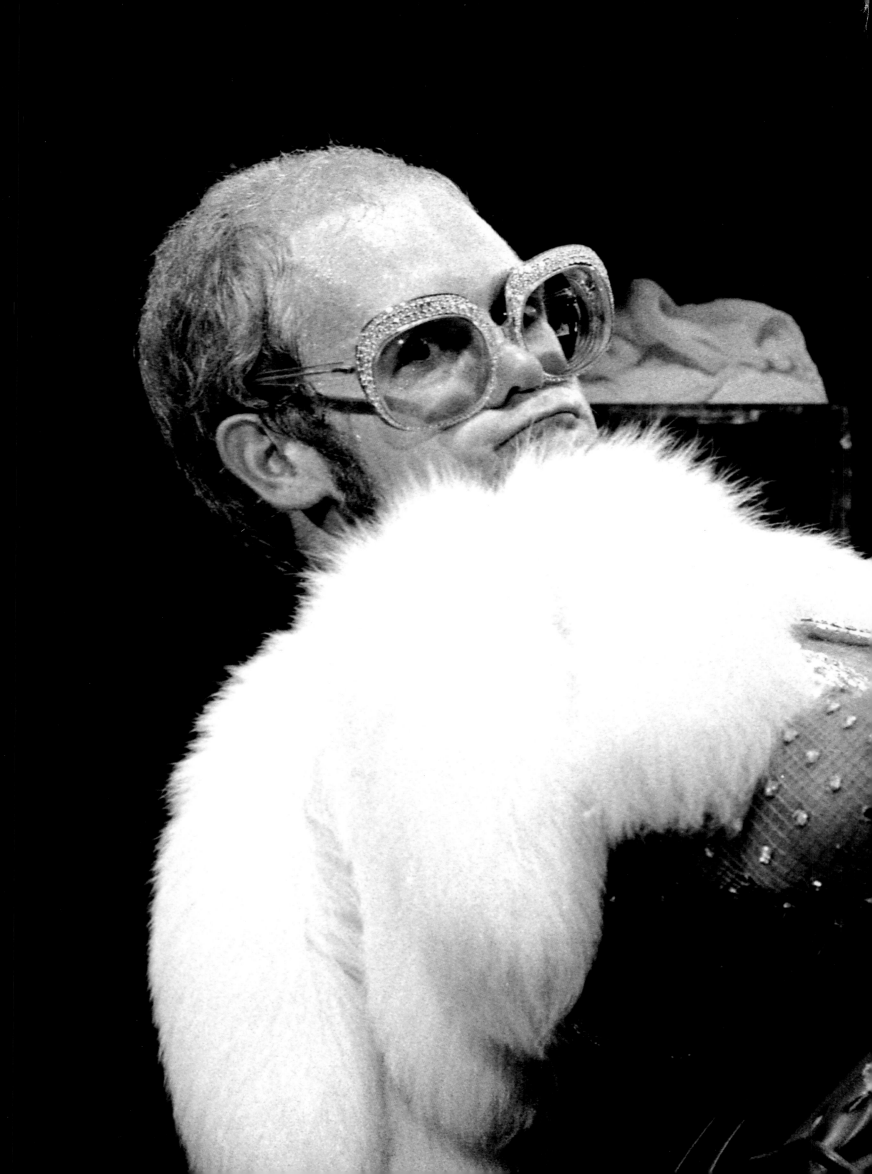

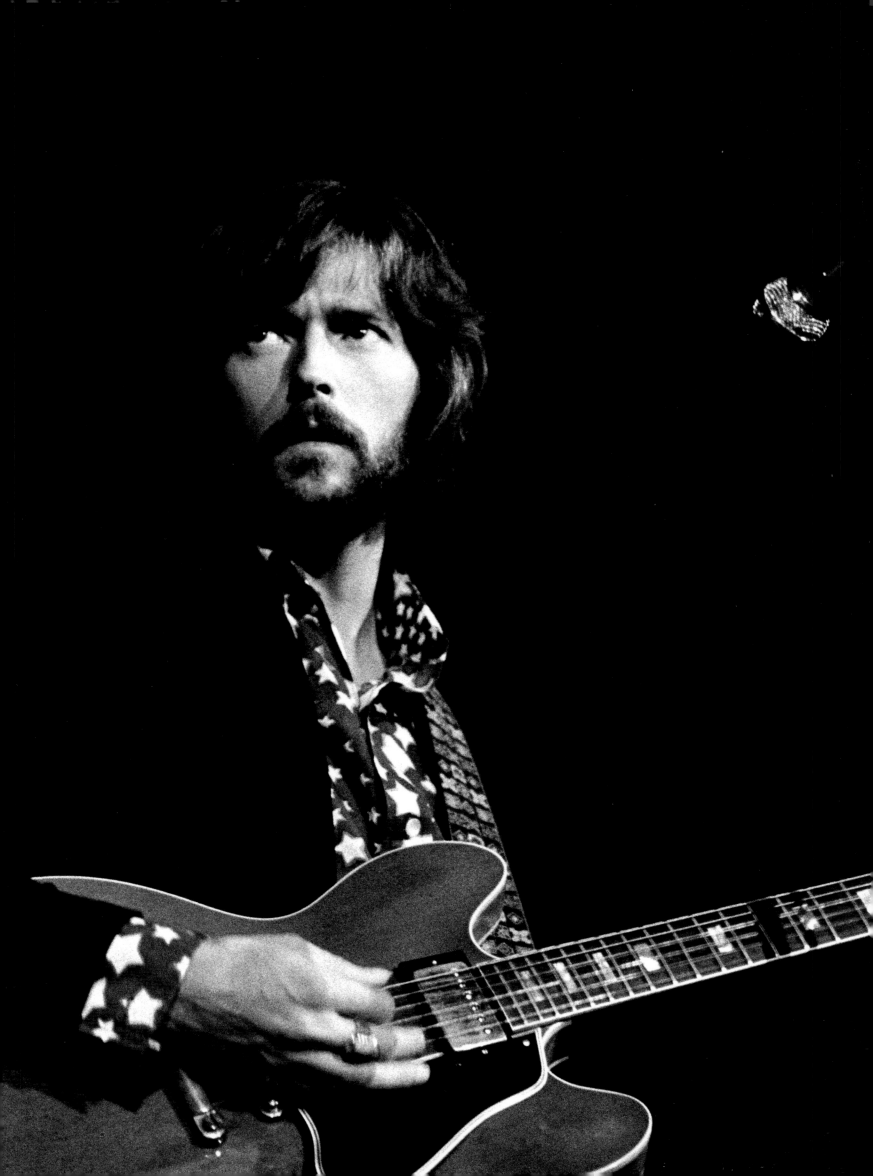

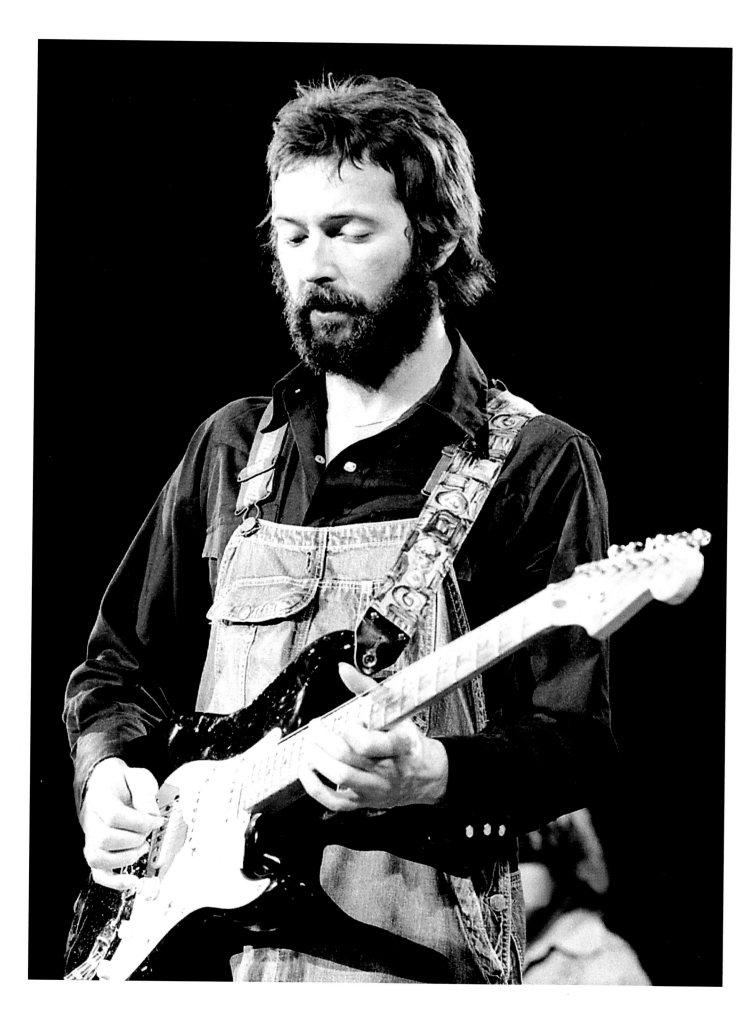

ERIC CLAPTON

Honolulu, Hawaii | 1970

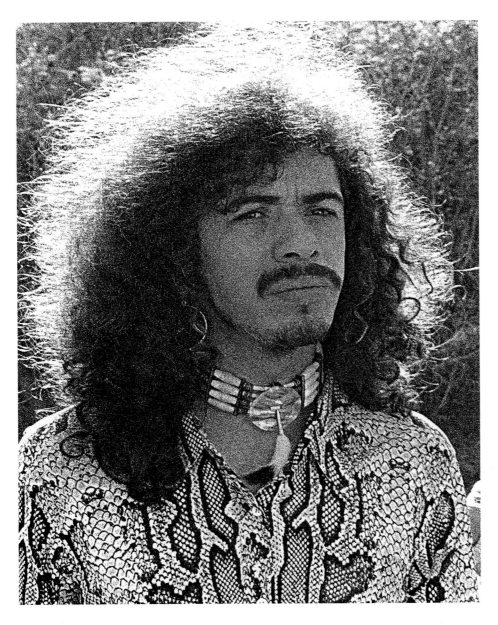

IT IS HARD FOR ME to express how much I admire and love Carlos Santana. As a guitar player, Carlos' sound is unique in the world. No one, no one, sounds like him. As a humanitarian, he is right up there with Bono. Maryanne and I are privy to charity works he has done for which he seeks no publicity. He has given a lot of money to Third World villages. He privately sold something like twenty of his best guitars and gave the money to Bishop Desmond Tutu. He helped

a village in Africa that Bill Cosby's wife had told him about, where young girls turned to prostitution because their parents had died of AIDS. When I asked him if he wanted to

NO ONE, NO ONE SOUNDS LIKE HIM

be in the documentary, he was going through a lot of personal difficulties and wasn't doing much of anything musically related. But in the midst of all of his great mental suffering, he

participated in the film. He said, "Do you remember that little boy with the little hat that you saw in Tijuana selling Chicklets?" Well, there's no difference between me and that guy, except

now I have a bigger hat." He broke down and cried while talking about Stevie during the film. I thought he would never sign off on that footage, but he did. He is an amazing friend.

CARLOS SANTANA

| | Crater Festival | Honolulu, Hawaii | Early '70s |

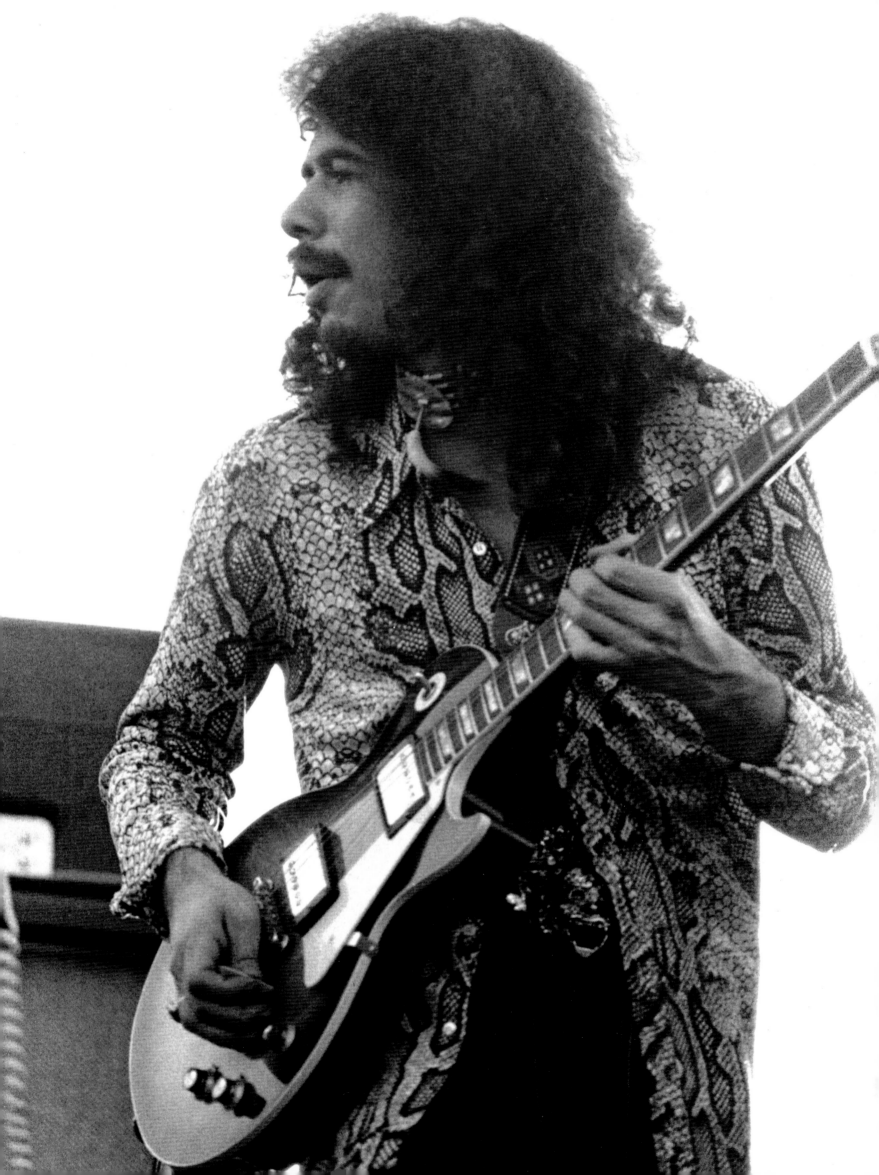

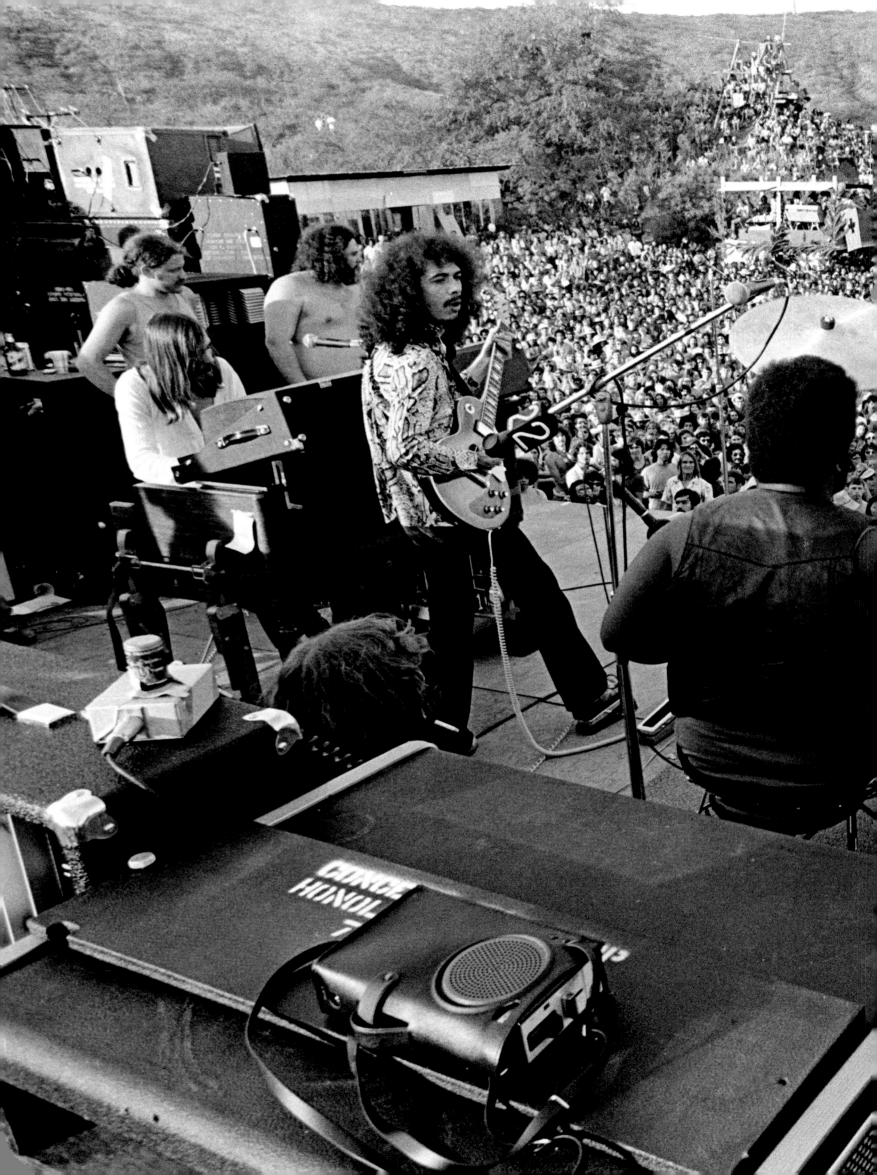

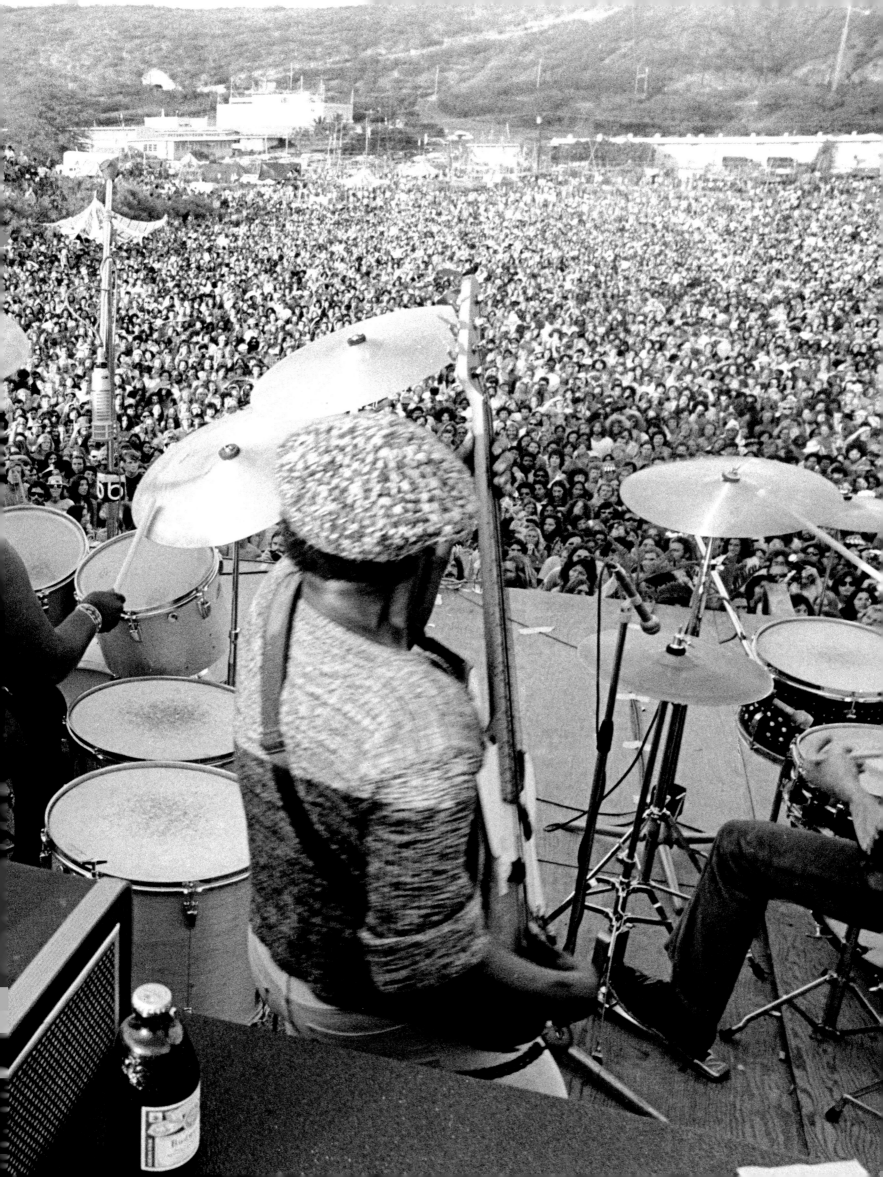

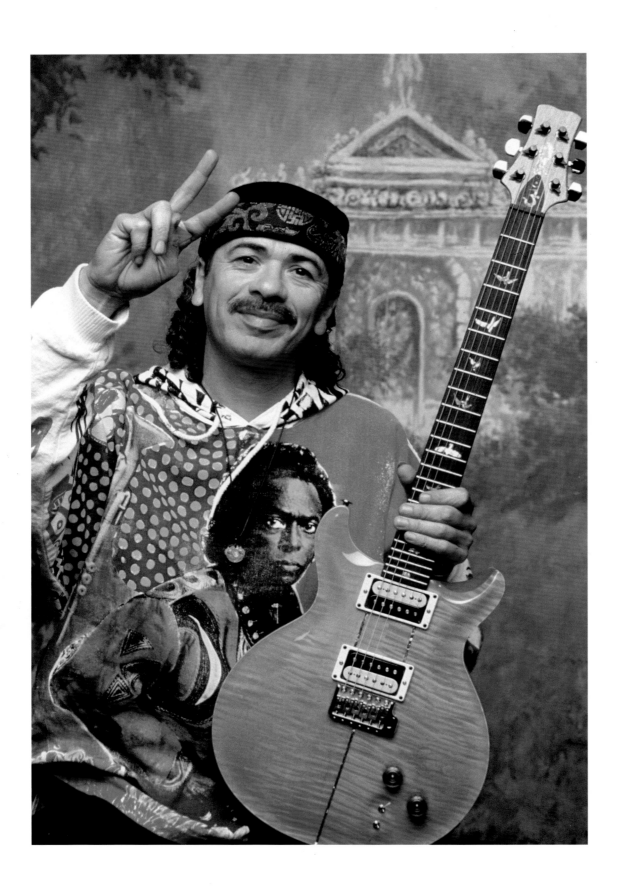

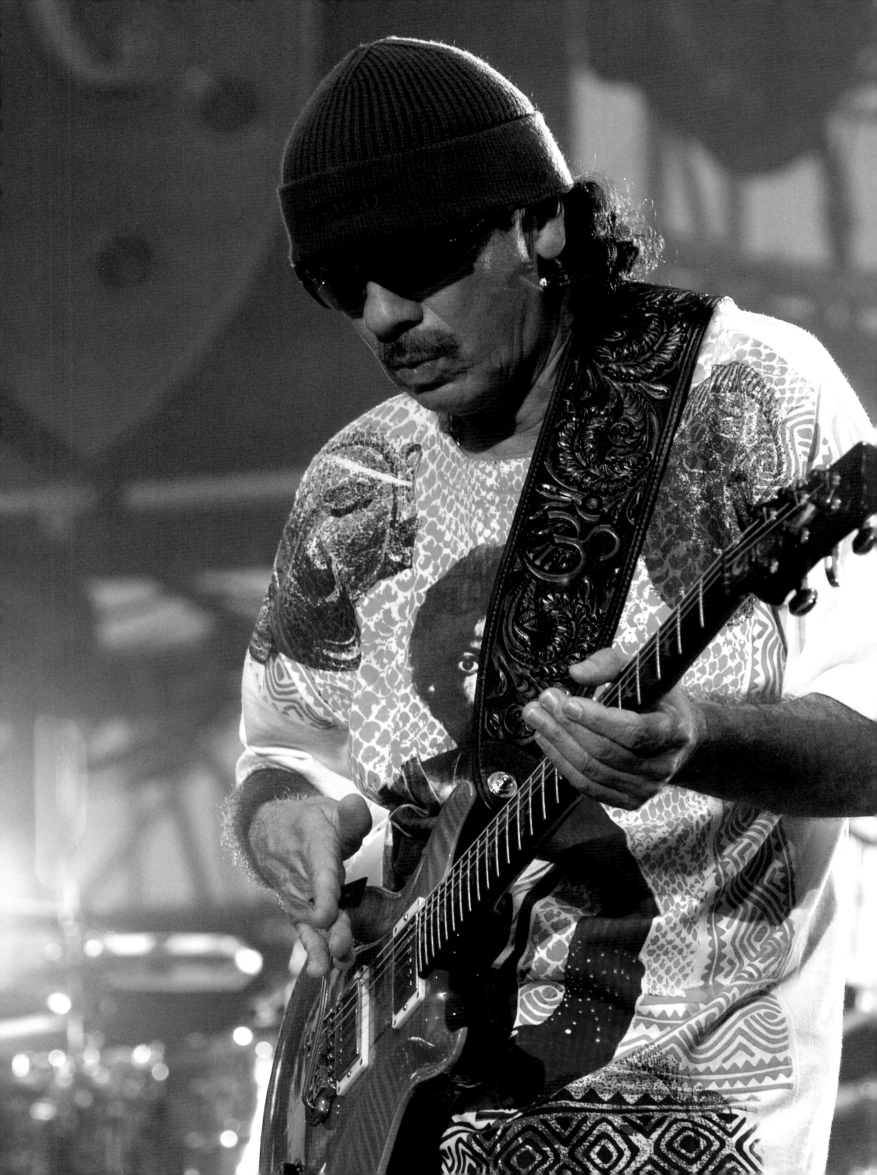

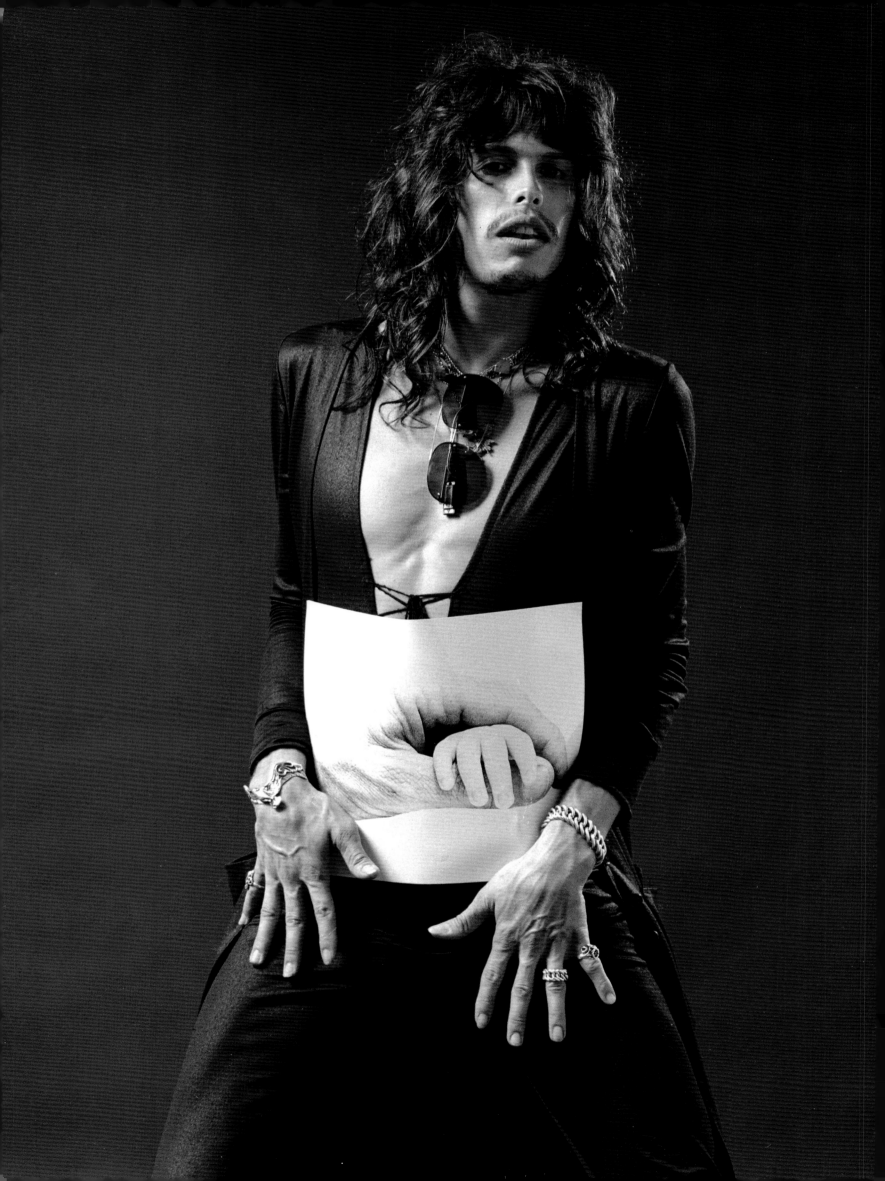

AEROSMITH PULLED a stunt on me at the MGM Grand in Las Vegas about two years ago. I had asked if I could shoot them for the outside of Guitar Center. When I got there, the publicist said, "You can shoot the second, fifth, ninth, and thirteenth song, but in between you have to leave." I'm like, "What is this all about?" They were really screwing with my head. Then, my phone rang, was about to happen. Suddenly this scrim lifted, and I found myself about three feet from Steven Tyler. For eight and half minutes they played "Helter Skelter." Then they actually posed for a photo shoot, on stage, and I did it with my back to the audience on the opening number. I mean, how crazy was that in front of 14,000 people? *That* was a rush.

THERE I AM STANDING ON THE STAGE IN FRONT OF THE MIC

and it is Steven Tyler's person saying, "You have 30 seconds to get in the dressing room." So I run to the dressing room. Steven Tyler walked up to me and said, "You're a scumbag. You only get one song tonight. One song. You get up on that stage, and you get one and a half feet away from my microphone." "What?" I said, not believing what he was telling me. "You heard me," Steven barked. "Get up on the stage." So I jumped out onstage. People thought the band was coming out, so the crowd cheered. There I was standing on the stage in front of the microphone. One of the show's techs walked toward me and I blurted, "I'm supposed to be here." He said, "I know. Can you just back up about six inches?" Then this scrim dropped down, and all of a sudden the house lights went off. So where was I supposed to set my exposure on the camera, because I don't shoot an automatic? All I could do was guess what

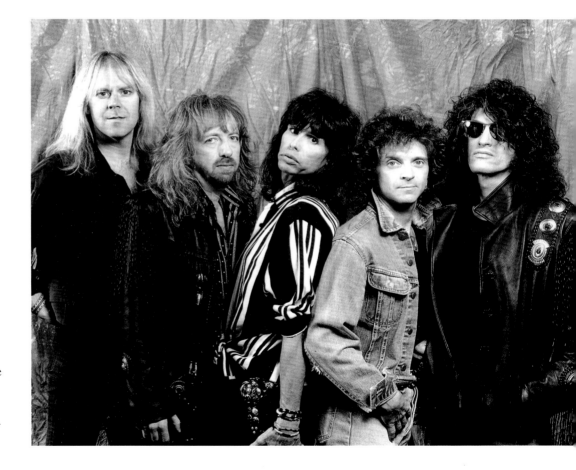

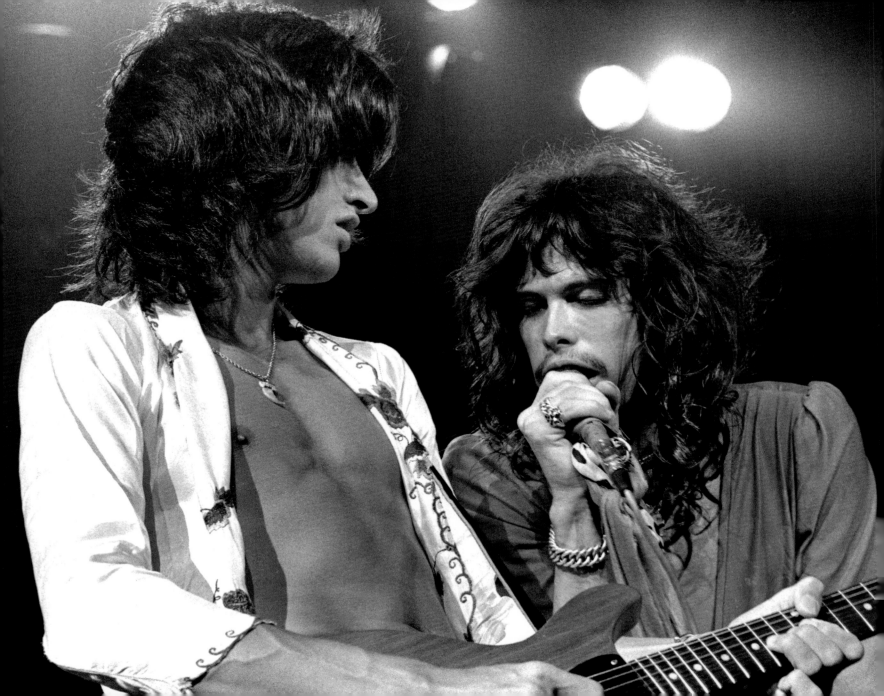

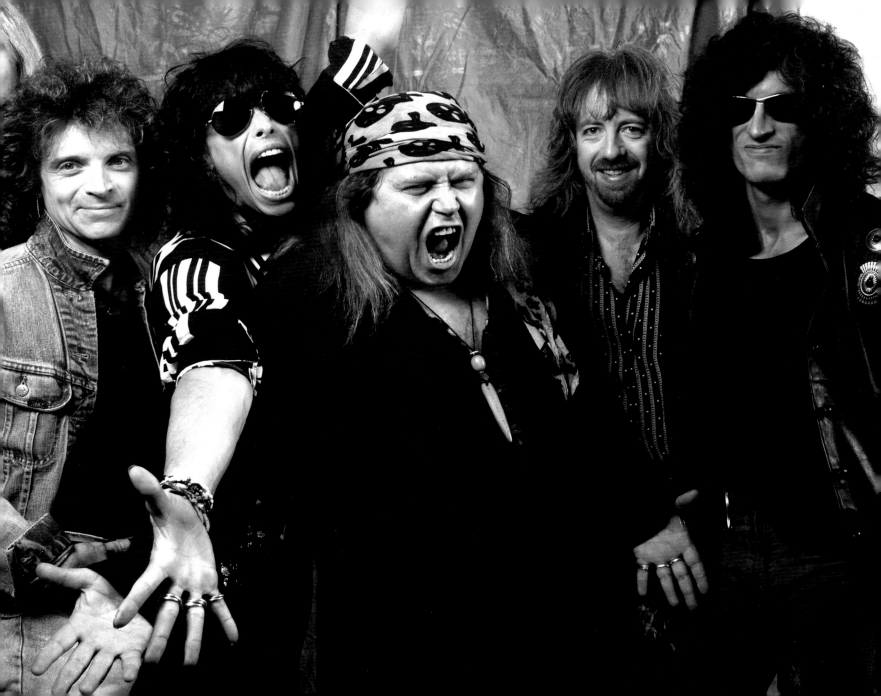

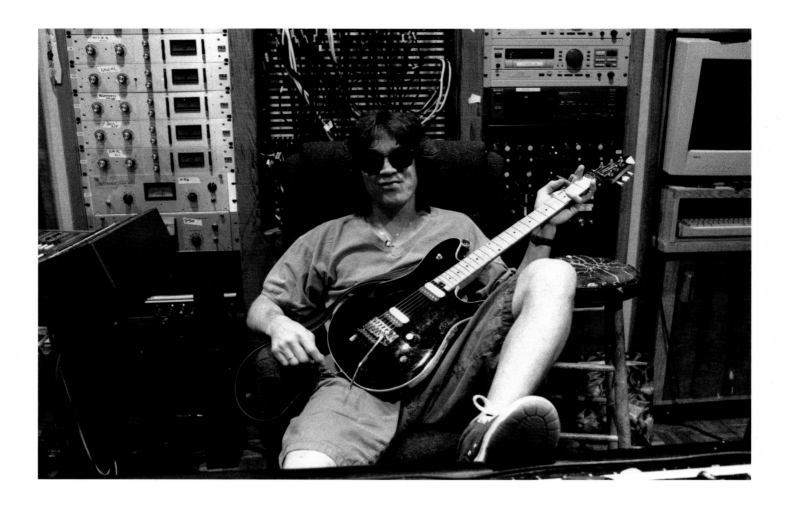

I MET EDDIE and Alex Van Halen through the first RockWalk induction. Guitar Center is like Eddie's home guitar store. I've been up to his house a dozen

couple of times. I got spectacular pictures because it was well past the three songs. I've never met David Lee Roth as I've always photographed Van Halen with

I'VE BEEN UP TO HIS HOUSE A DOZEN TIMES.

times. When we started to put photos on the outside of the building, I wanted to create a montage with Van Halen, so Eddie let me shoot the whole show a

Sammy Hagar. Later I became friends with Sammy. It's like a tree. You meet one, you meet the other, and then it branches out.

EDDIE VAN HALEN

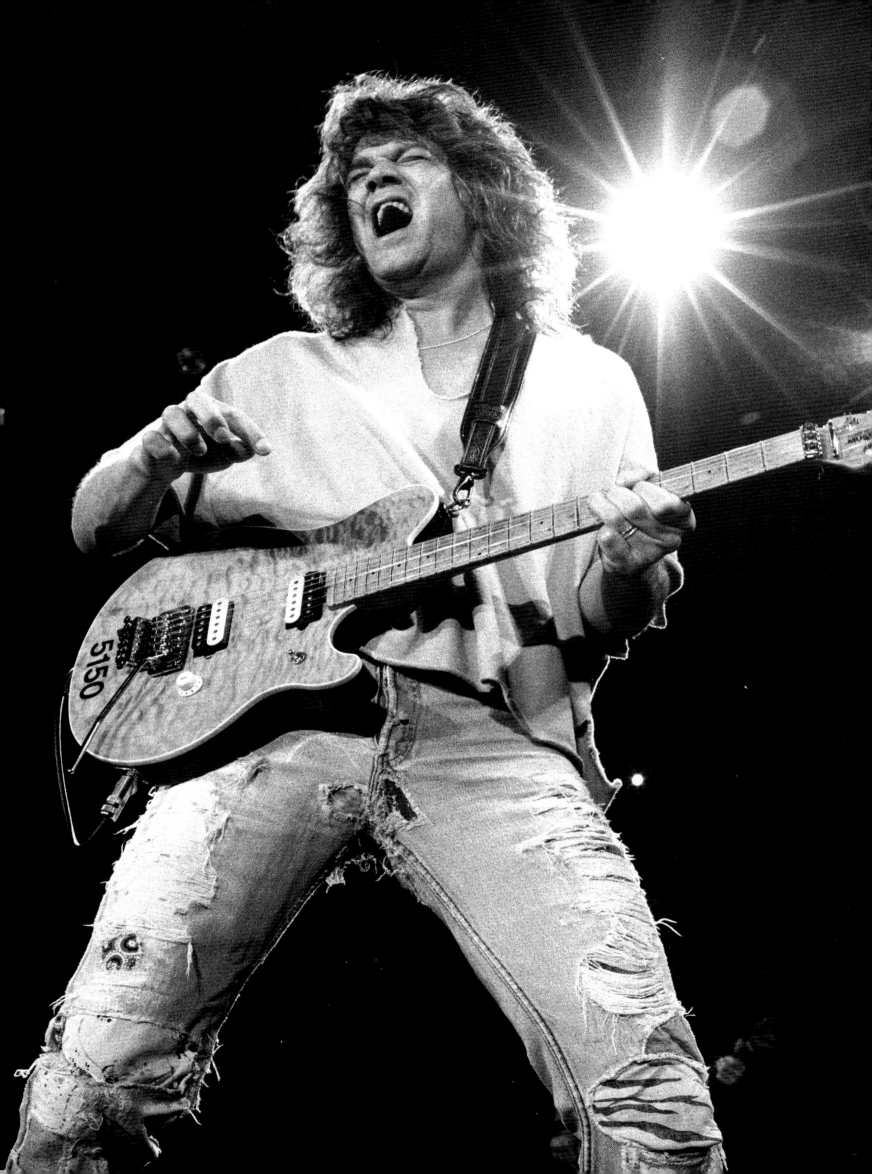

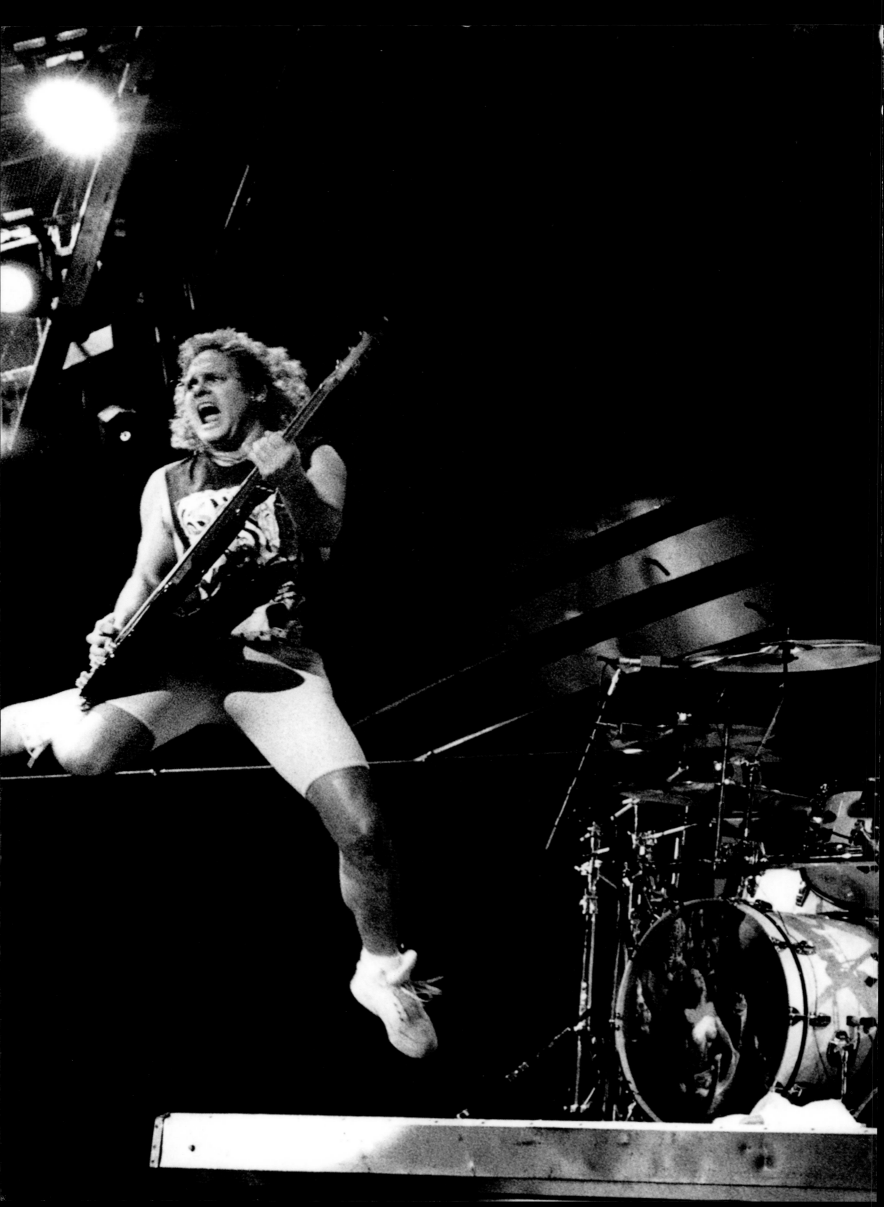

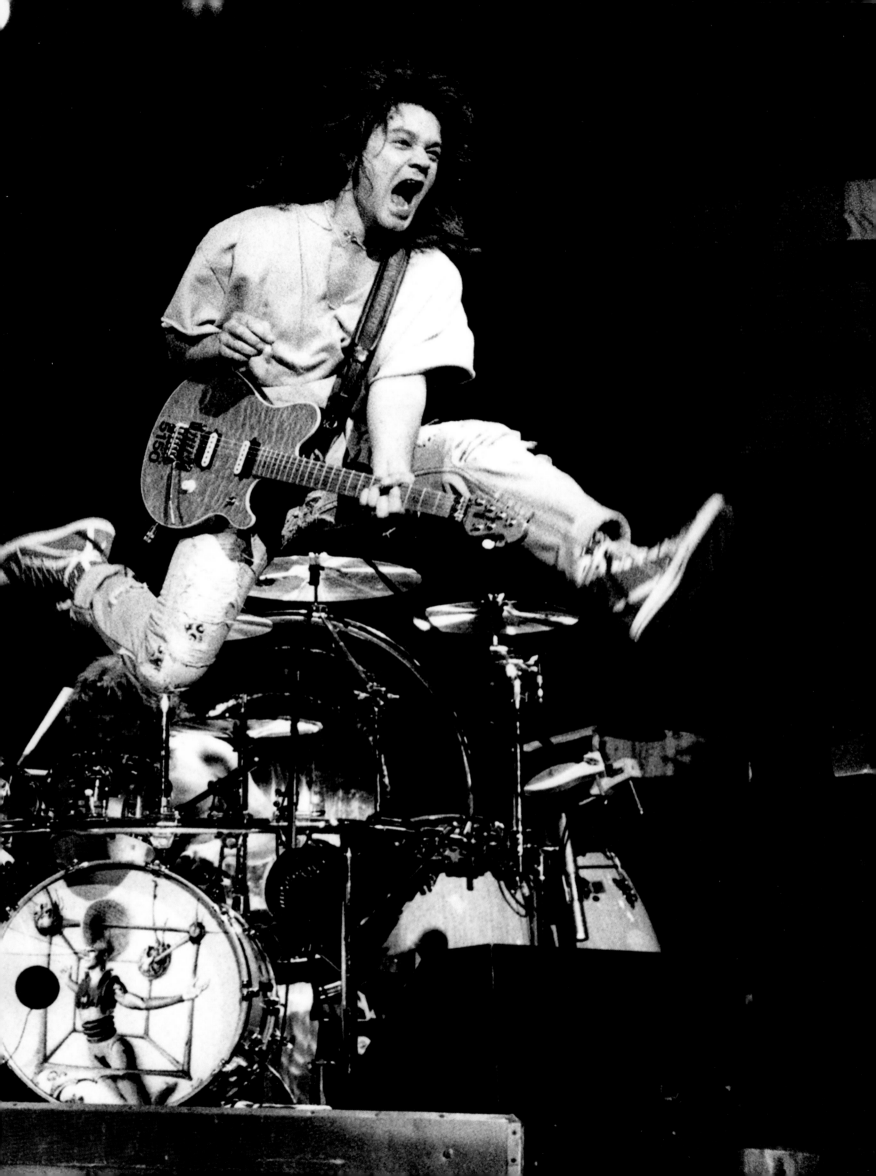

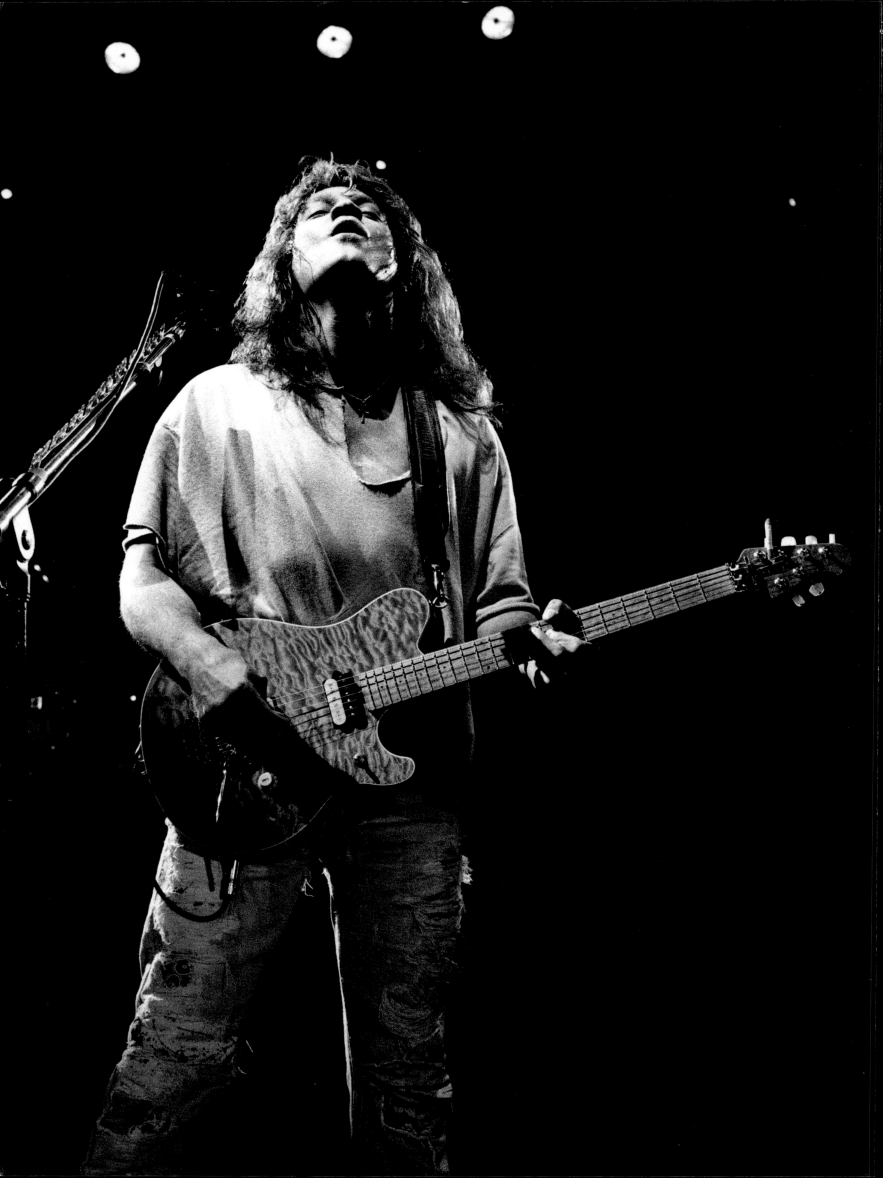

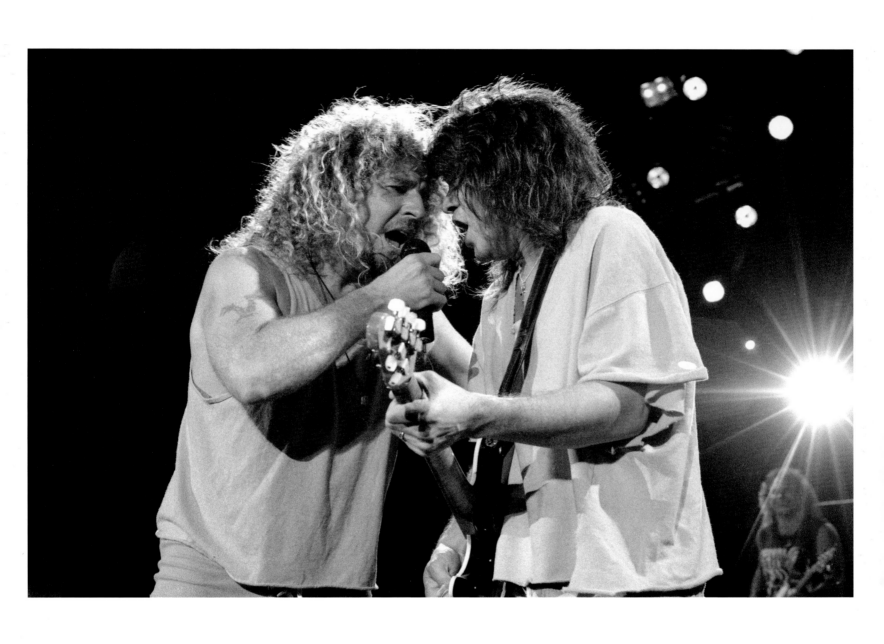

SAMMY HAGER AND EDDIE VAN HALEN

Van Halen Costa Mesa, California circa 1995

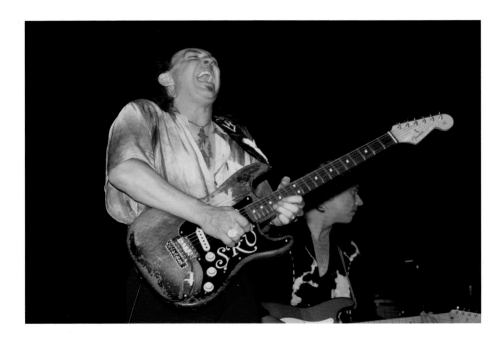

STEVIE RAY VAUGHAN invited me to Alpine Valley, Wisconsin for a very important photo shoot with Eric Clapton and other guitarists for a Fender Guitar poster. Alpine Valley, located about one hour from Chicago and forty-five minutes from Milwaukee, is a ski resort that turns

Four Seasons and fly back and forth with me in the helicopter. We can go see Buddy Guy." I decided to stay the night at the lodge and move to another hotel in Milwaukee the next morning.

The problem was, the next day, when I went to check out, all of my

a hospital and straightened up his life. He said, "You know, I'm on borrowed time. God gave me some more time. But I don't know how much time I've got left. I don't think it's that much. I can feel it." The morbidity of our discussion started to depress me to the point that Stevie noticed how it was affecting me. But he just shook his head. "Listen, Robert, just don't worry about it. When it's your turn to go, there's nothing you can do. Absolutely nothing."

It was time for the big shoot. I photographed Clapton alone, and then with Stevie. I shot the band, and Stevie and his brother, Jimmie. I did a full shoot. Then Stevie said, "Robert, I want you to shoot the concert tonight. Because you were Jimi Hendrix's guy, I'm going to do "Voodoo Child," and it'll be just for you and me." The concert was about to start and I still didn't have my portable lighting system. We stood in a circle back-stage; Stevie, me, my assistant, Stevie's manager Alex Hodges, and some road

I'M GOING TO DO "VOODOO CHILD," & IT'S FOR YOU & ME

into a huge concert facility in the summer. Since it was a two-day concert stint, I checked into the ski lodge on the grounds.

The photo shoot was scheduled for the first night. Eric Clapton arrived by helicopter from Chicago and had completely forgotten about the shoot. We rescheduled for the following afternoon.

So there I was, in Alpine Valley with nothing in particular to do. I ended up just hanging out with Stevie that first day. "Where are you staying?" he asked me. I said, "Right here behind the venue, in the lodge." He said, "You have to check out of that hotel." "Why," I asked. He said, "I promise you. I've stayed there a few times, and I have such a bad vibe about that hotel. Check out. Come down to Chicago, stay at the

portable lighting equipment had disappeared. I thought somebody had broken into my room. I was beside myself. I beelined to Milwaukee and scoured the city searching for a portable lighting system I could buy. But I couldn't find any. I drove back to Alpine a few hours before Eric was scheduled to show up. While waiting, Stevie and I sat in the back room. We started talking. The subject turned to life and death. I said, "Did you know that Otis Redding died nearby here in a lake?" Stevie paused for a moment and answered "Do you know that my manager was Otis' manager?" The association upset me. But Stevie turned and said, "You know what, Robert? I virtually died six years ago, and I was given a second chance at life." He then told me how he had overdosed on drugs in Switzerland, ended up in

guys. Stevie looked at me, and asked, "Robert, what's wrong? You seem to be kind of agitated." I told him my lighting equipment got ripped off at the hotel. Stevie winked and said, "Robert, don't worry about it. It will show up." And right there, in front of ten people standing in that circle, my lighting equipment appeared on the ground at our feet. To this day, I don't know what happened.

The concert began and I photographed the show. But then, the encore came and Stevie launched into the opening notes of "Voodoo Child." Suddenly, I couldn't hold my camera. It was like a block of ice. It was so cold. I didn't know what was wrong. "Why does my camera feel like it is frozen," I wondered. I looked down at my arms and saw they were covered in gooseflesh. I freaked out and left

STEVIE RAY VAUGHAN

the photo pit. I went backstage, and Alex Hodges said, "Robert, what are you doing here? Stevie wants you out there." I said, "I can't. Something weird is going on." Stevie finished the song, came backstage, and asked why I left. "Stevie, look at my arms," I said. "They're covered in gooseflesh." He rolled up his arms and said, "Look at mine." His were doing the same thing. I looked him in the eyes and asked, "Where were you the night Jimi died?" "Why?" he asked. I said, "Because I didn't see you tonight during the encore. I saw Jimi. I felt like I was watching Hendrix again. It wasn't the way you were playing. It was the same energy, like Jimi was there."

I don't believe in channeling. I'm not a New-Ager. I can only describe the incident as a weird overshadowing.

Then, Eric Clapton walked up: "I've got an extra space on one of my helicopters if anybody wants to go back early," he said. Stevie turned to me, "Come on, Robert. Let's go back to Chicago. Let's go see Buddy Guy." I said no. I just wanted to drive back to the hotel. Then, Stevie said, "Don't take the freeway. Take the back road to Milwaukee. It will be a lot quicker for you." I took the back road, with my assistant in the car. We were really pumped because we had a great shoot but as we were driving, all of a sudden the lights started going out. As we passed a street lamp, the light would burn out. We'd pass another street lamp and that light would go out. This went on all the way back to Milwaukee. It was crazy. When I returned to the city, I thought we would go to dinner and celebrate. Then, suddenly, a wave of depression washed over me and I just went to bed. The next morning, the alarm clock, which the previous room occupant had preset, woke me up at 9:00 AM sharp with the news: "Eric Clapton and members of his entourage have died in a helicopter crash." I was stunned.

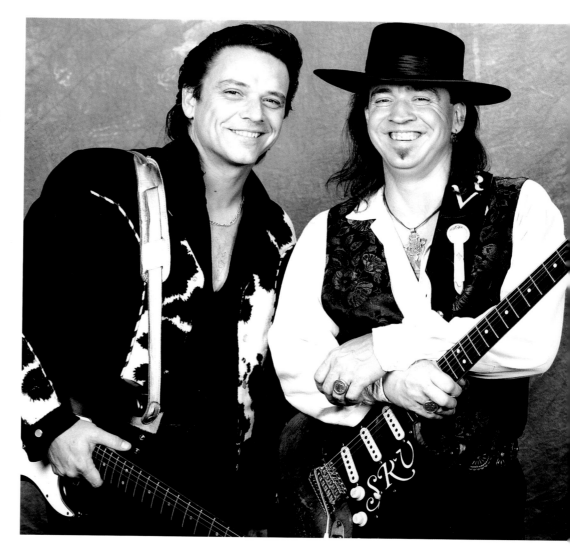

"Eric is dead?" I rushed to call the Four Seasons in Chicago, and asked for Stevie's room so he could tell me what had happened. But instead, I got Alex Hodges' son. He was the one who told me. "Robert, it wasn't Eric. It was Stevie."

The very last thing Stevie Ray Vaughan ever said to me during that conversation about life and death was "Robert, if anything ever happens to me, you'll know me when you hear me."

Immediately, news outlets inundated me with requests for photos of Stevie on his last night alive, his last night performing. Several photographers were in the pit the first night. But I was the only person allowed to shoot the second night. The problem was, I couldn't give up the photos. It

felt like blood money. I was afraid my photos would show up next to shots of a squashed helicopter. I held onto them and waited a long time before I did anything with them. Finally, two years later, Stevie's publicist said to me, "Robert, Stevie would have wanted you to put those out. Let them go. It's okay."

JIMMIE & STEVIE RAY VAUGHAN

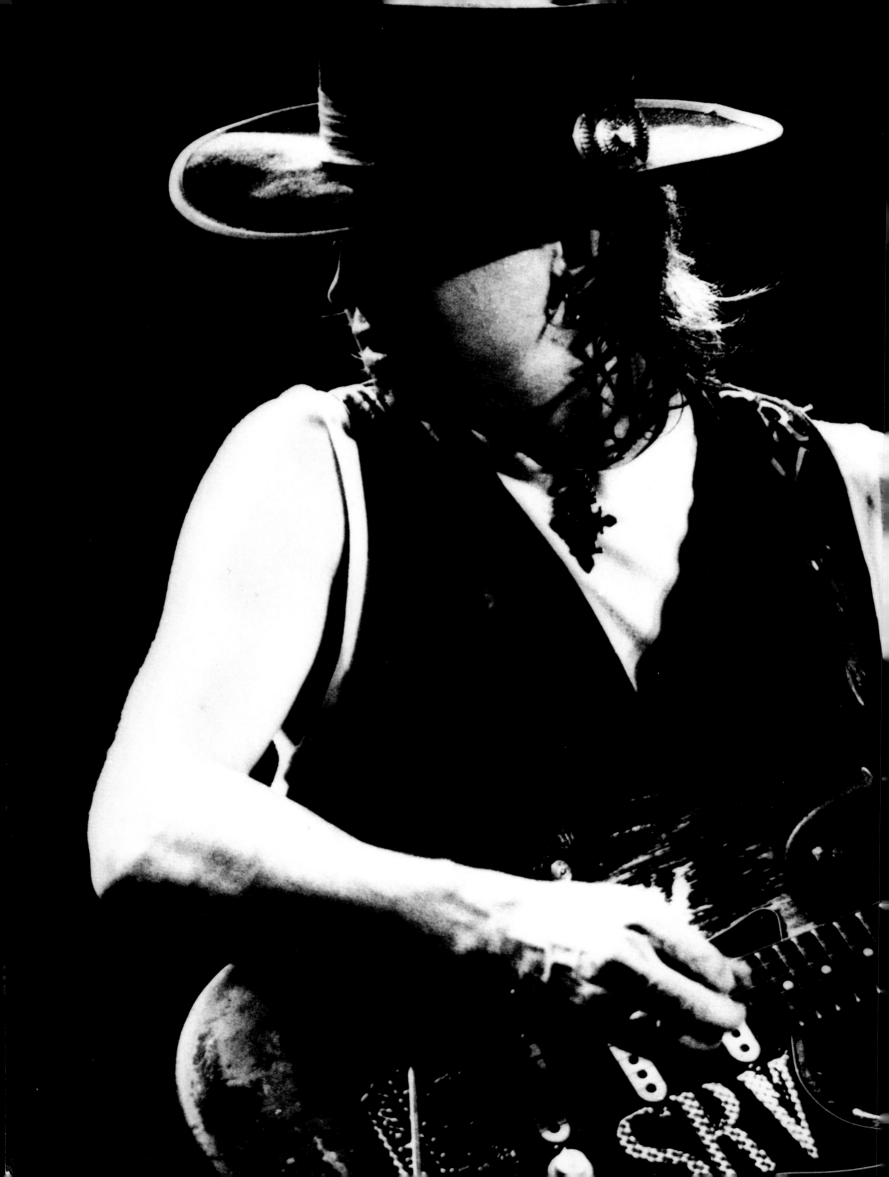

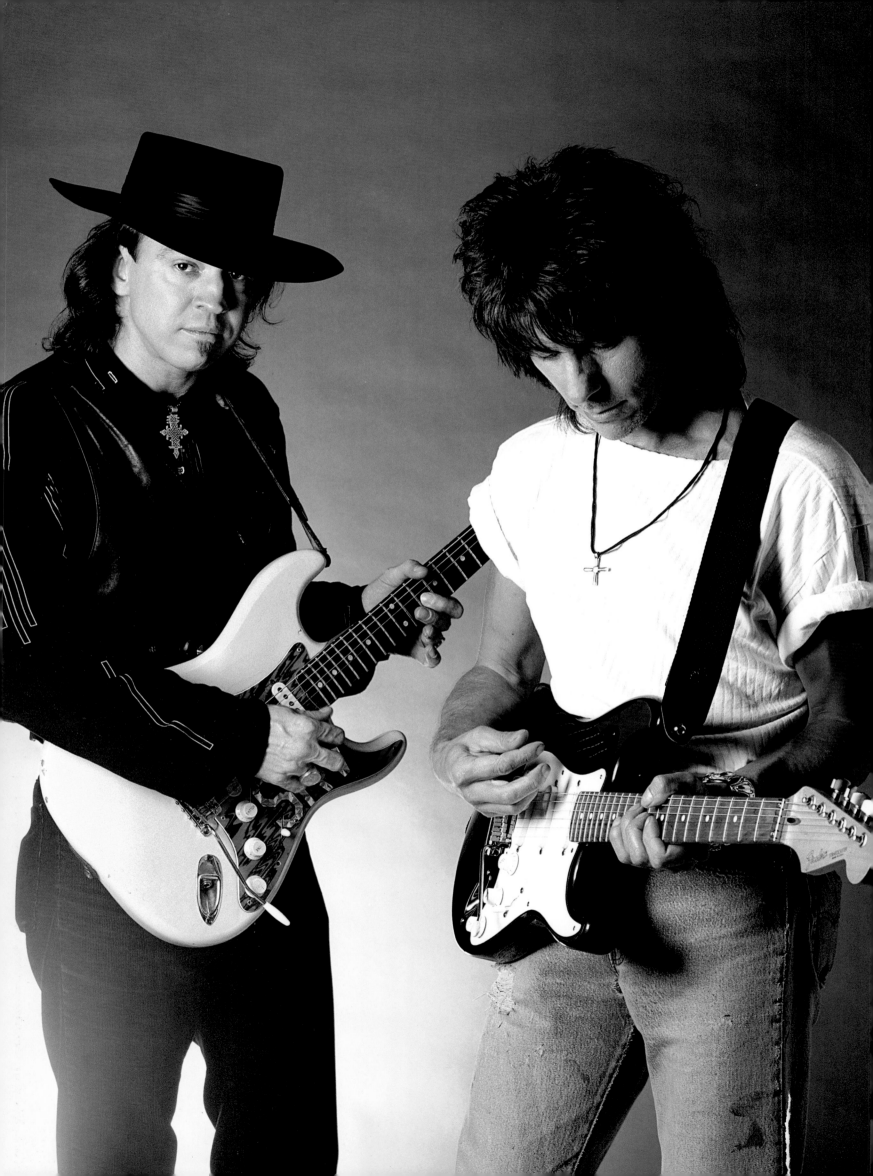

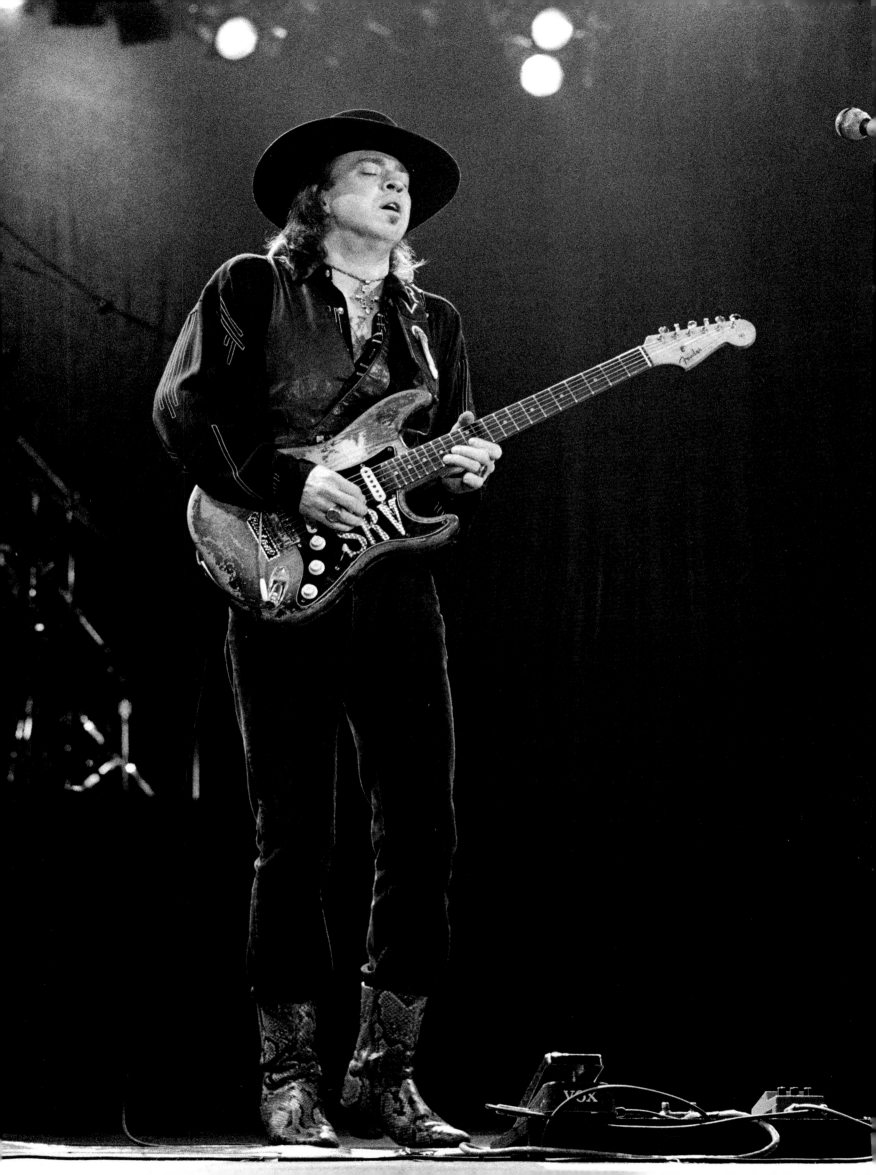

WHEN I FIRST MET Slash I expected to see this drunken guy with a hat and tracks all over his arms. Instead, he was just the most pleasant, sweet guy you could imagine. He shook my hand with one of the strongest grips of anyone I have ever met. Slash lifts weights. He could rip off your arm. Slash reached into the back of my Jeep and carried my lighting equipment into a Guns N' Roses session. Axl wasn't there, but the oth-

him. Luckily, right now, he is in a period of incredible clarity. He had a heart attack a few years ago and had a defibrillator inserted in his chest so he literally can't do anything too extreme anymore. Anytime he gets really excited or worked up, his heartbeat starts to get crazy and an electric shock snaps him back.

A lot of people don't know it, but Slash is English. He and Ronnie Wood are like brothers. Now, because

HE HAD ONE OF THE STRONGEST GRIPS

ers were. Slash introduced me to Izzy and Dizzy and I don't know who else. It was like the Seven Dwarfs with so many "izzies" in the room. I did the photo shoot and Slash and I started a friendship. He would call when he needed photos for a side project and after he left Guns 'n' Roses. Eventually we just became best buddies, yet, at the same time, I would read all these horror stories about this guy.

Slash has experienced ups and downs in his life but when it came time to do the film, the first two people I called were Steve Vai and Slash and both of them said yes. Even though Slash was going through a tough period with his band at the time, Velvet Revolver, he still said yes. Slash always has dramas going on around him and seems to rather thrive on it, but yet the drama never seems to taint him. I have a lot of love for Slash. I really feel like he's a son or something, but I worry about

Slash is such a major presence on the hit video game *Guitar Hero III*, he is probably the most recognized and famous guitar player on the planet.

The hair, the hat, the guitar, and the cigarette. You see them and you go, "Oh, there's Slash." He is iconic. Slash and I went to NAMM this year, the largest music products trade show, and thousands of kids lined up to ask Slash for autographs. They were maybe six to ten years old. Slash laughed and said, "Dude, I have millions of fans that have never heard of Guns N' Roses or Velvet Revolver."

OF ANYONE I'VE EVER MET

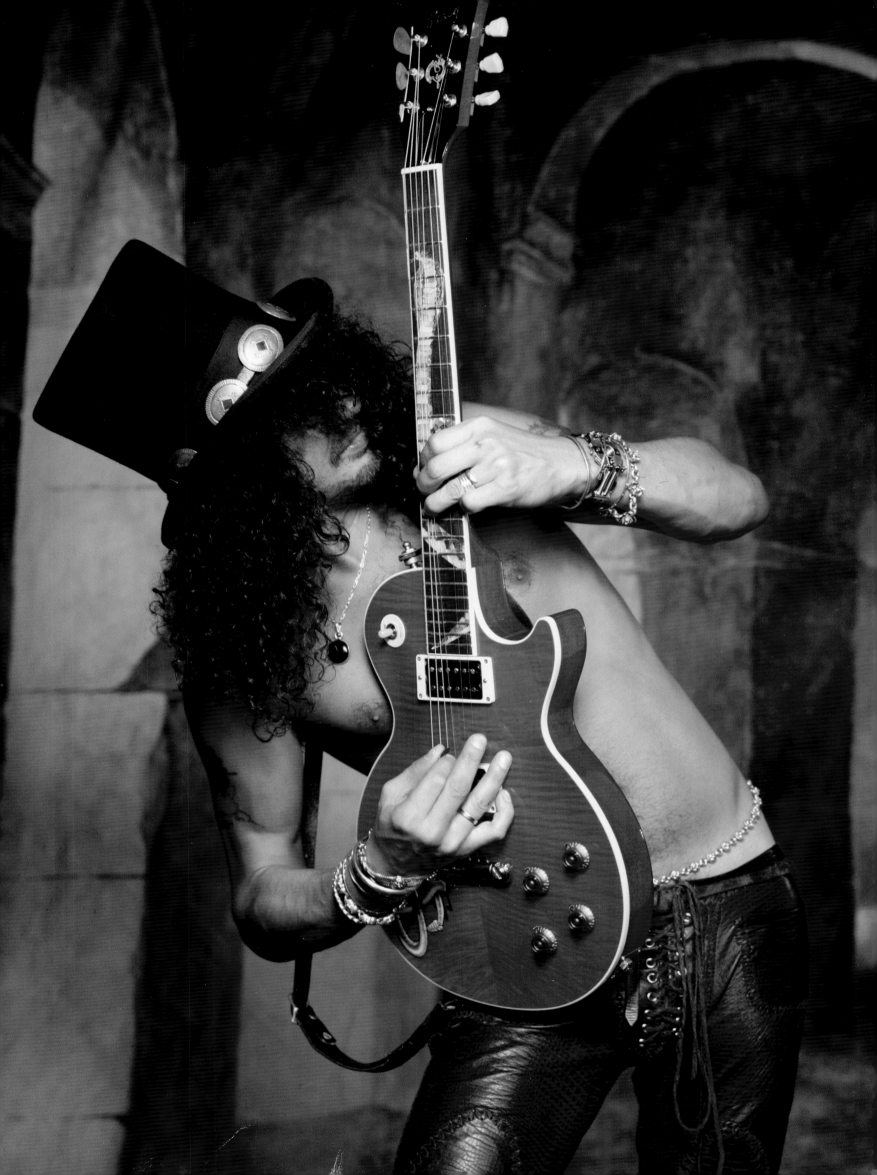

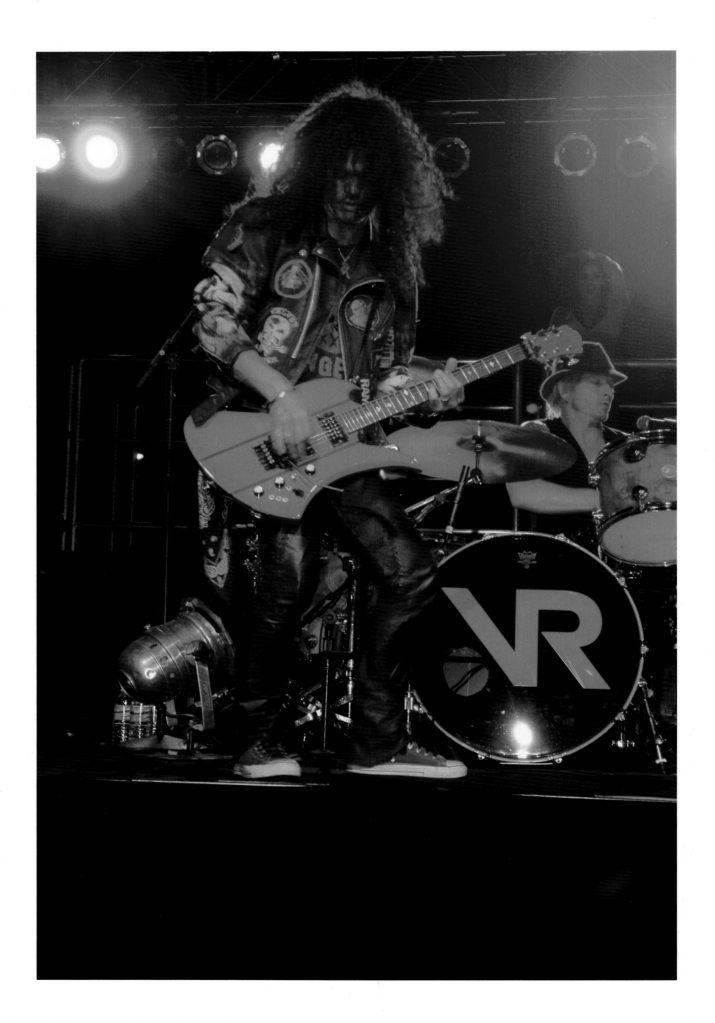

DUFF MCKAGAN & SCOTT WEILAND

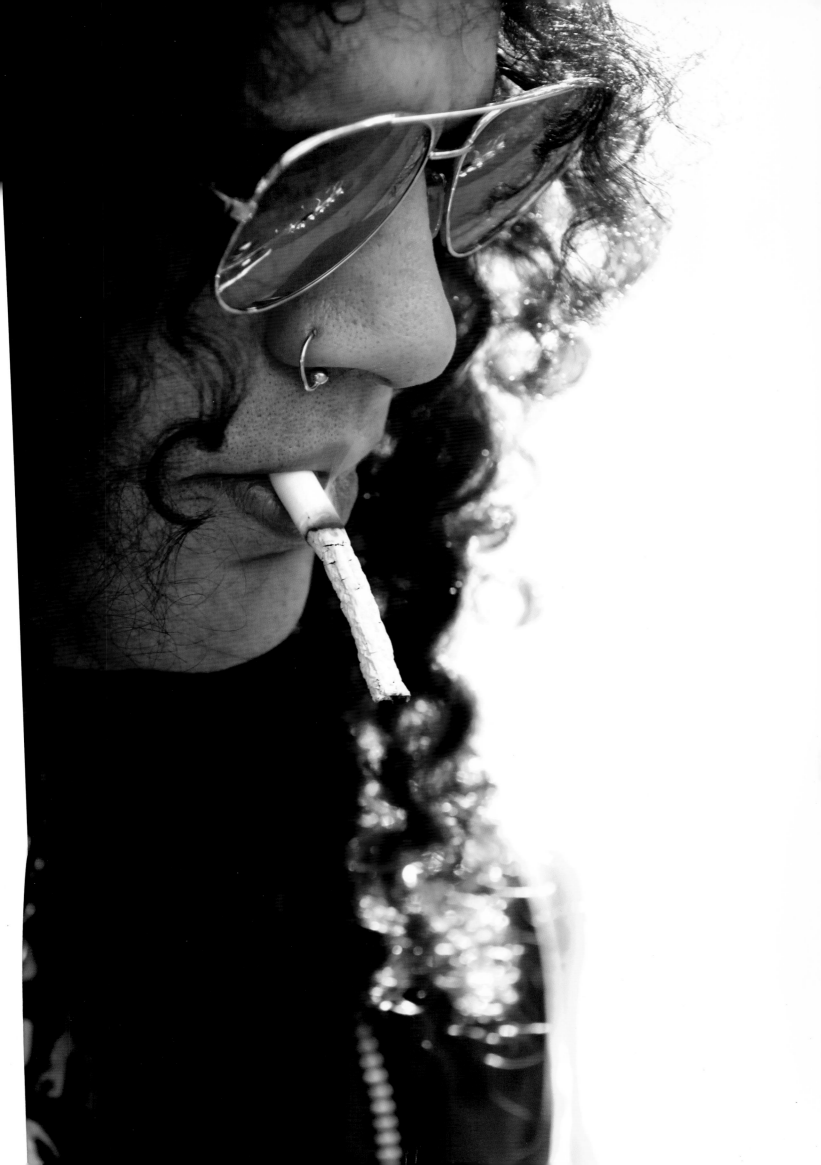

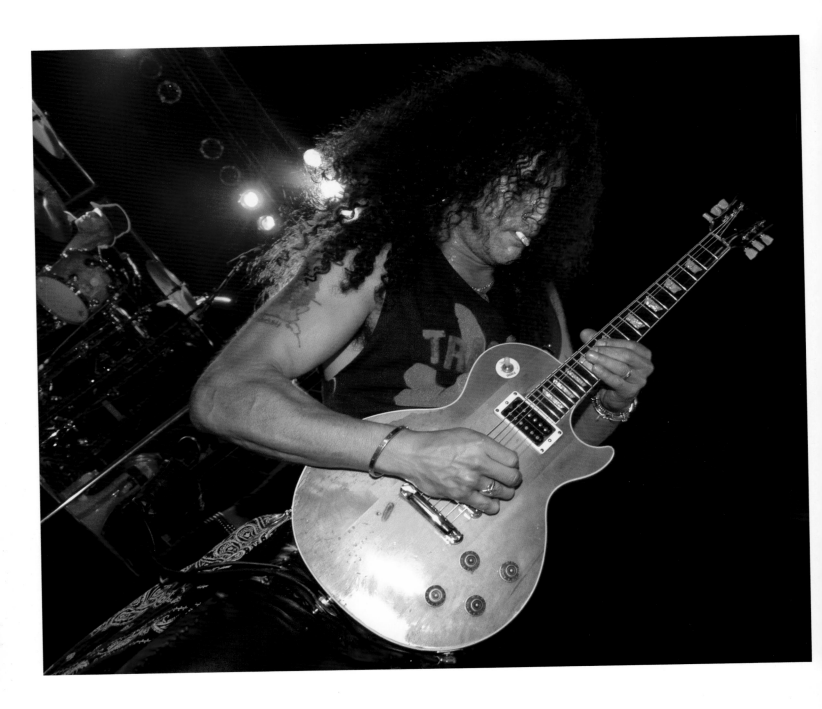

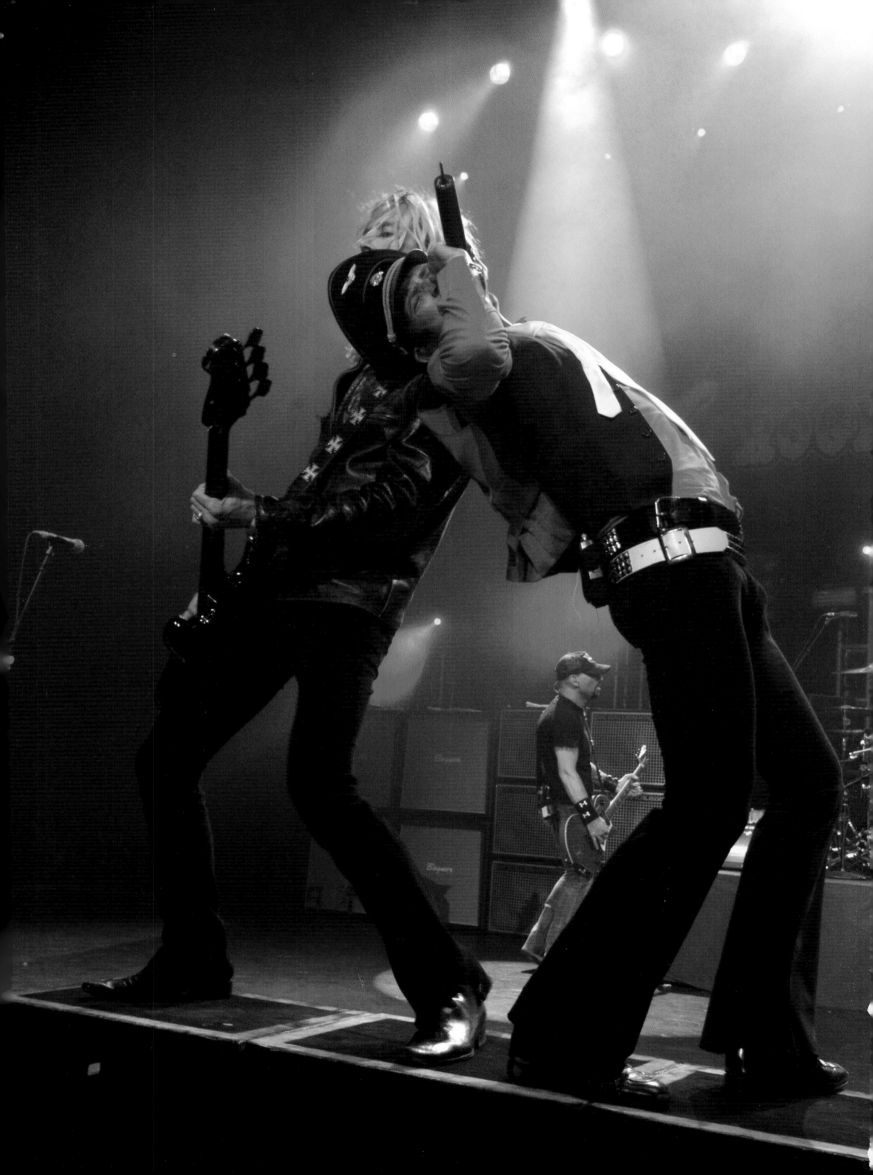

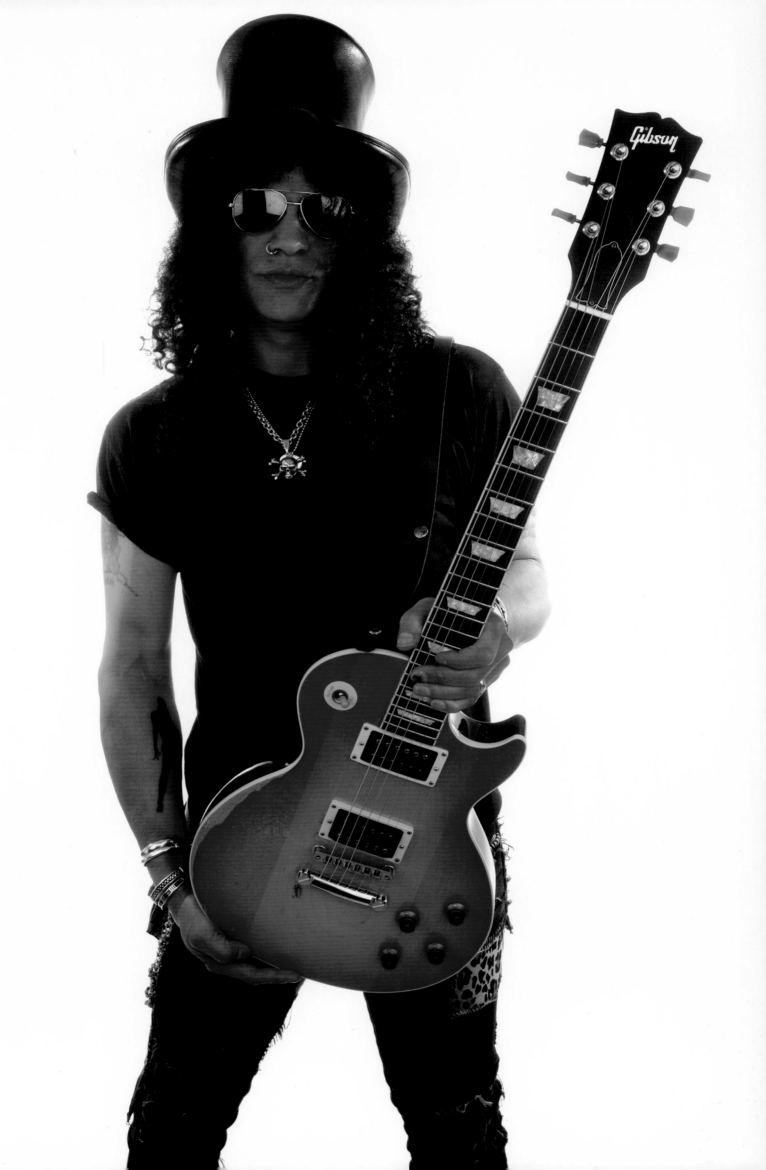

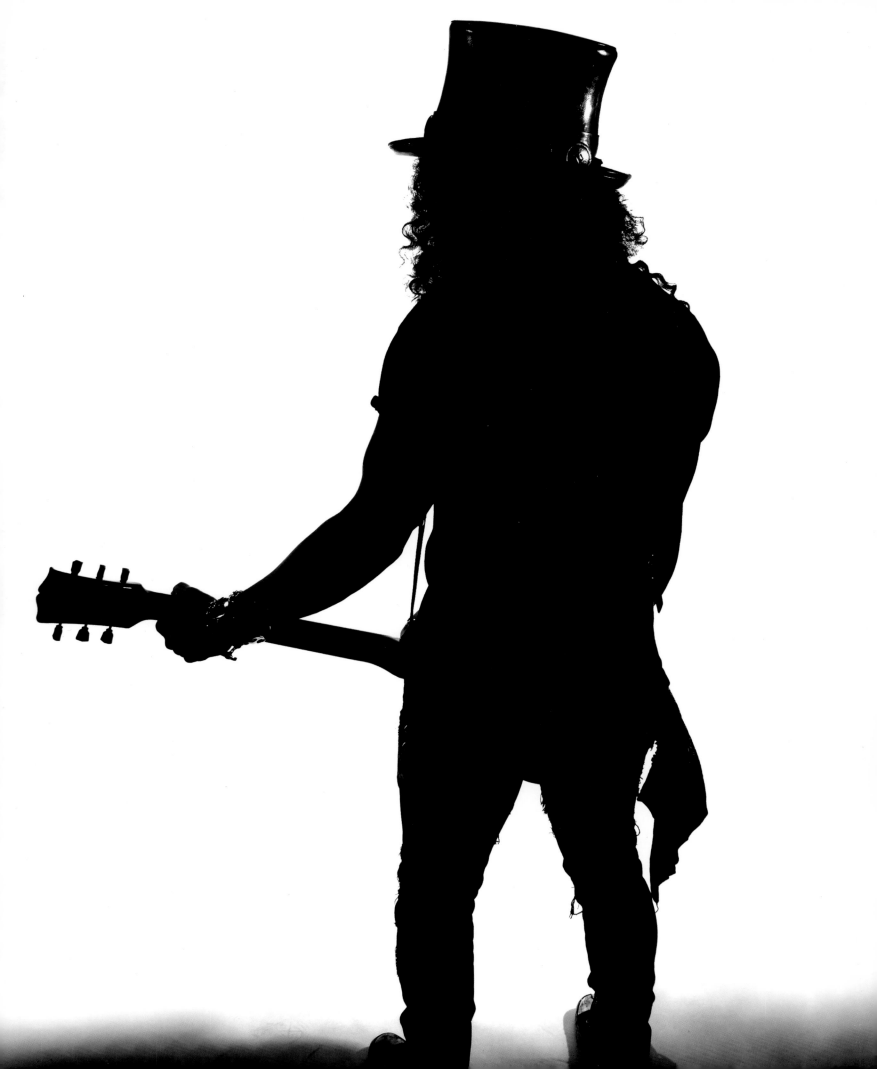

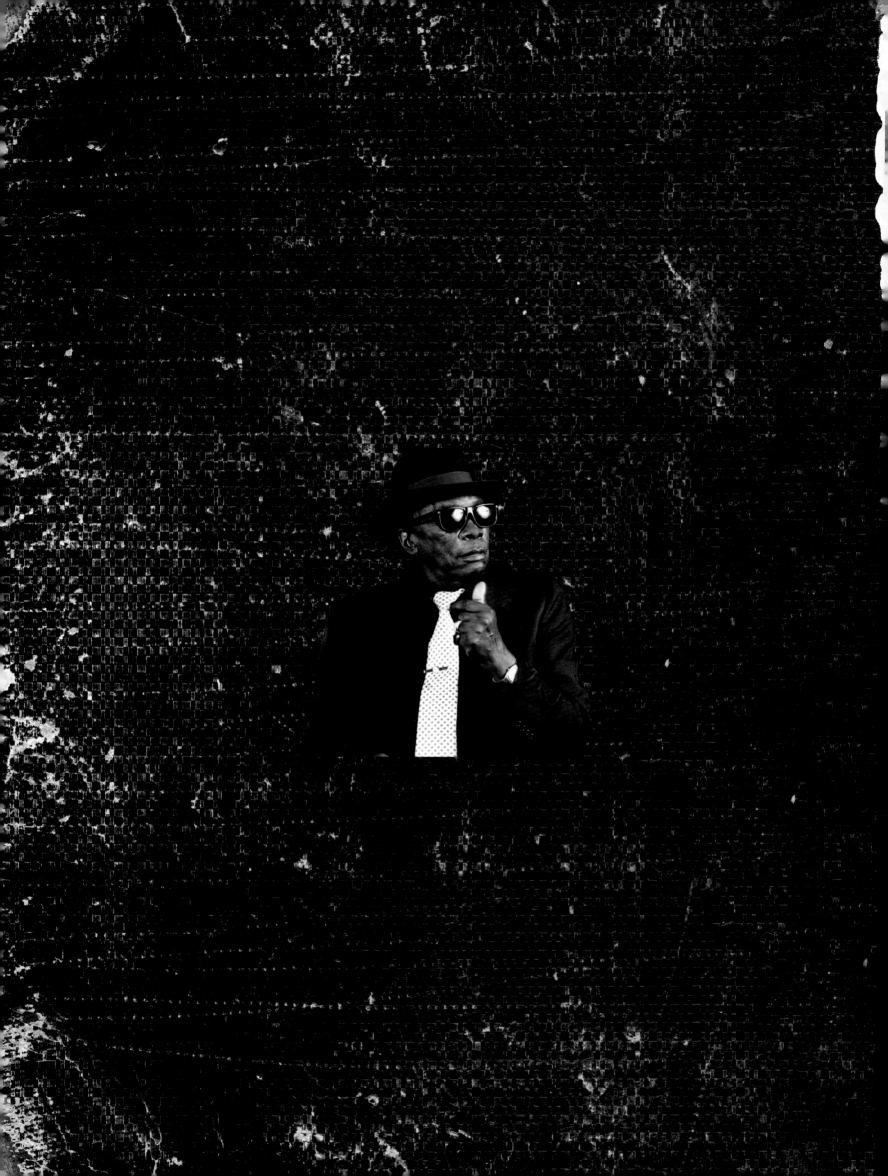

3

INFLUENCES

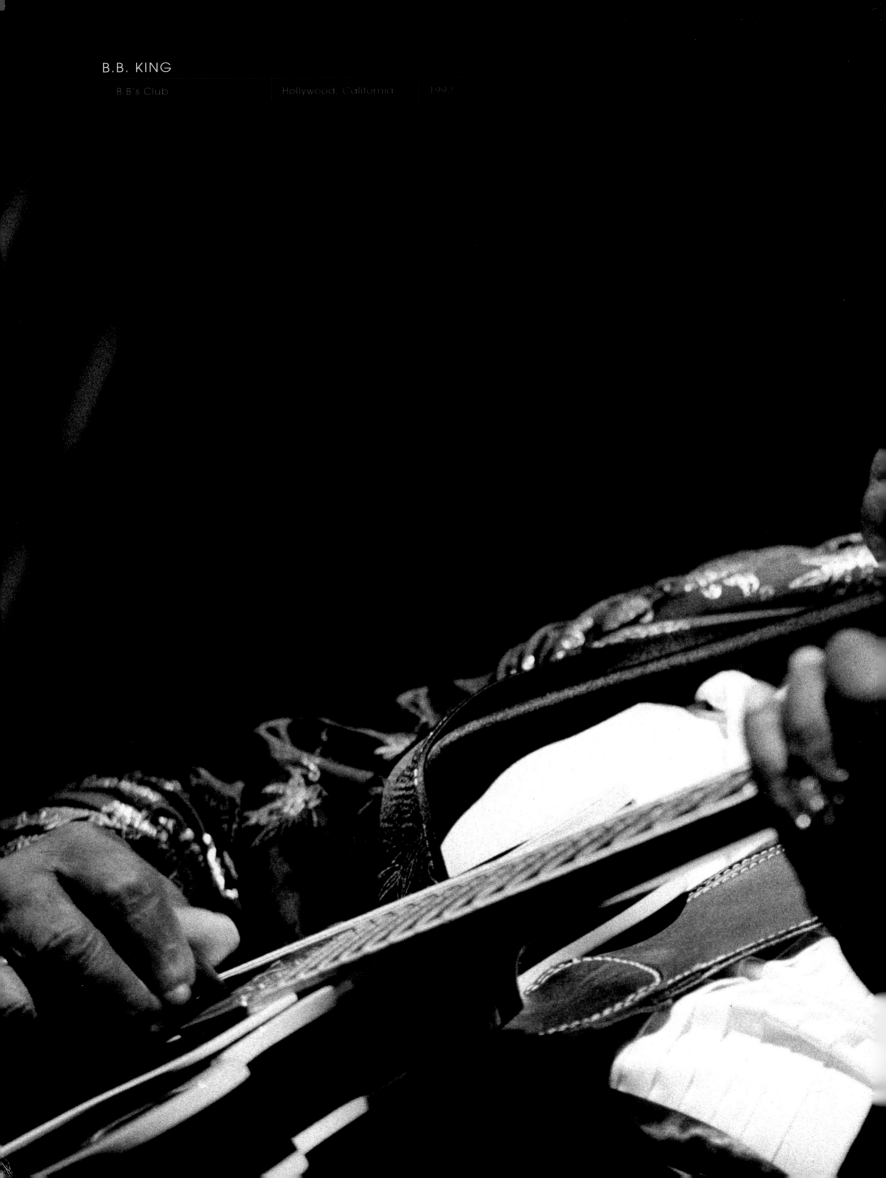

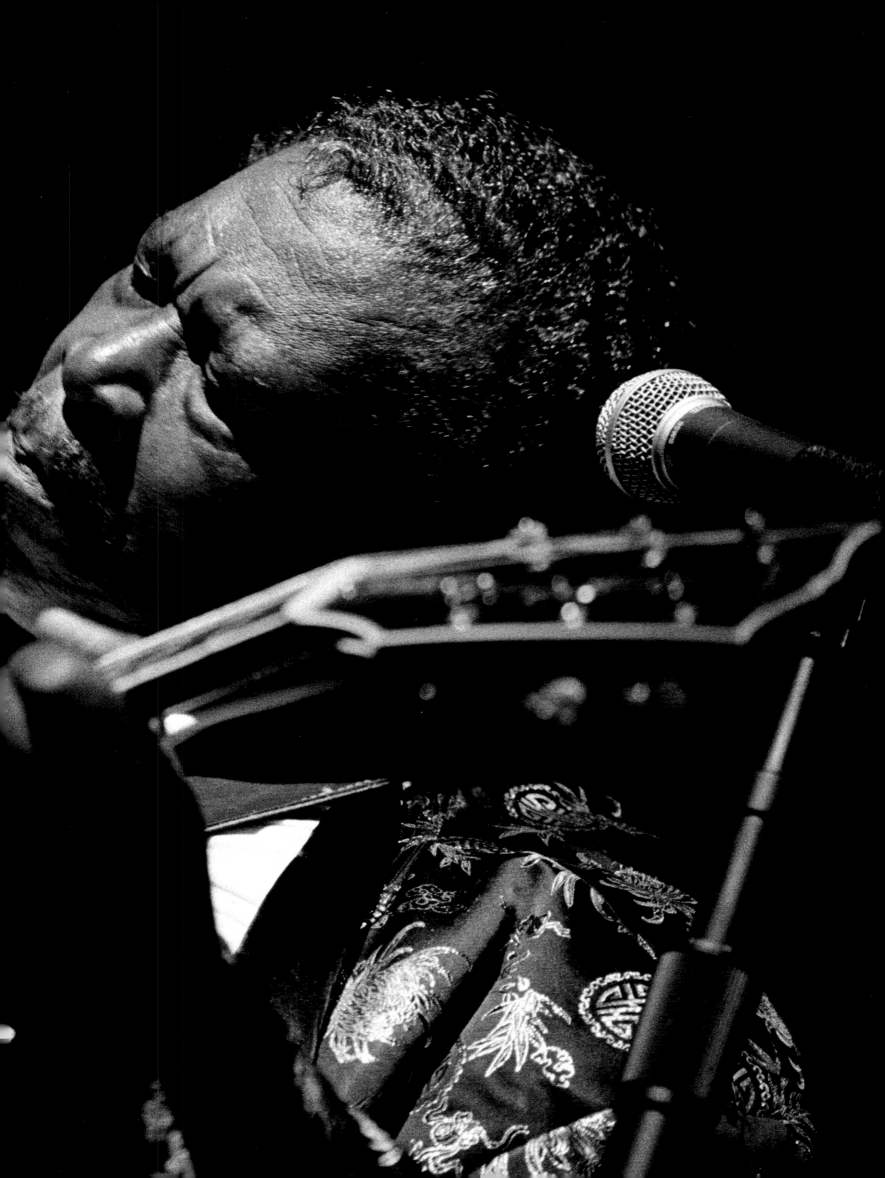

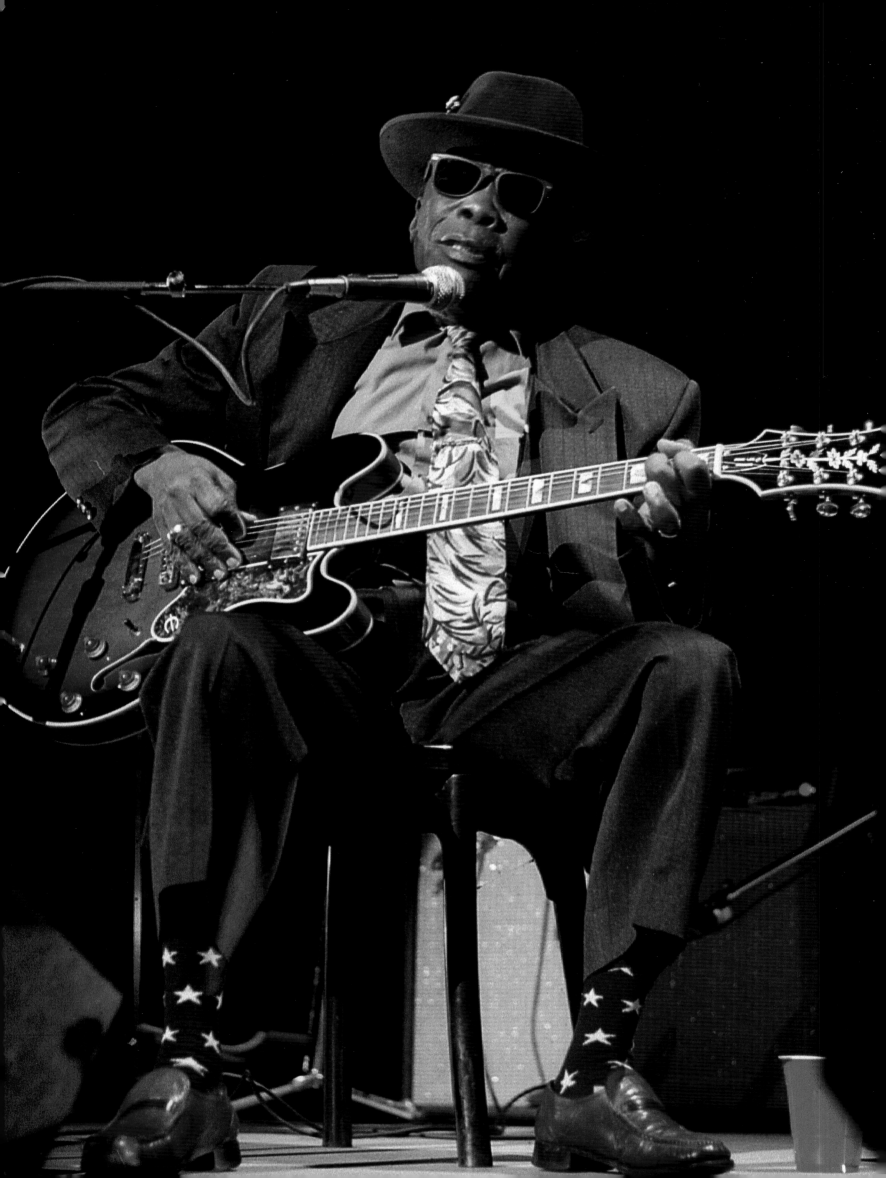

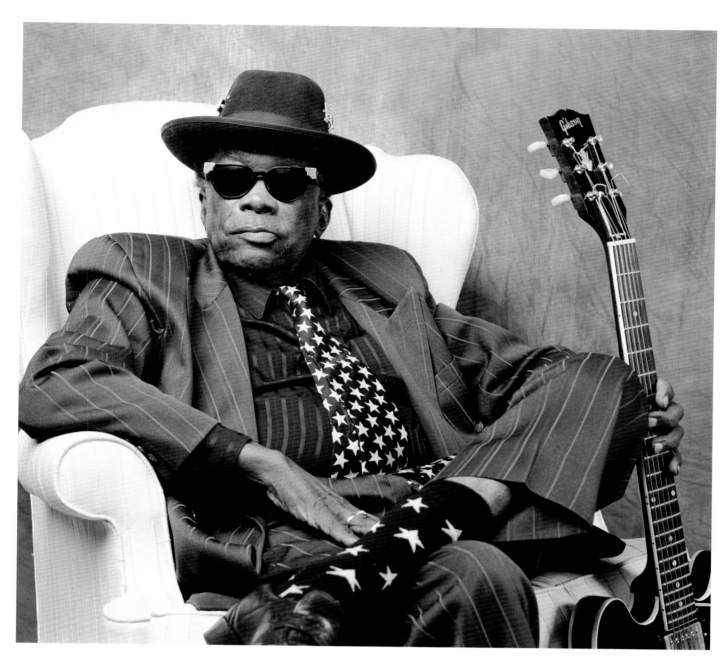

THERE WAS SOMETHING FORBIDDEN THERE

THE FIRST TIME I heard John Lee Hooker's music, it scared me. I started to think that what my parents told me about rock music being dangerous might be right. My parents wouldn't really let me listen to the radio or go to the movies, so when I heard John play, "It Serves You Right to Suffer,"

it shocked me. There was something forbidden there. Over the years I've done a lot of photo shoots with him and John has become a really good friend of mine.

JOHN LEE HOOKER

| Universal Amphitheater | Los Angeles, California | 1995 |

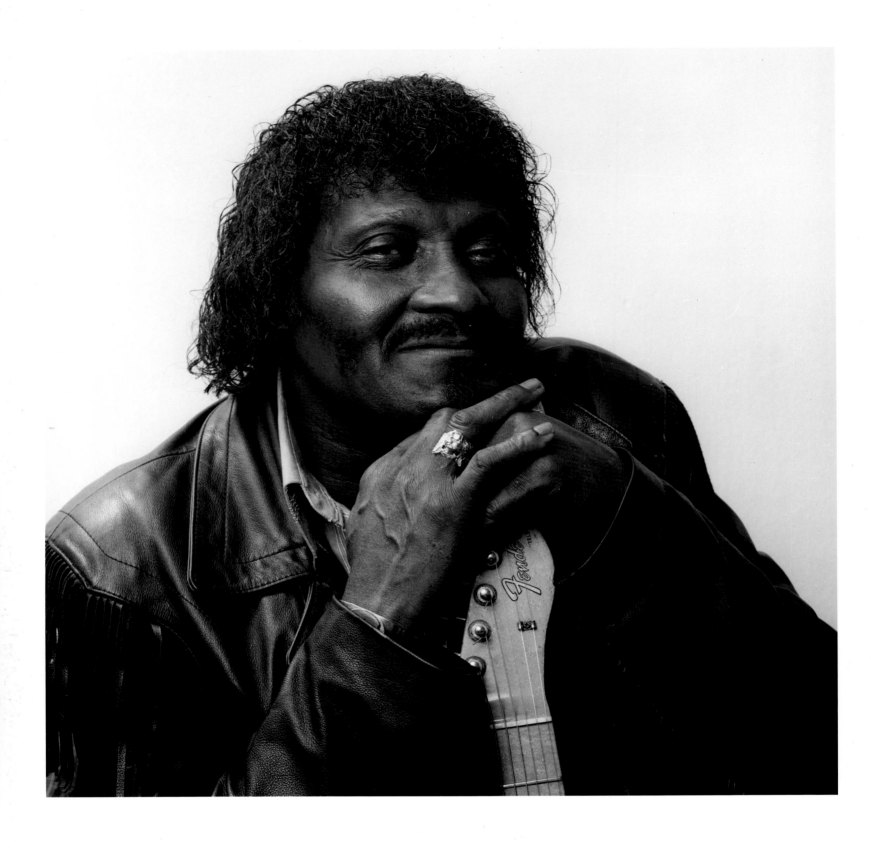

ALBERT COLLINS

FREDDIE KING

Long Beach, California | circa 1990

Honolulu, Hawaii | 1972

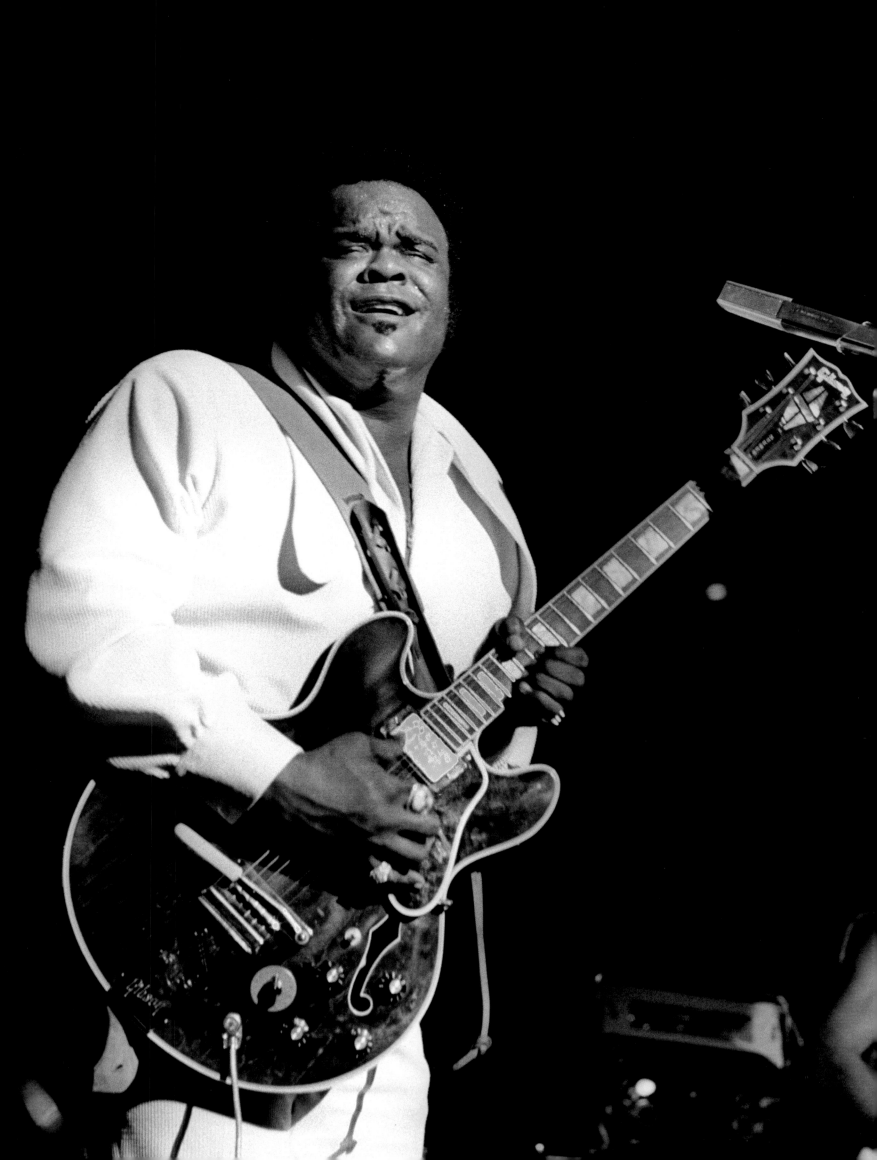

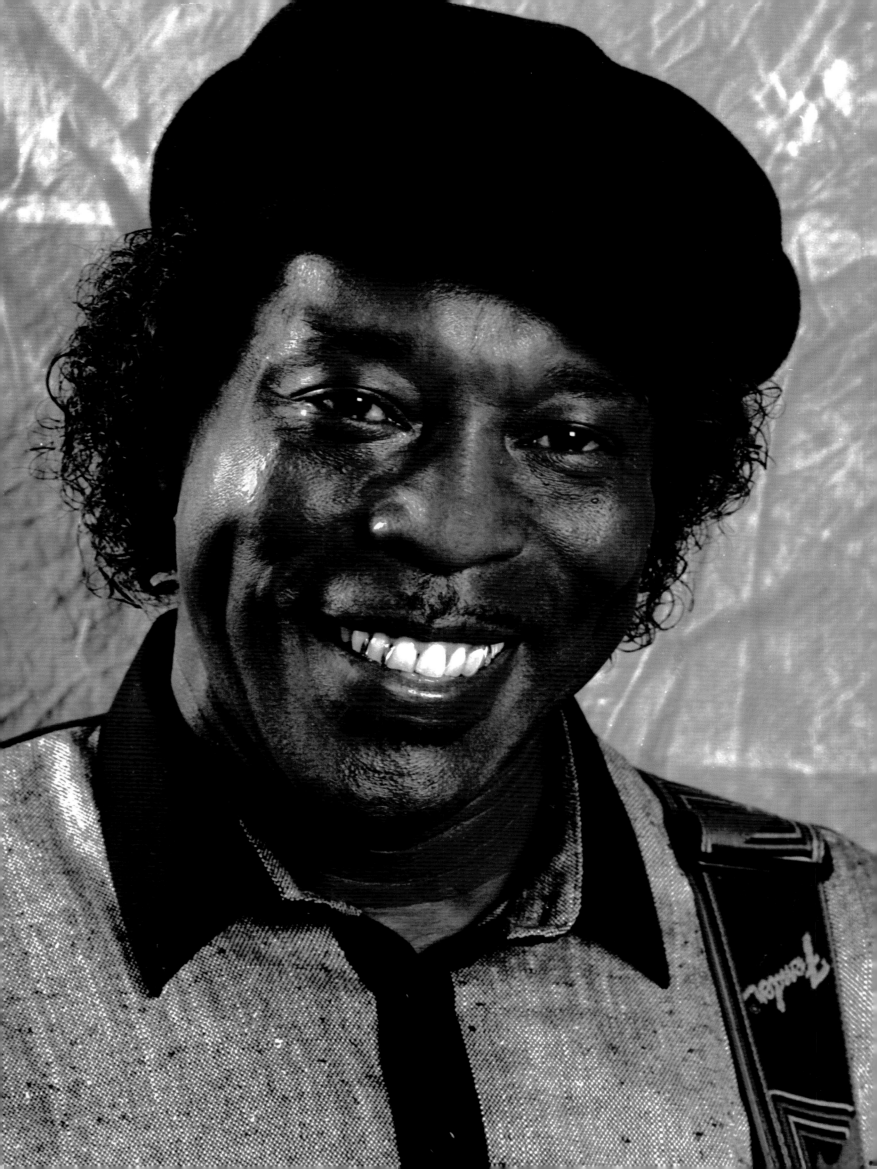

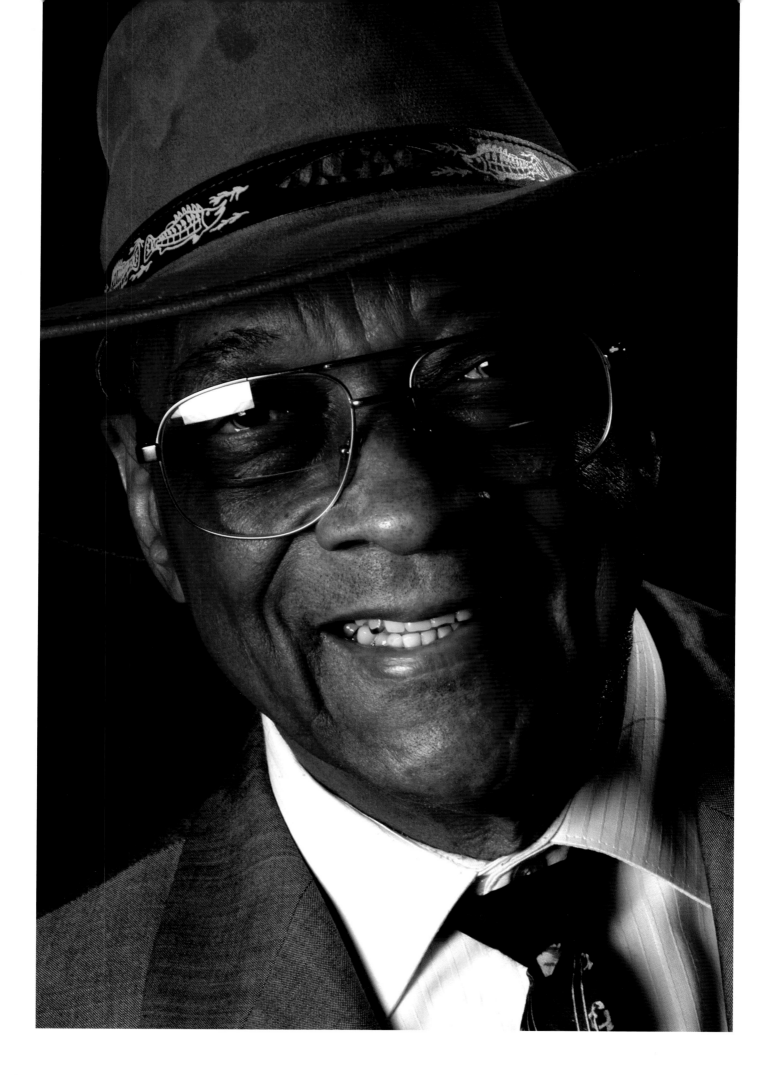

BUDDY GUY

HUBERT SUMLIN

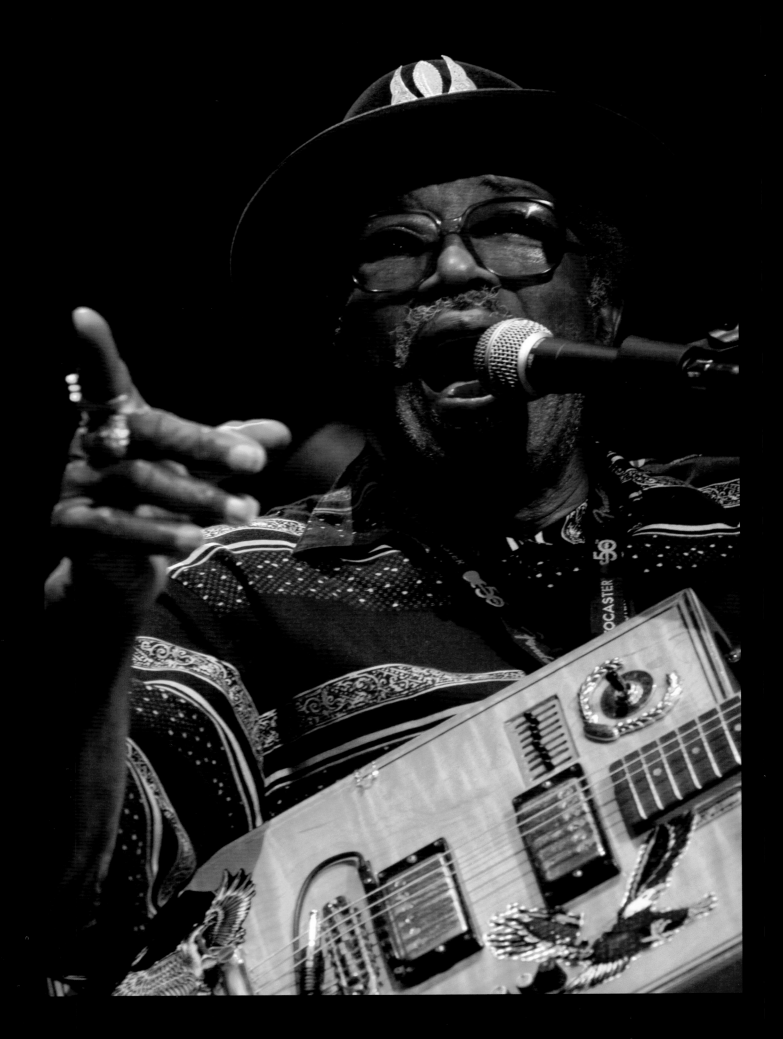

BO DIDDLEY

DAVID "HONEYBOY" EDWARDS

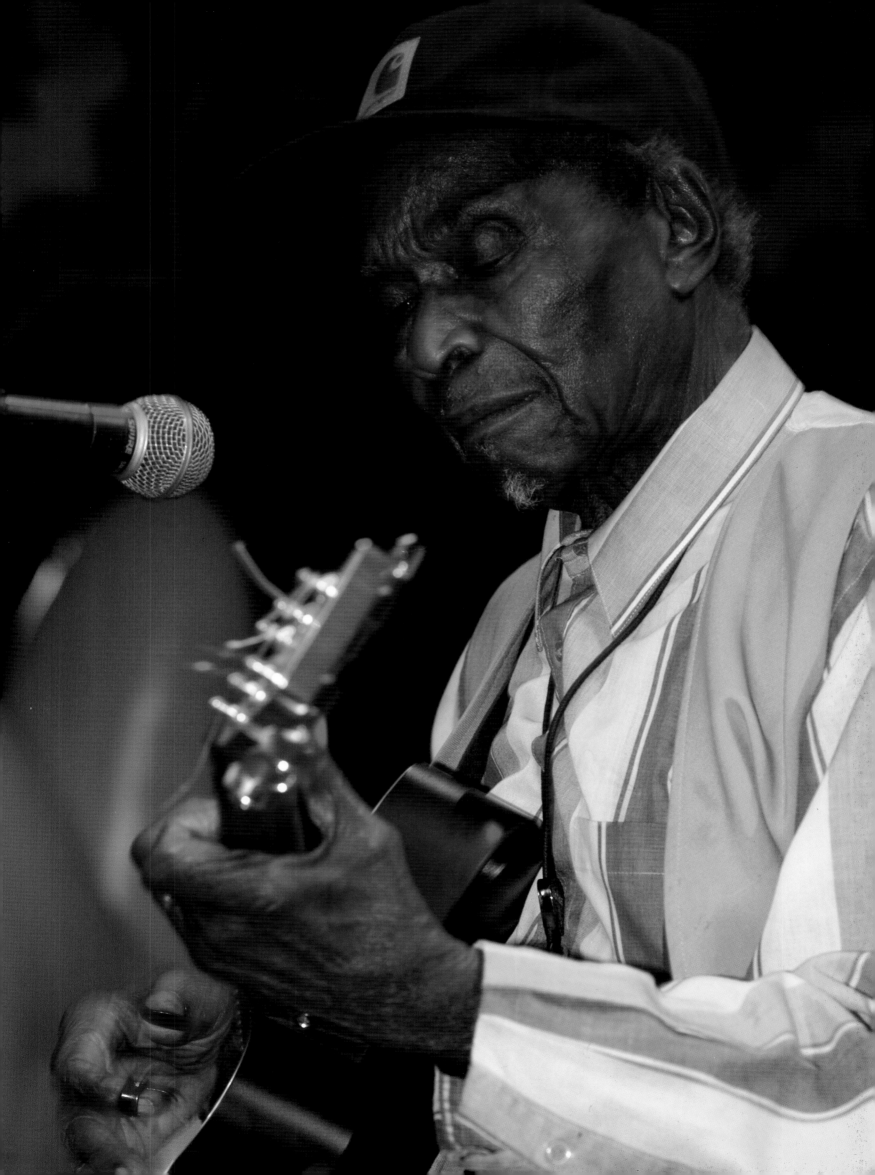

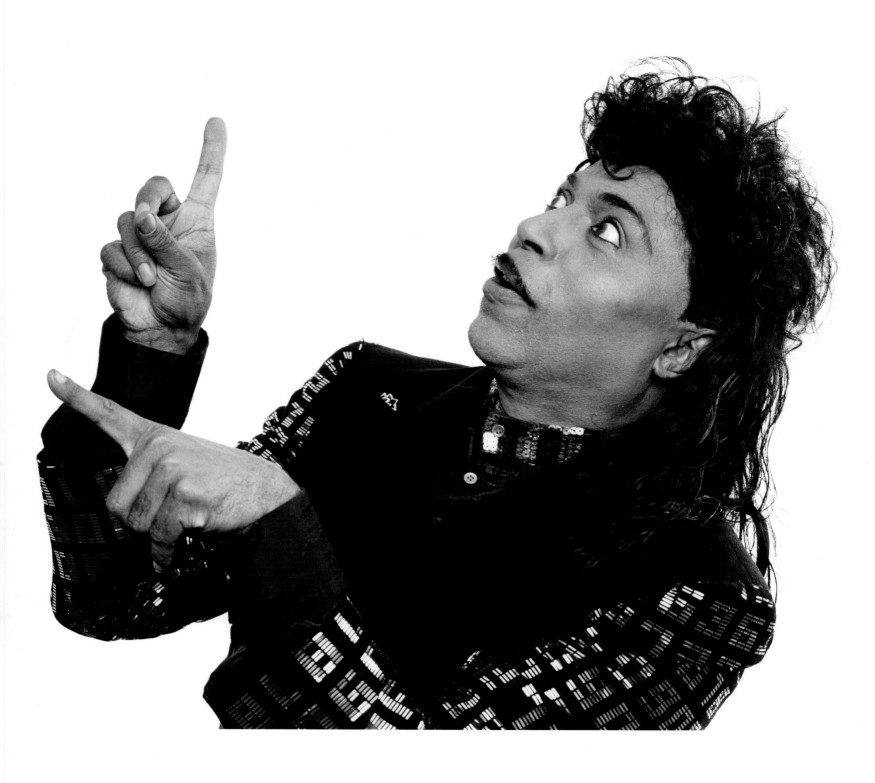

LITTLE RICHARD

JAMES BROWN

Mid '90s | RockWalk Induction | Los Angeles, California | 1992

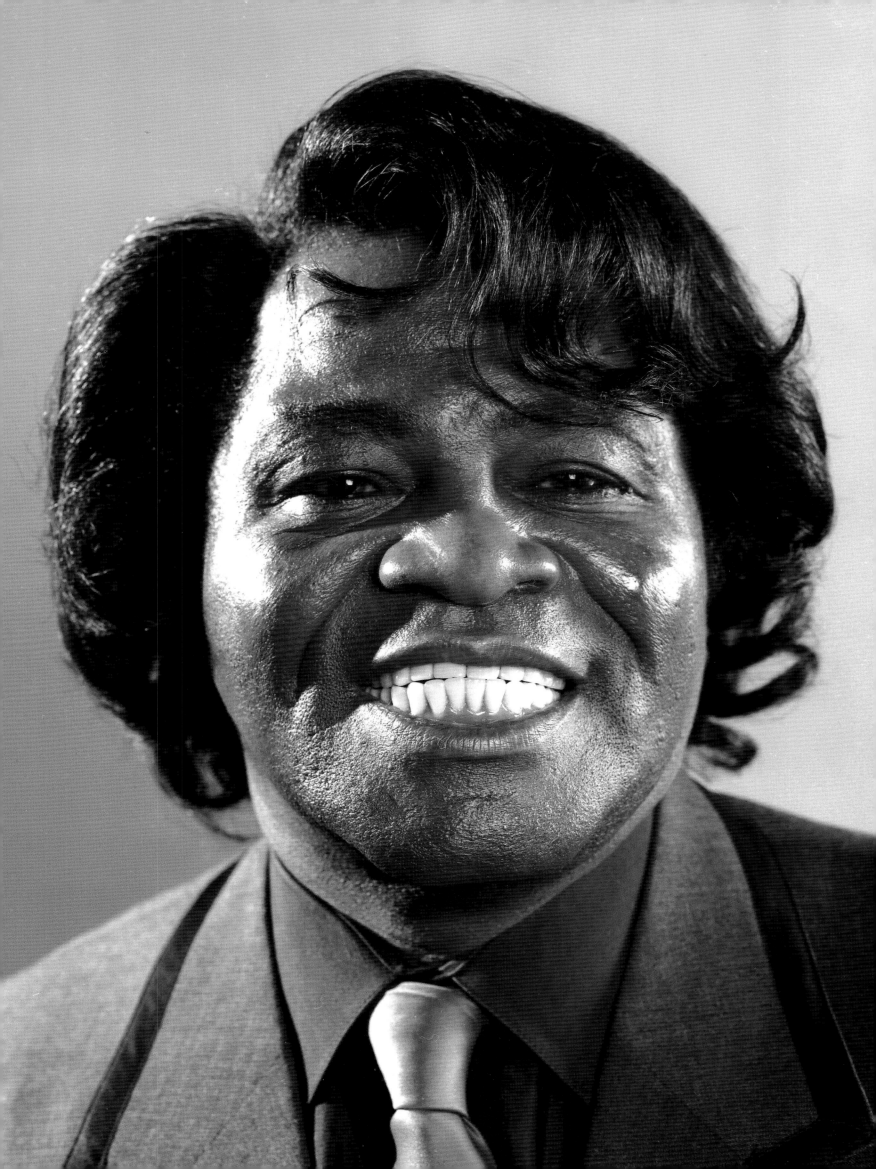

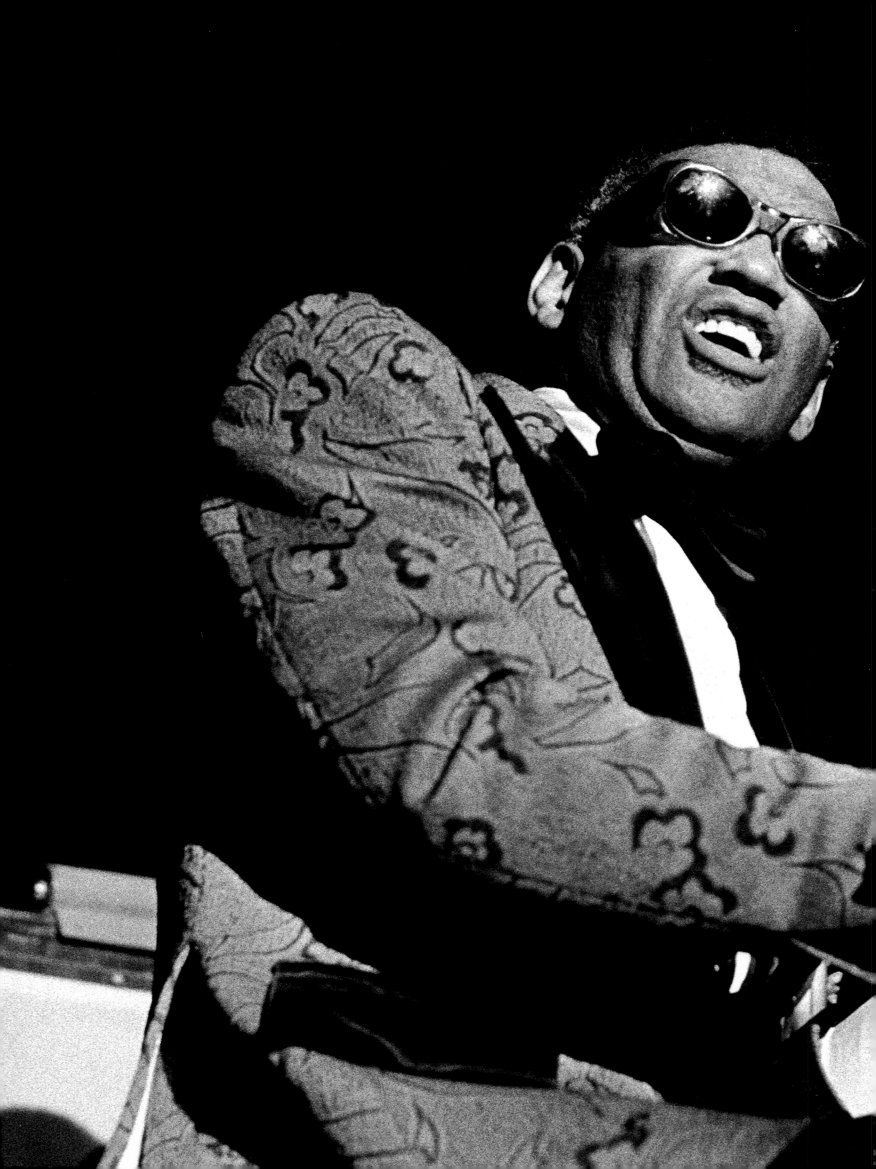

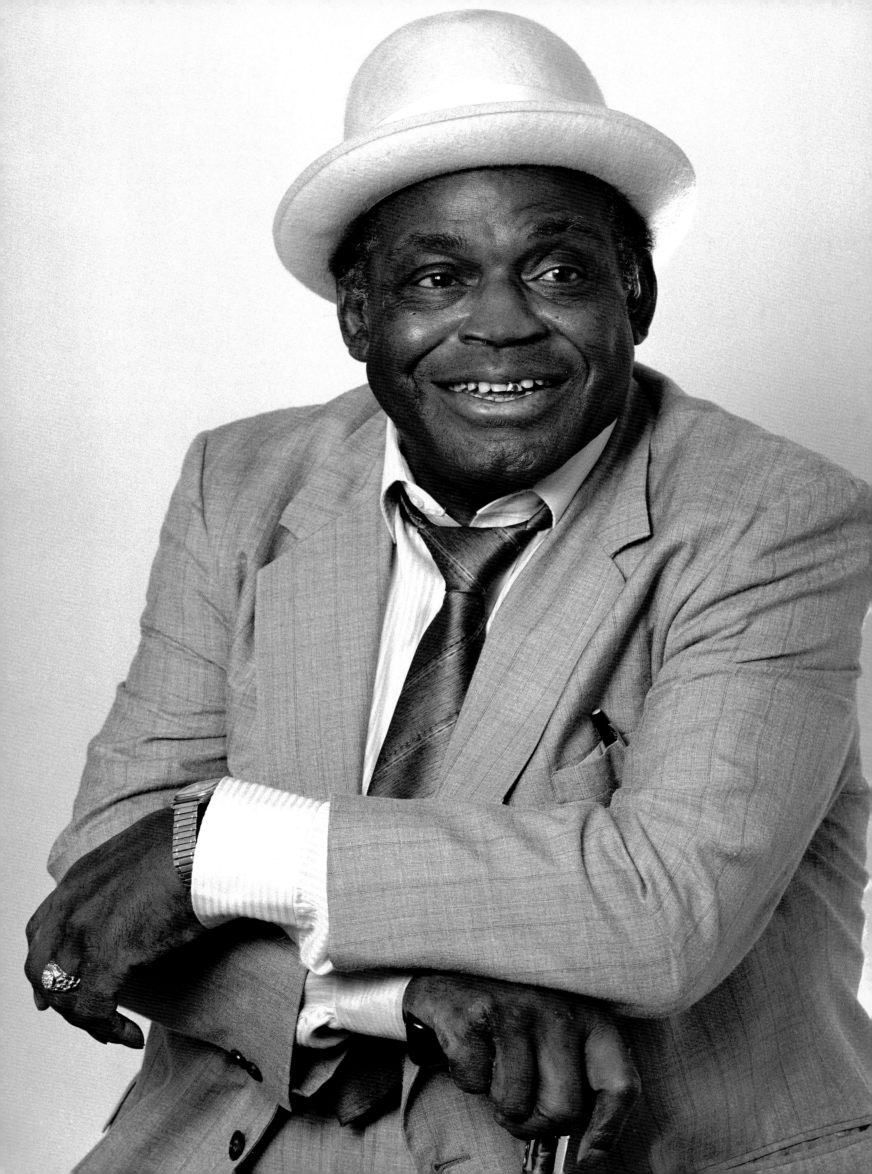

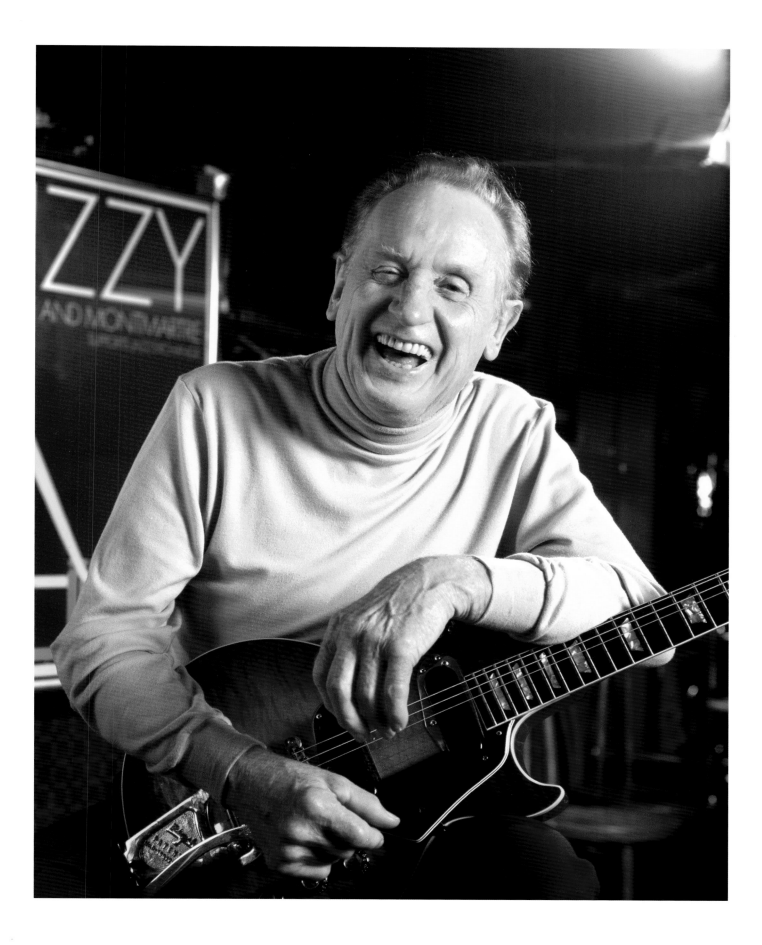

WILLIE DIXON

LES PAUL

| RockWalk Induction | Los Angeles, California | 1989 | | New York City | 1990 |

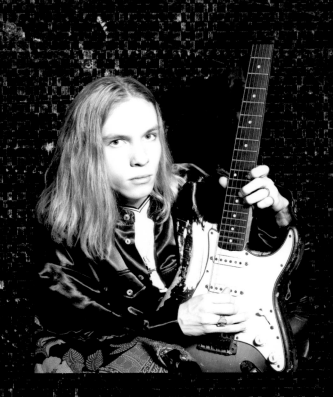

4

GALLERY

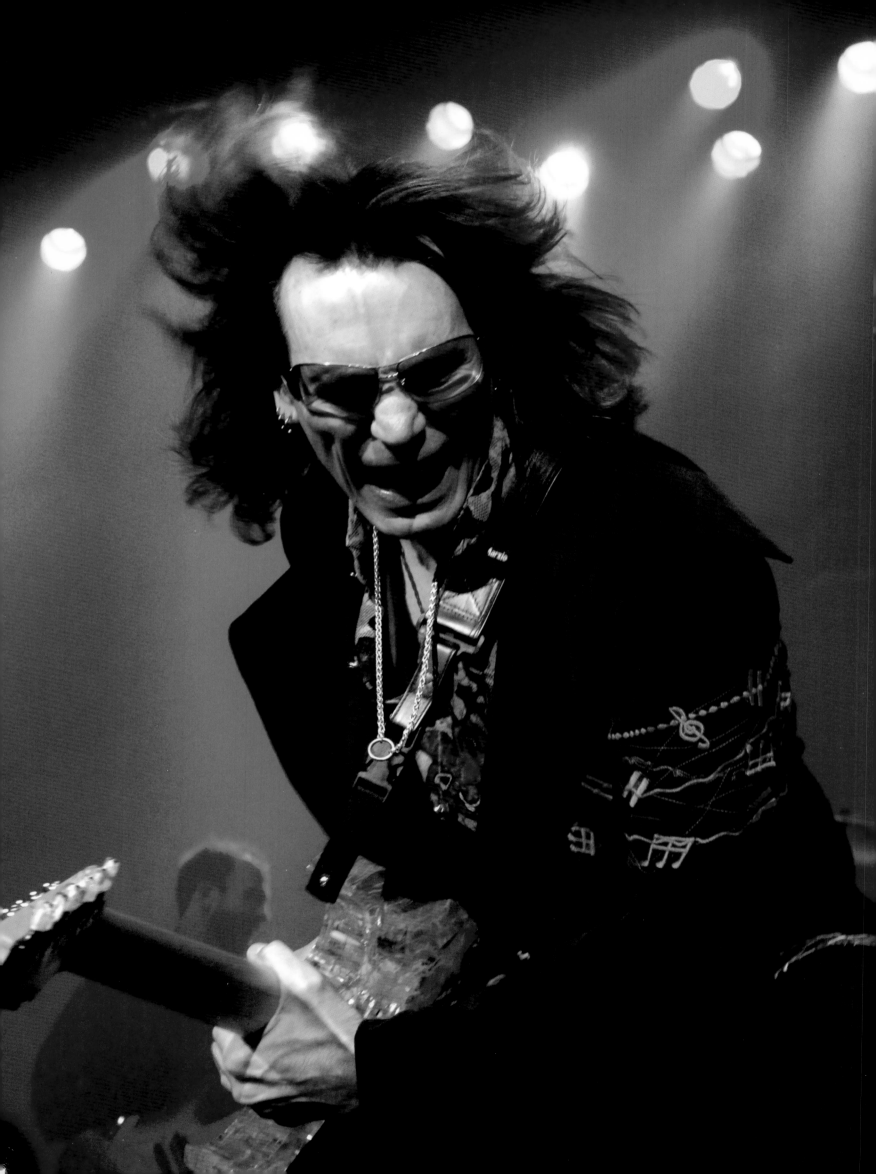

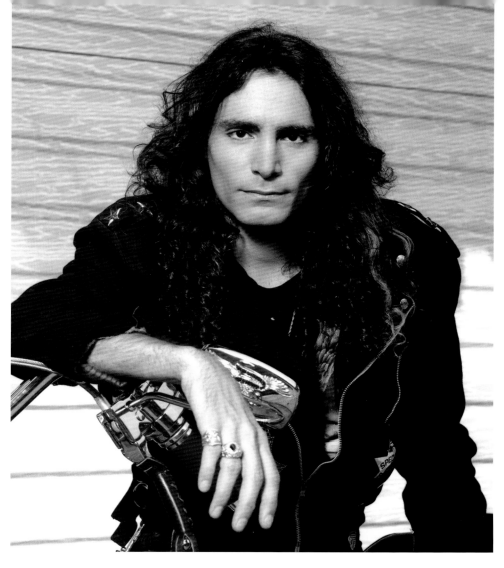

PEOPLE TRY TO IMITATE what Steve Vai does on the guitar, but they can't. He plays from another realm. It's not really emotional, like a blues musician, but rather like a mathematical chess player. He thinks of ways to play the guitar that just defy the because they are definitely like an Olympic athlete's feat. Everything is about precision. It takes skill, practice and discipline like you wouldn't believe. Steve fasts for two weeks before he embarks on a new record. He meditates, focuses and abstains

HE PLAYS FROM THIS OTHER REALM.

imagination. You have to appreciate that. I often tell Steve that after I see him solo on a song, I want to hold up a scorecard like at the Olympics that says 9.2 or 9.6. You feel like you've got to rate his guitar solos from various activities to put his brain down the path he wants it to go. I don't know many people who are as dedicated as Steve Vai.

STEVE VAI

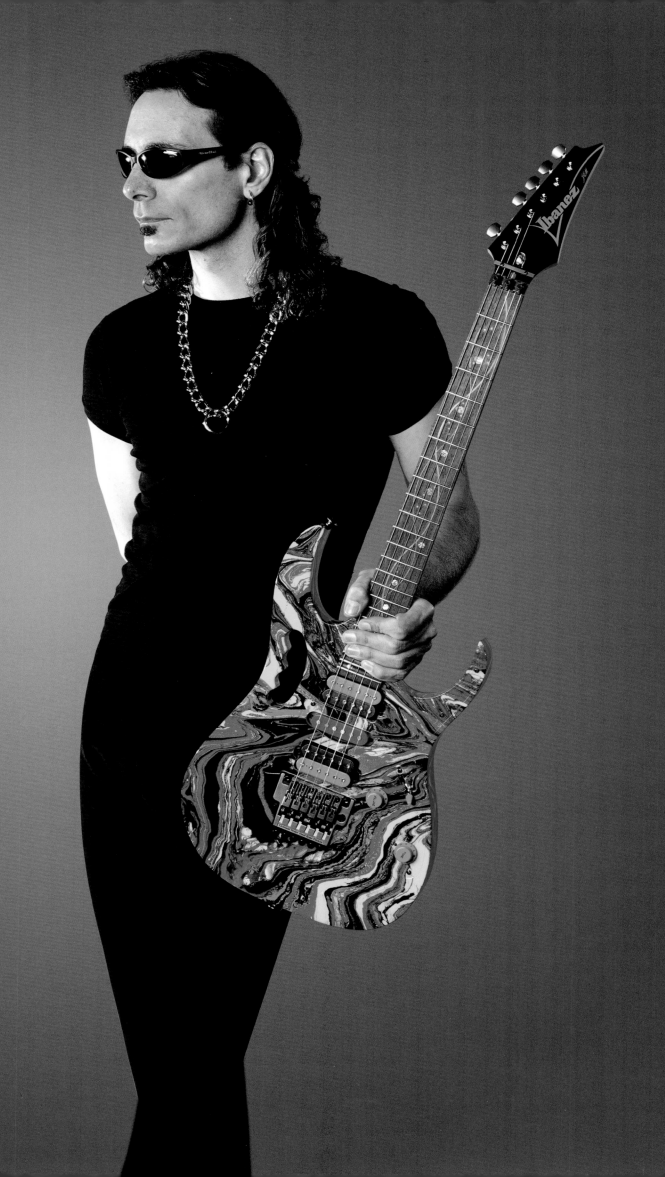

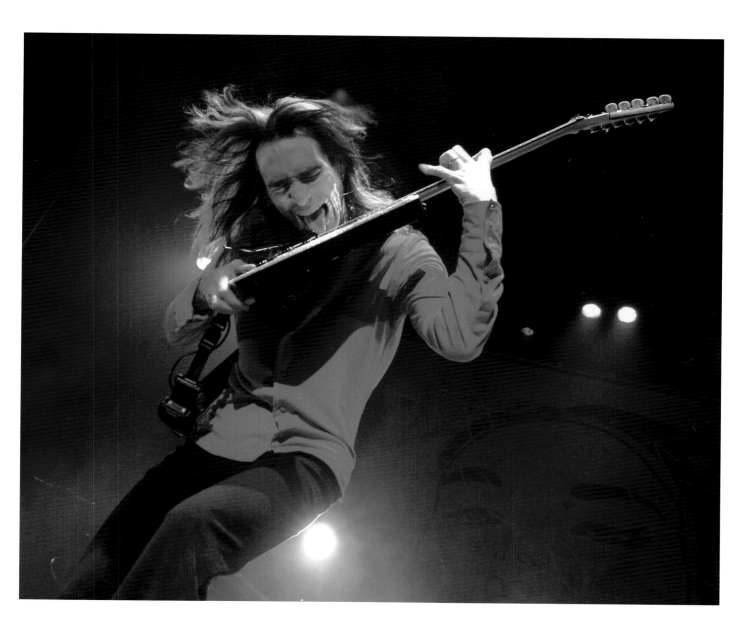

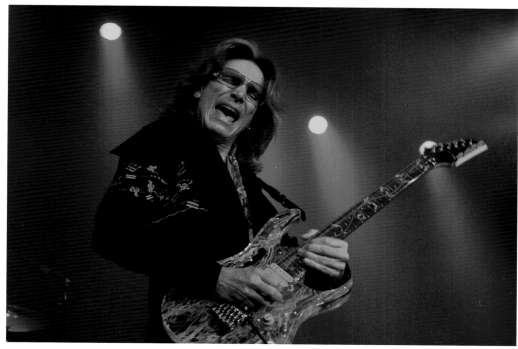

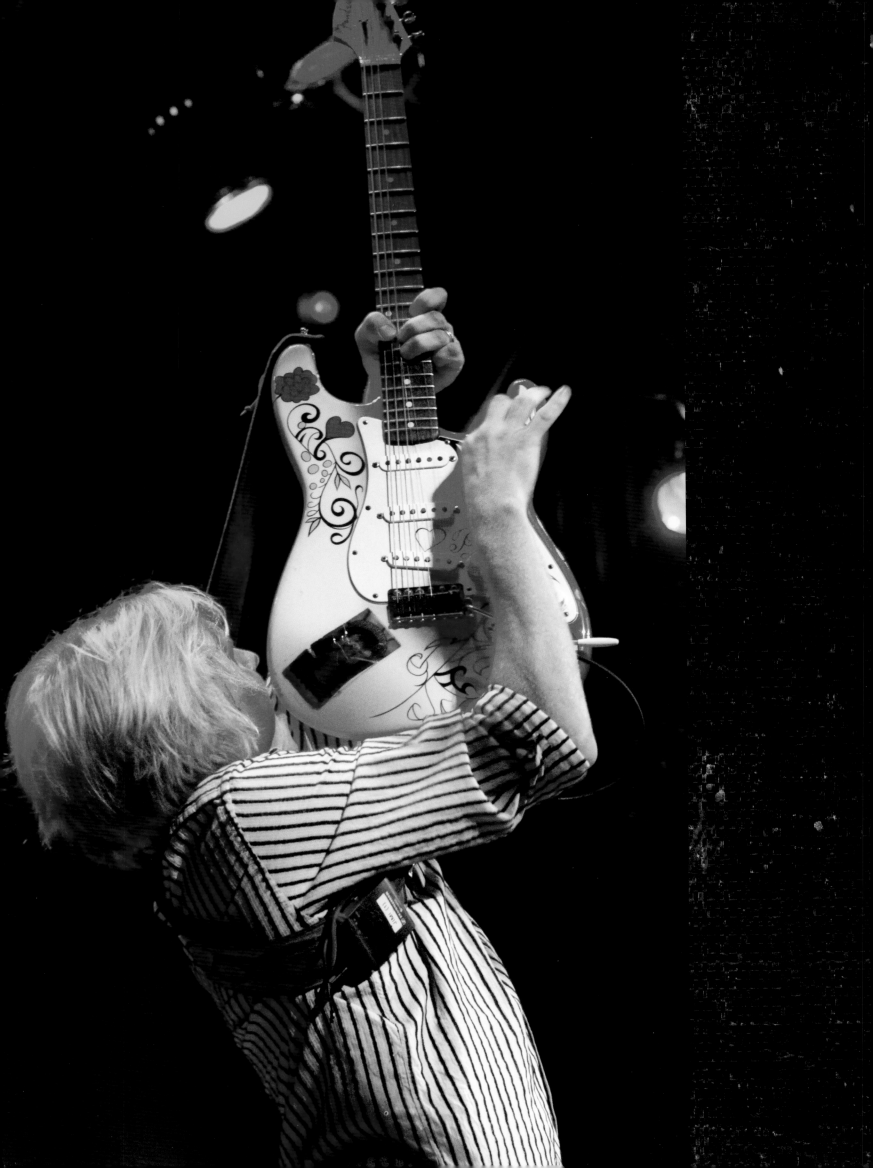

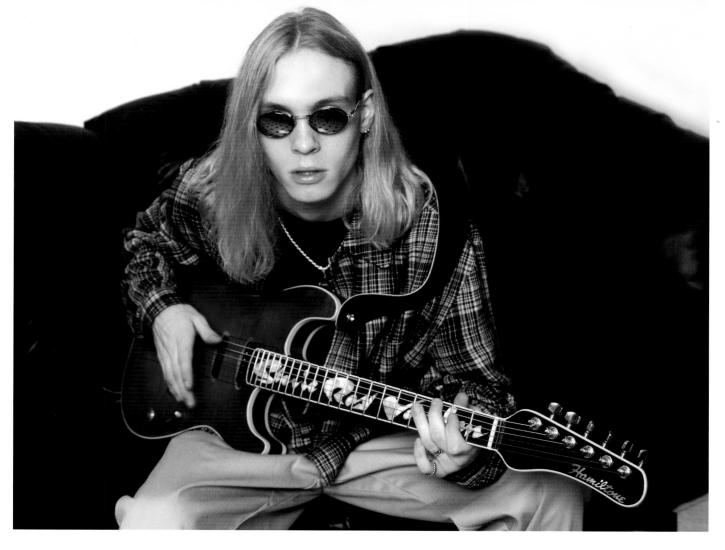

I PULLED OFF TO THE SIDE OF THE ROAD BECAUSE I WAS JUST

FOUR OR FIVE years after Stevie's death, I was driving in Austin, Texas when I heard a song on the radio that I thought was Stevie Ray Vaughan but I didn't recognize it. I pulled off to the side of the road because I was just blown away by this fantastic song with a long guitar solo. As I listened, I looked around, and I noticed that I was parked in front of the place where Stevie was buried. The deejay broke in and said, "And that was Kenny Wayne Shepherd." He was playing, "Deja Voodoo," a song about synchronicity. I thought, "Who is Kenny Wayne Shepherd?" I wondered if this is what Stevie meant when he said, "You'll know me when you hear me." Was there a connection here with this

kid? I returned to L.A., checked into this Kenny Wayne Shepherd and discovered that he was doing an in-store performance at Tower Records in just a couple of days. When I arrived at Tower Records, I noticed a tour bus parked in front, and the first person I saw was Stevie Ray's sound guy. "Donny, what are you doing here?" I asked. He said, "I'm working for Kenny Wayne." He invited me on the bus and introduced me to Kenny, who was this young boy at the time. I walked up to him and said, "Do you recognize me? Look at me. Do you know me?" I asked those questions because of this weird psychic thing around Stevie. Kenny stared at me and said, "No, I

don't, man … but I think I'm going to." I said, "How would you like to go up outside of a Guitar Center?" I photographed him for Guitar Center. No one knew who he was yet but we put him up on the outside of the store. I bonded with Kenny and he and I are still very good friends.

BLOWN AWAY

KENNY WAYNE SHEPHERD

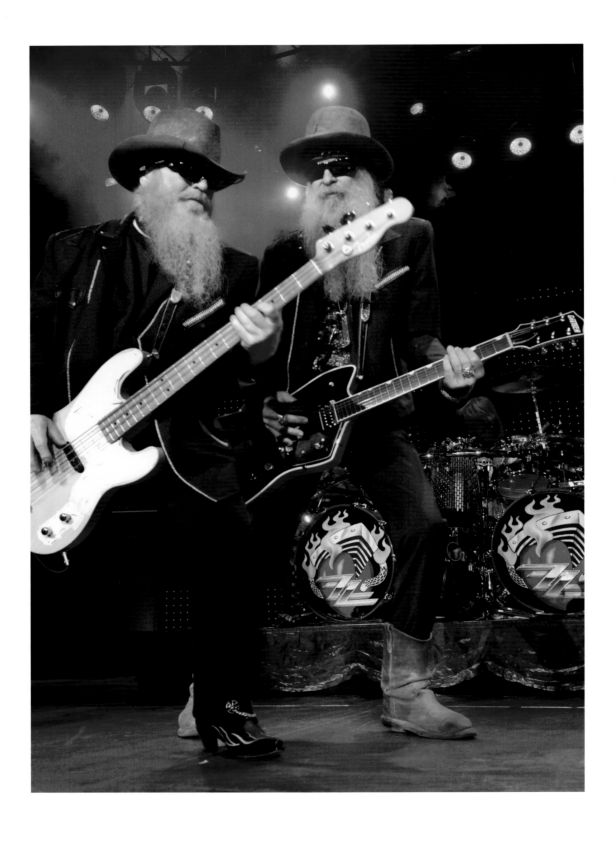

128

BILLY GIBBONS & DUSTY HILL

ZZ Top | Las Vegas, Nevada | 2007

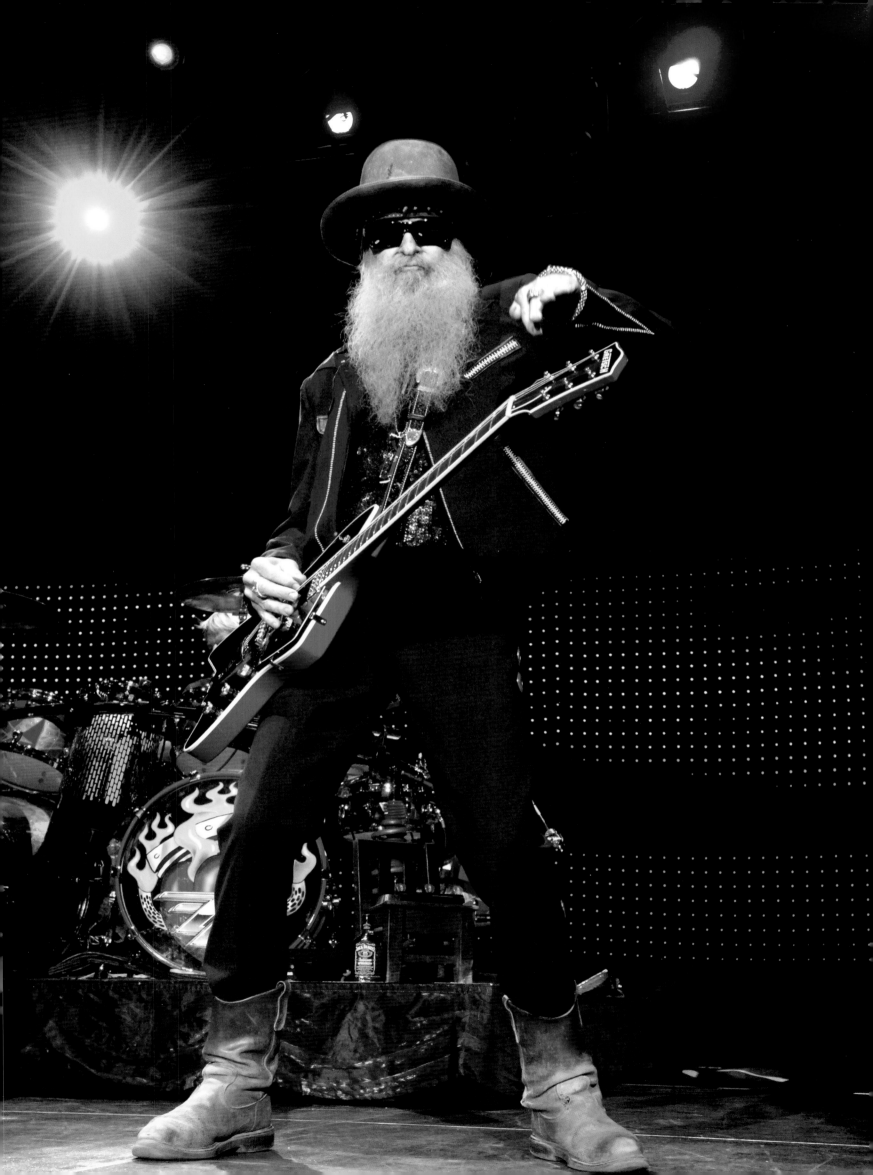

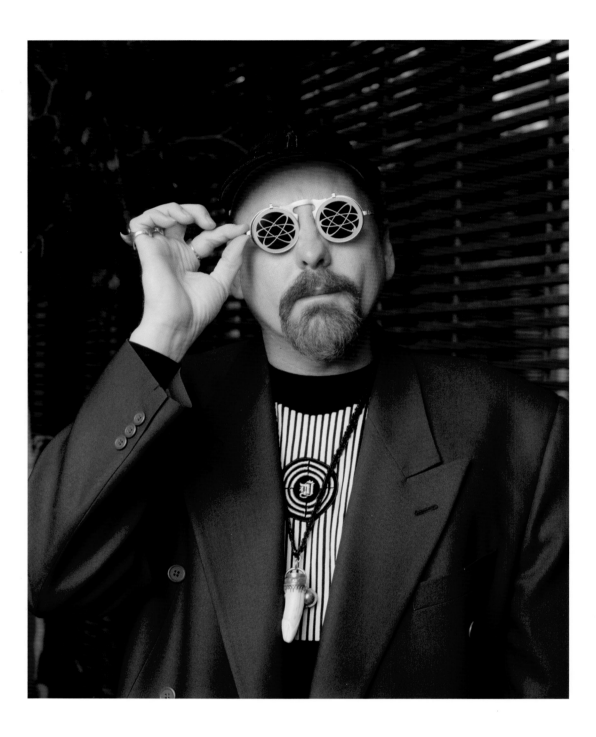

RICK NIELSEN

Cheap Trick | 2007

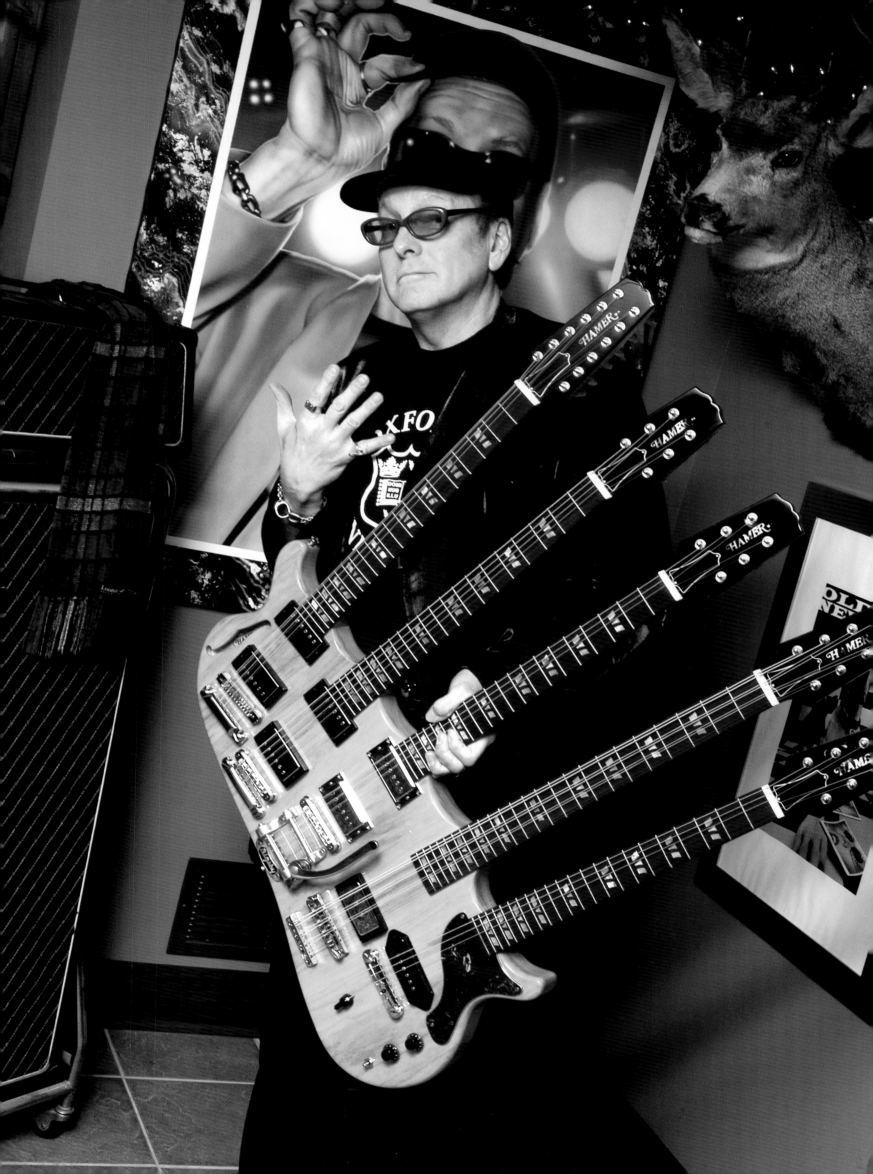

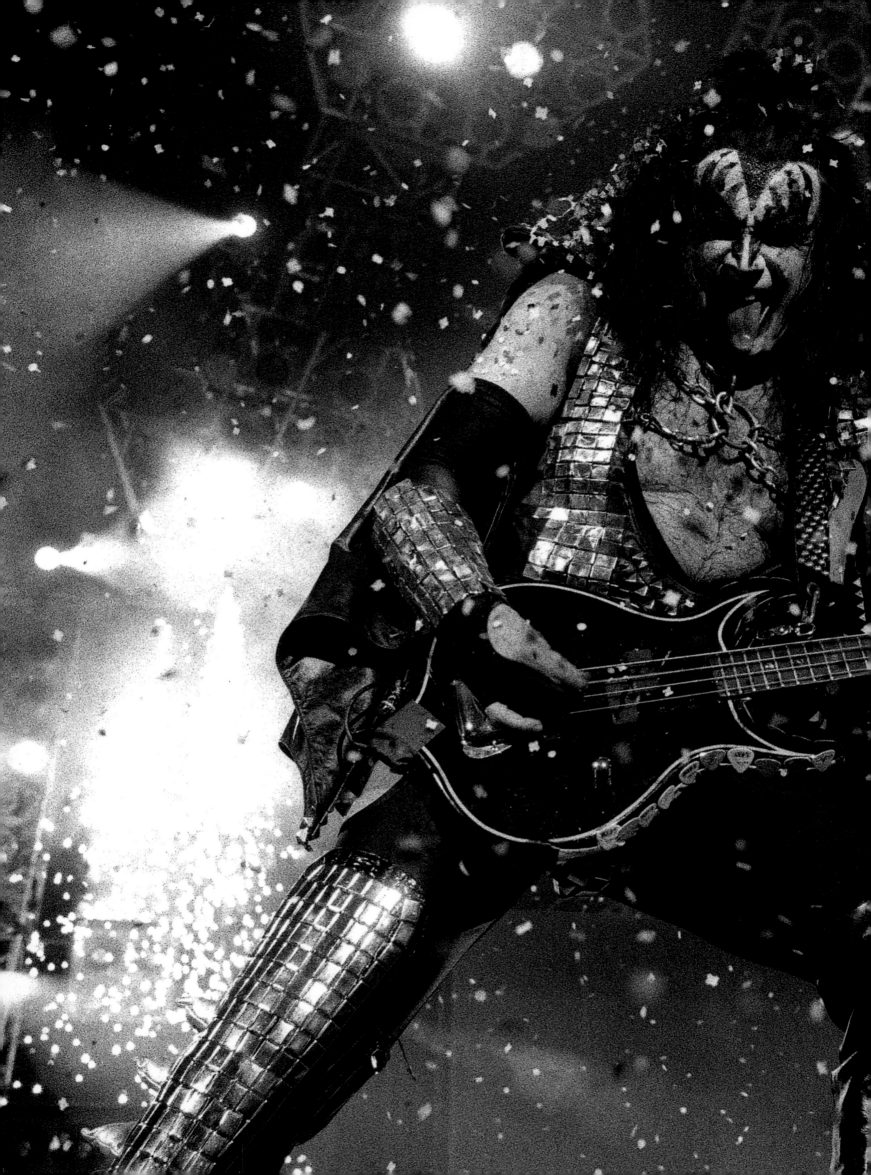

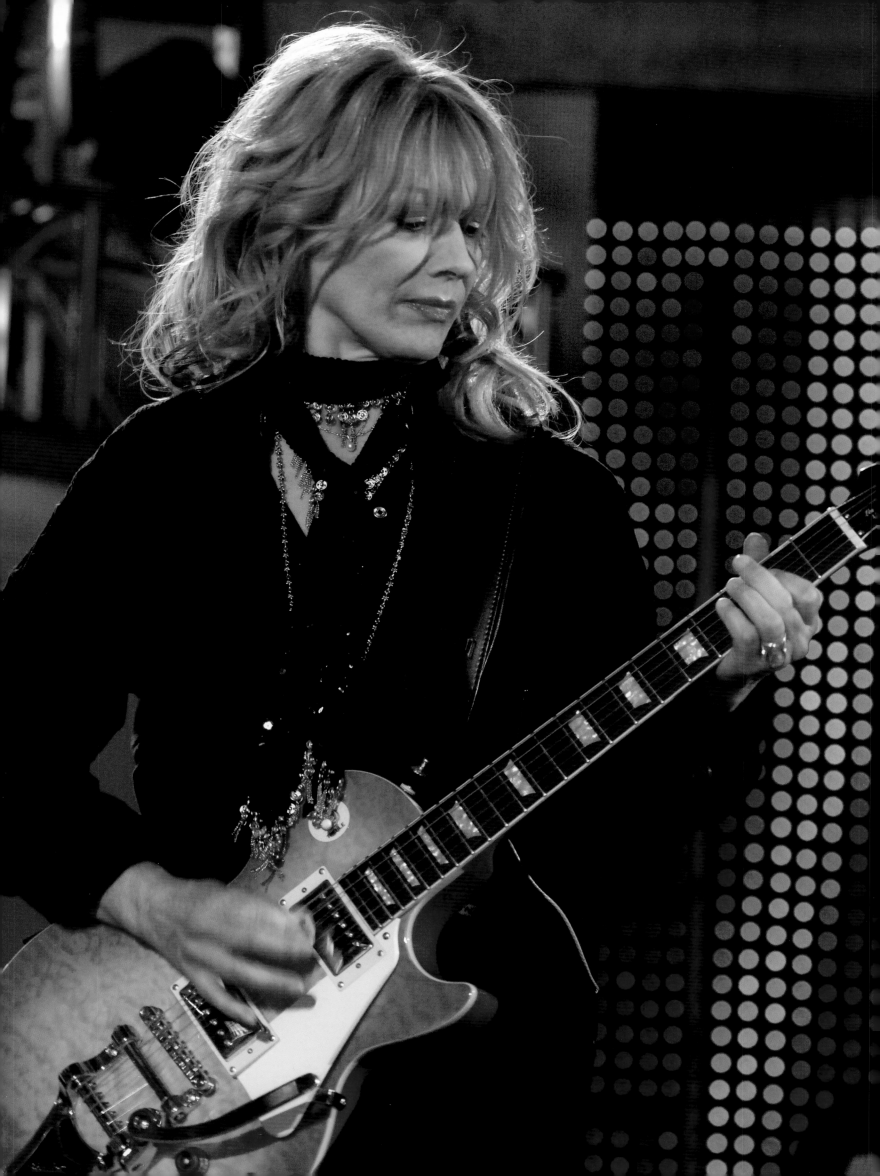

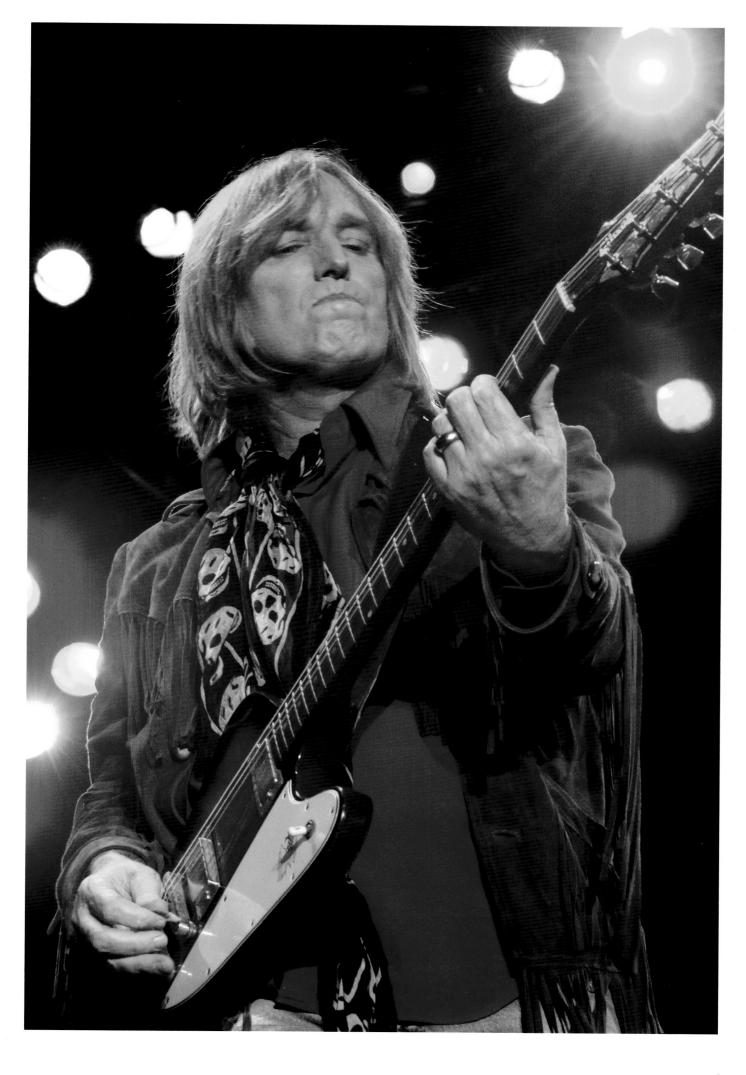

NANCY WILSON

Heart | Las Vegas, Nevada | 2007

TOM PETTY

Tom Petty & the Heartbreakers | Las Vegas, Nevada | 2007

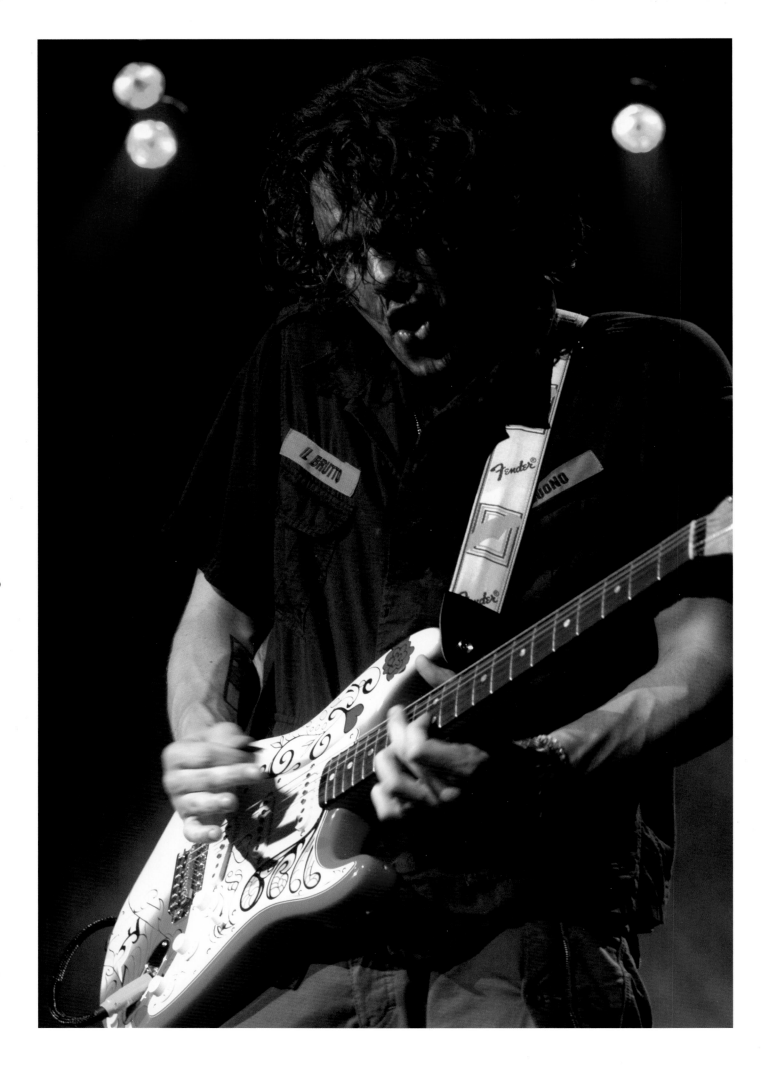

JOHN MAYER

SHERYL CROW

| Tampa, Florida | 2006 | | Tampa, Florida | 2006 |

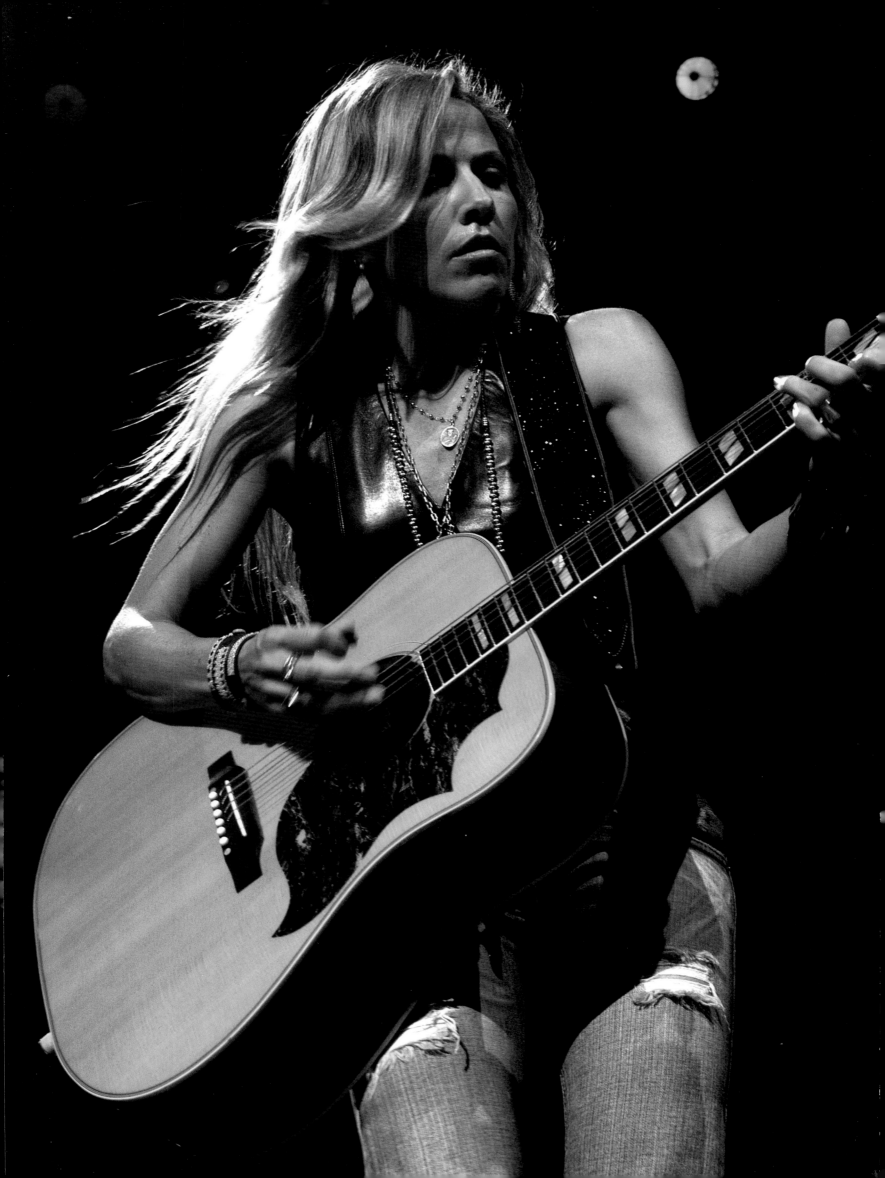

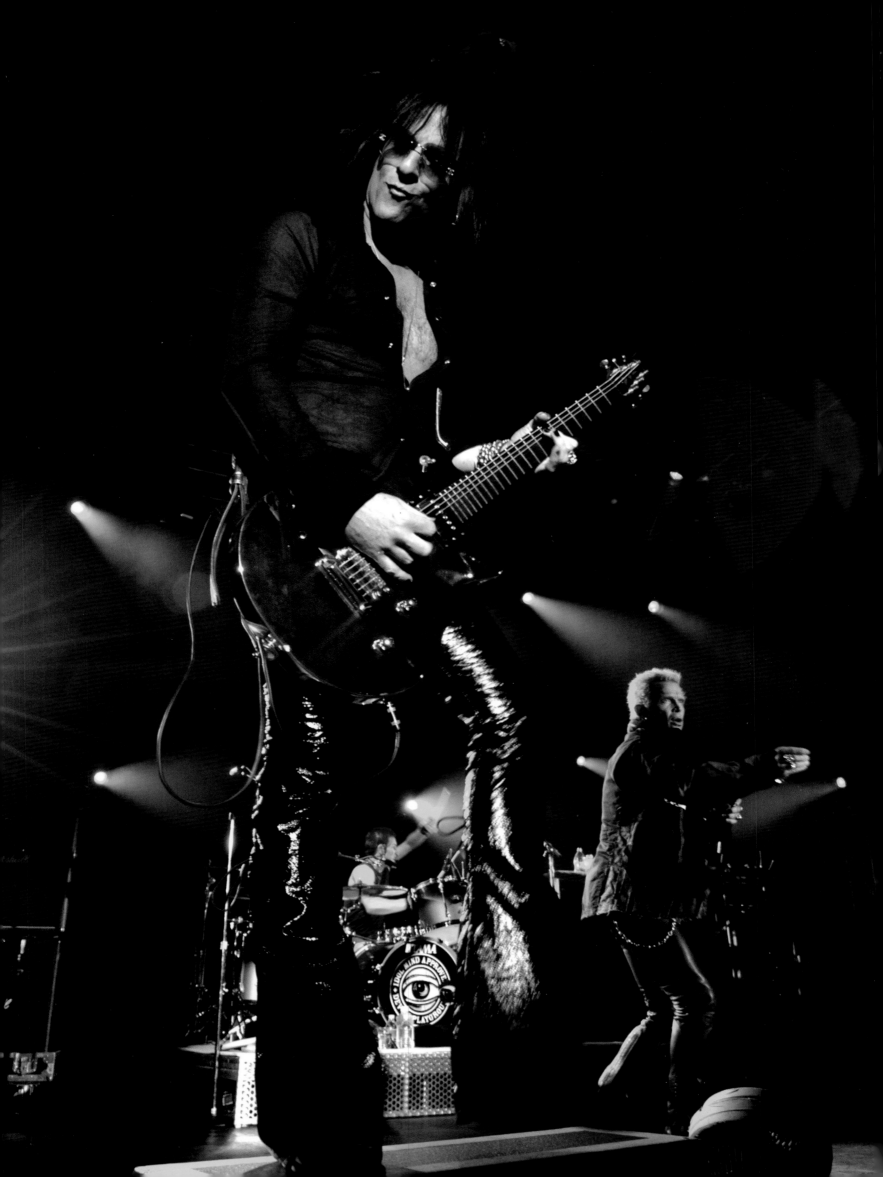

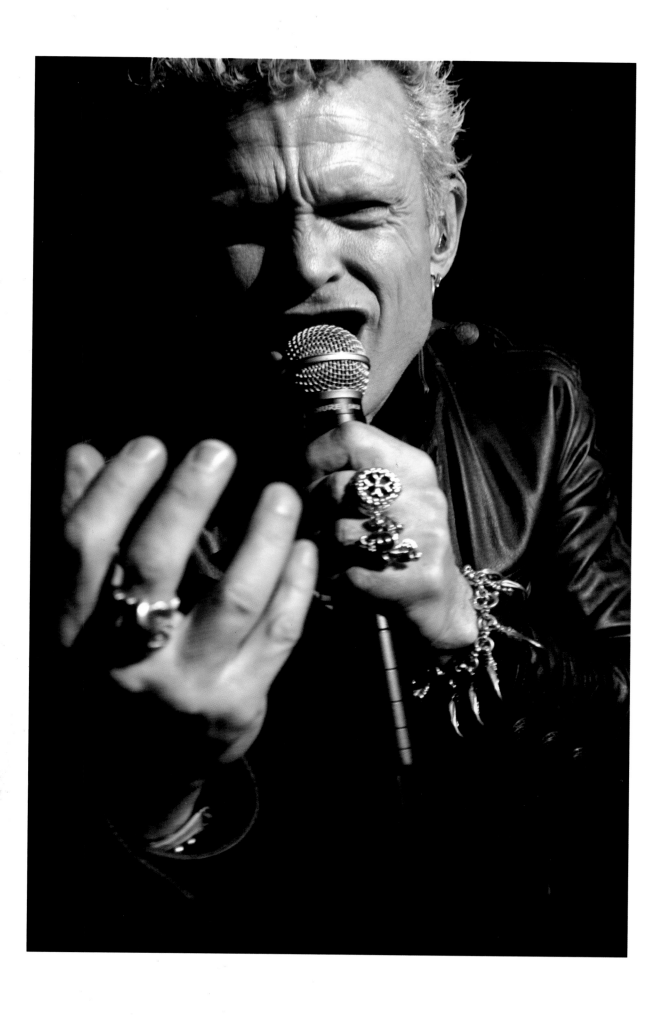

STEVE STEVENS & BILLY IDOL

| Billy Idol | Las Vegas, Nevada | 2005 |

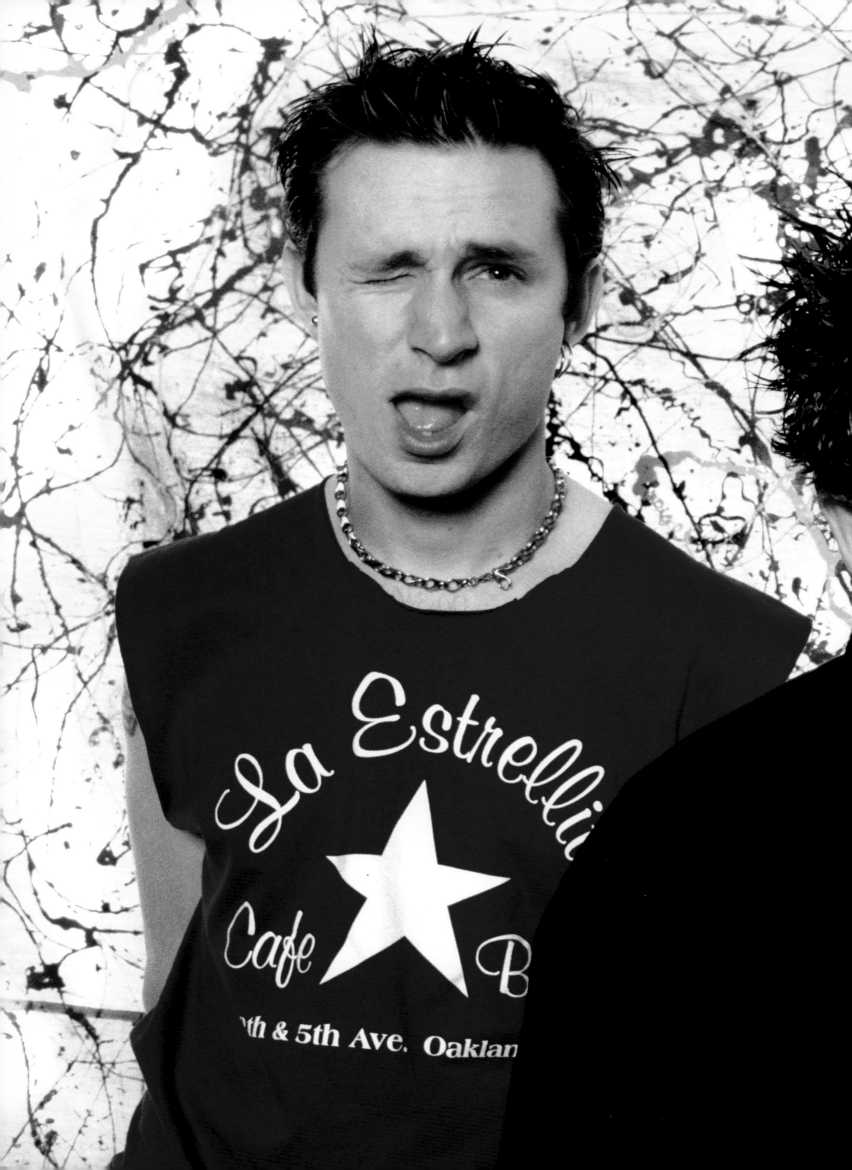

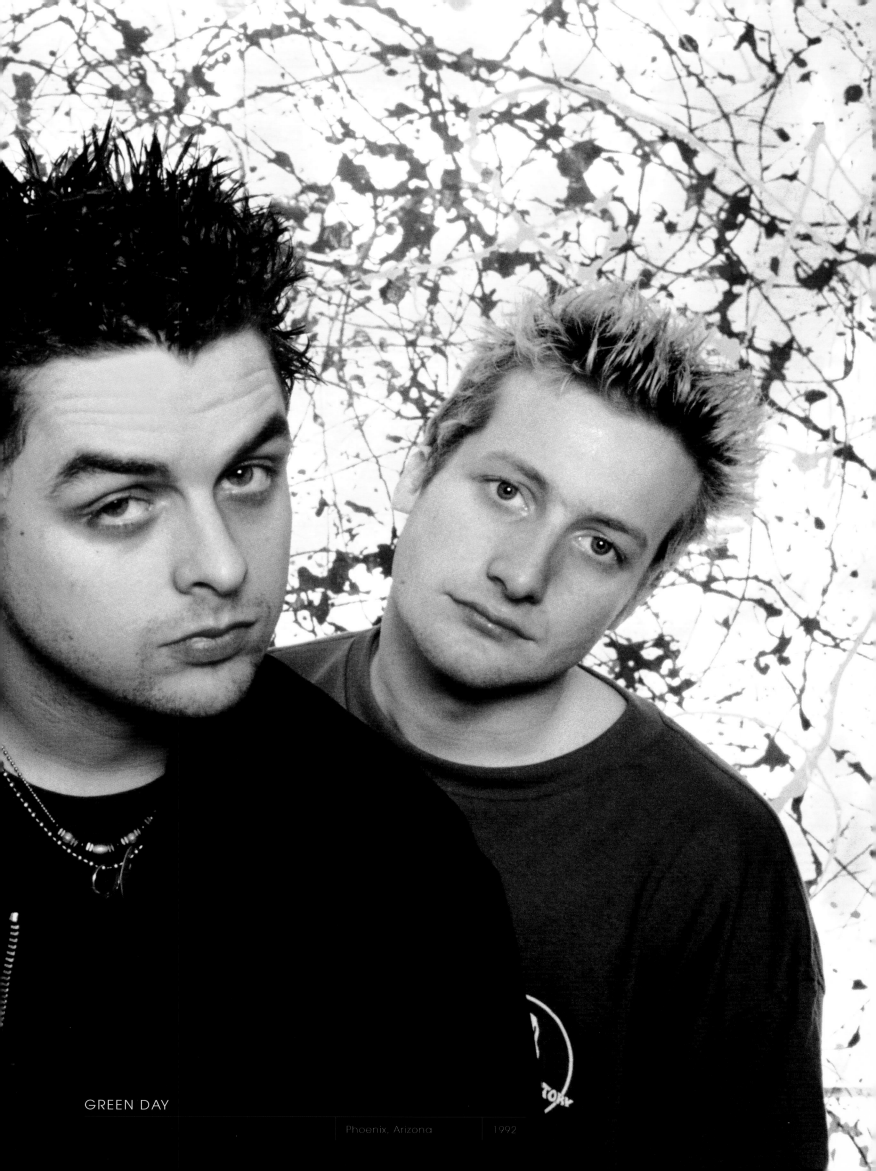

GREEN DAY

Phoenix, Arizona 1992

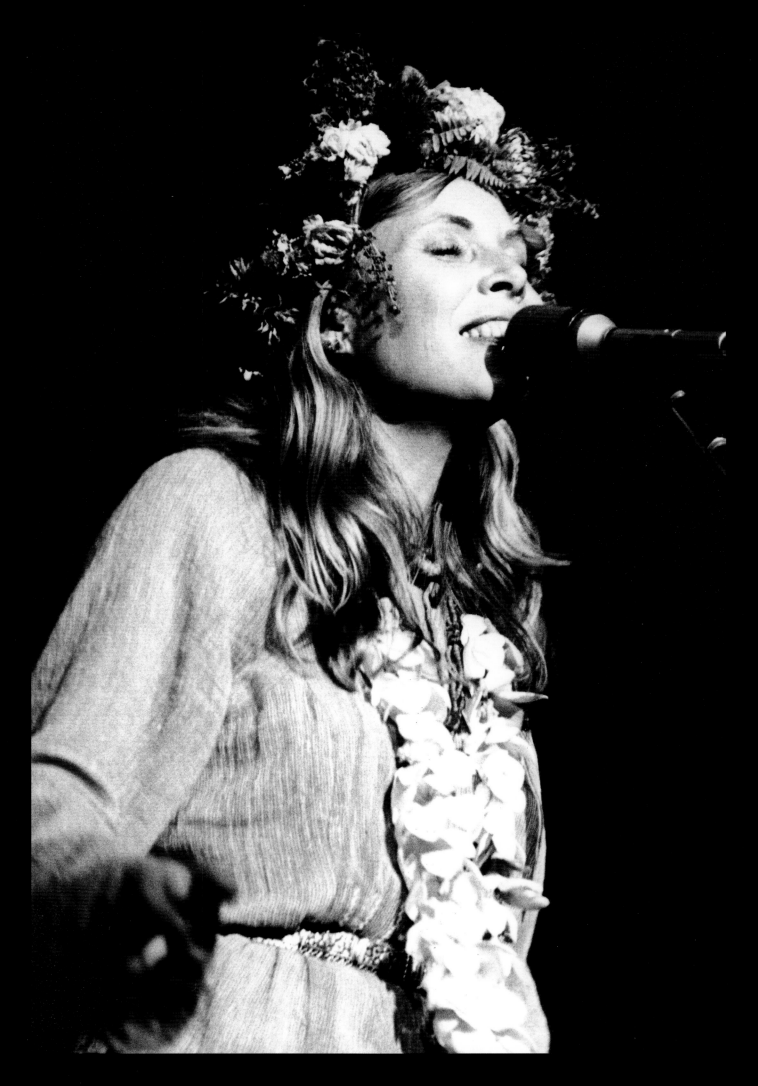

JONI MITCHELL ISAAC HAYES

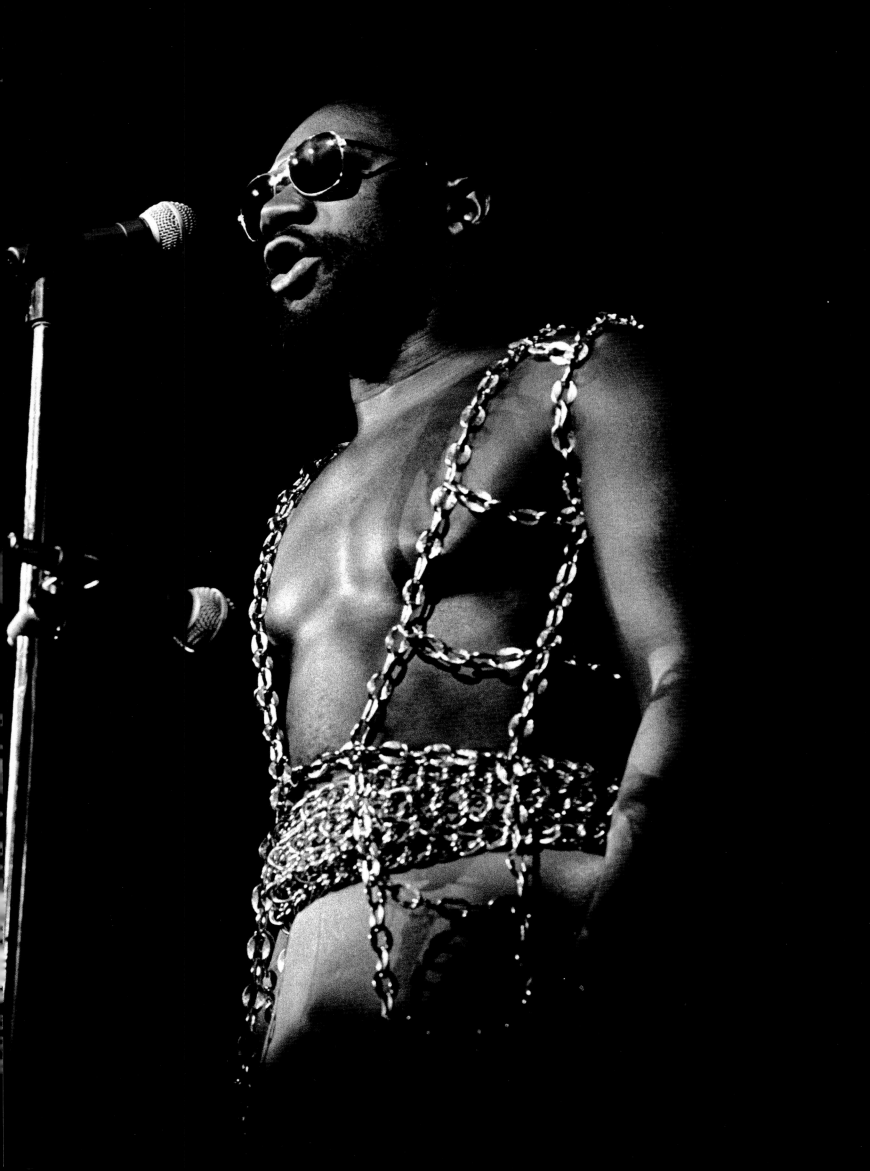

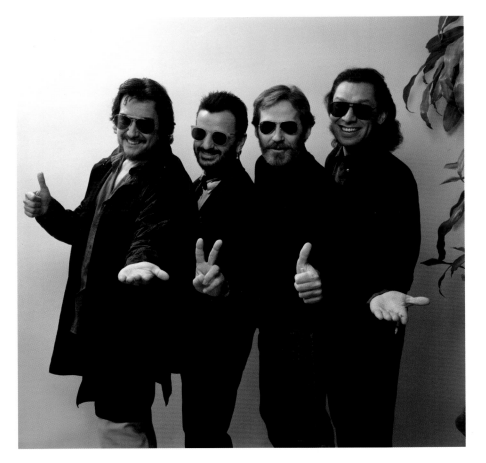

I DIDN'T GET into The Beatles until the *Sgt. Pepper* album. When I was a kid, The Beatles were what is basically now called a boy band. It was

where Keltner said he would meet us.

At the Bel Air, I called the designated room and this English guy answered the phone. I asked,

Alex was sober so Ringo said, "Tell him to come down." Jimmy Keltner arrived, then Alex. At that point, I was in a room with four of the top drummers in the world and all my cameras were in the car. I was scared to death to bring it up. Then Ringo turned to me and said, "Where's your camera? Go get your camera." So I got my camera and lights and everyone posed for a really campy photo shoot where they lined up and kicked their legs like the Rockettes. Ringo then asked, "Can you do portraits of Barbara (Bach, Ringo's wife) and I?" I shot he and Barbara and then told him, "Listen, Ringo, I'll never

THE DAY ENDED UP AS A BIG JAM SESSION AROUND THE PIANO

144

not hip for a guy my age to like The Beatles. I was into the Stones, The Pretty Things, The Kinks, The Who.

I ended up working with Ringo much later, however, by accident. Jim Keltner, one of the top session drummers, who's played on Stones and Eric Clapton records and with dozens of other big artists, called me. His son needed photos which I did for him. Jim wanted to pay me but I refused because it was for his son. Later the same day, Keltner called me and said, "I've got a little surprise for you. Tomorrow, at 12:00 noon, I want you to go to Santa Monica to the Miramar Hotel. At the front desk, ask for Buck Dollar's room." So I drove to Santa Monica, asked for Buck Dollar at the front desk, and a couple of minutes later, Levon Helm, the drummer from The Band, strolls into the lobby. Levon hopped in my Jeep and we proceeded to the Bel Air Hotel

"Is Jimmy Keltner there?" The guy with the English accent said, "No, he's not here, but is this Robert?" I said yes and he said, "Well, come on down to the room." Levon and I got to the room and found Ringo Starr there. I was blown away because I was meeting my first Beatle. Keltner then called and said he was running late. So I stepped out of the room and called Dave Weiderman, who is a complete drum freak, and said, "Dude, I am here with Ringo. I am meeting a Beatle." About ten minutes later, my phone rang. It's Alex Van Halen, who said "Robert, I have got to meet Ringo. Can I come over?" So I turned to Ringo and said, "I just got a call from Alex Van Halen, and he wants to know if he can come over." Ringo responded, "Well, listen. I don't drink or do drugs now, and I don't want to be around people that do. Is he sober?"

let these pictures out." And he said, "Why not? Do what you like, Robert. Just feel free." It was the most amazing day with these drummers. Two weeks later I got a phone call from Harry Nilsson. Ringo had given him my number. Nilsson said, "Can you call that Van Halen guy and come over and meet me at the St. James Club, because Ringo said you guys were really cool." Alex and I went down, and we spent almost the whole day and night with Harry Nilsson, along with Joe Cocker, Whoopi Goldberg and Timothy Dalton. The day ended up as a big jam session around the piano in the bar at the St. James Club hotel. All of that came from Ringo.

RINGO STARR

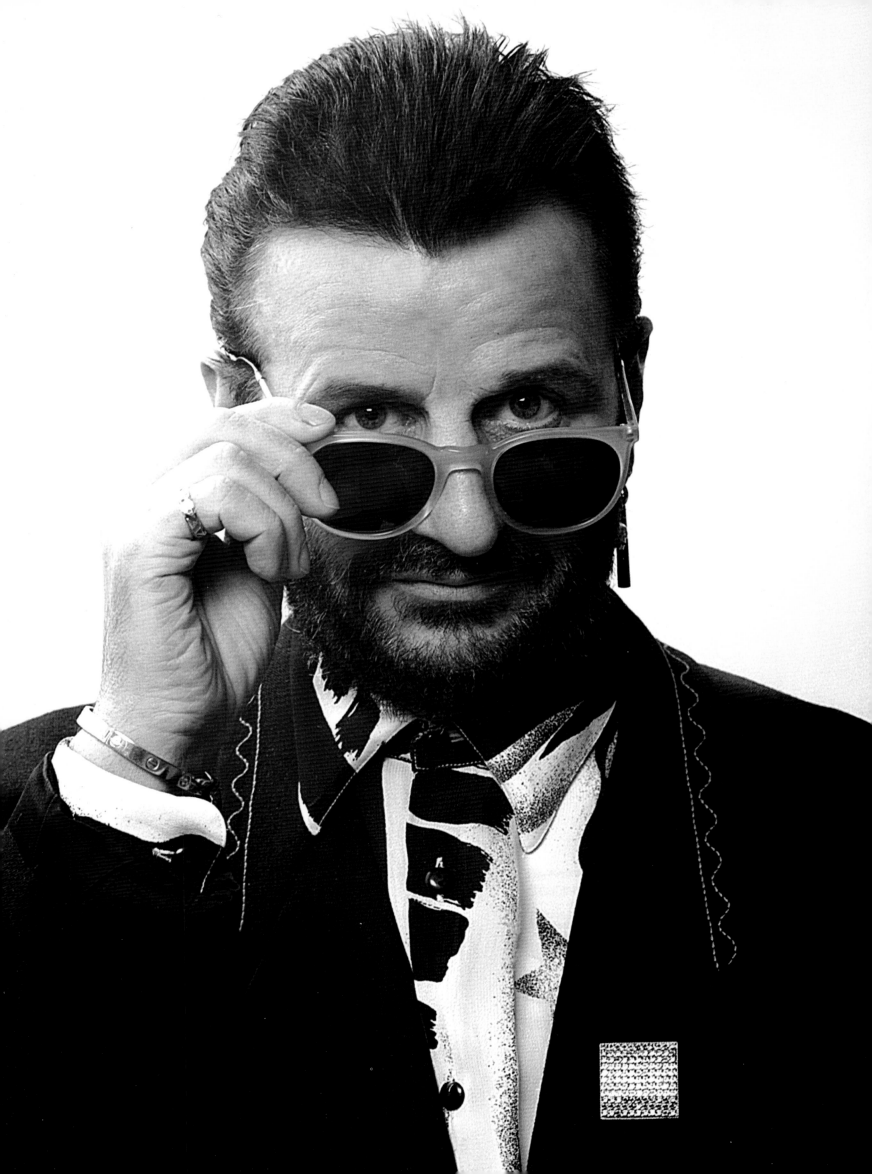

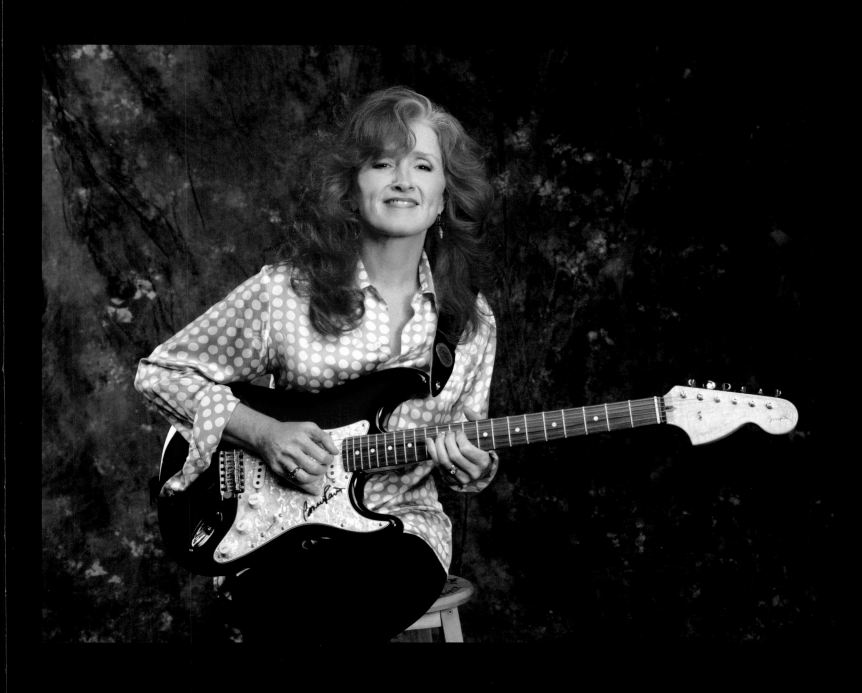

BONNIE RAITT

Hollywood, California 1996

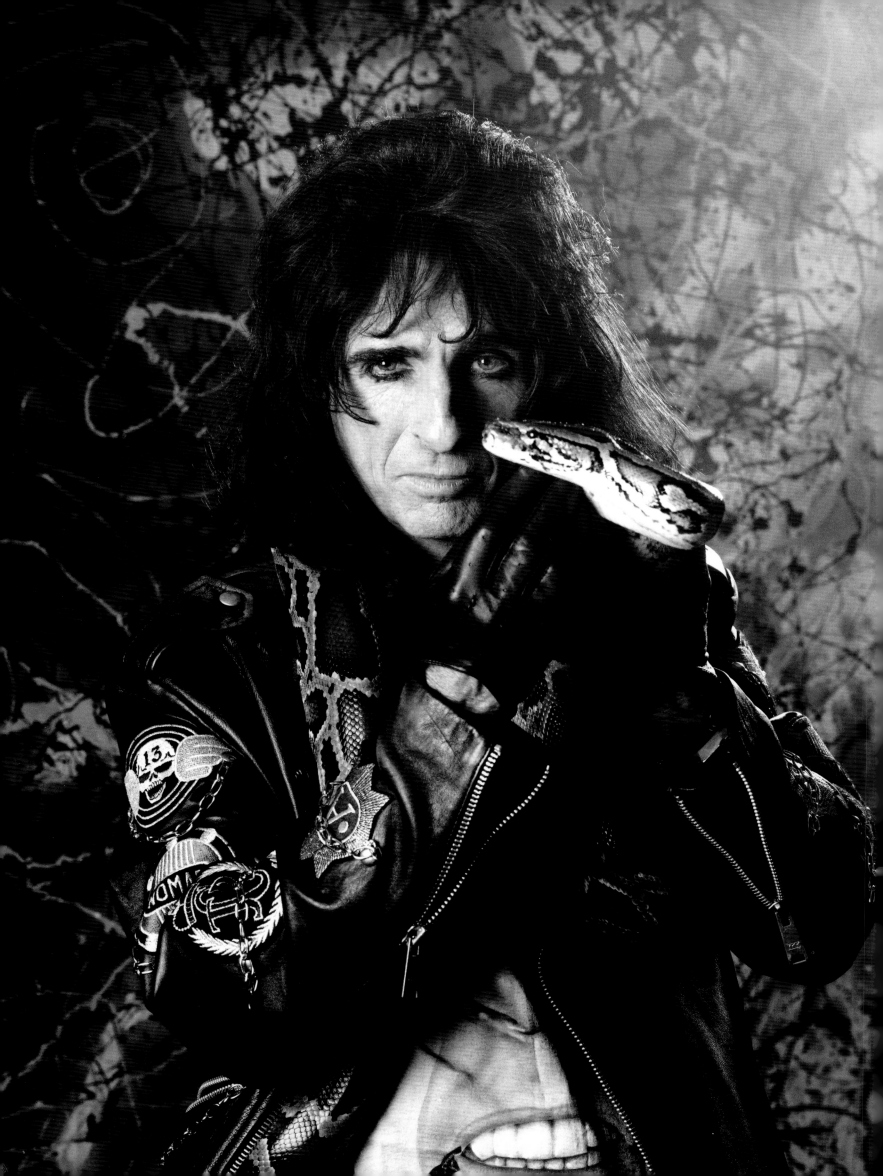

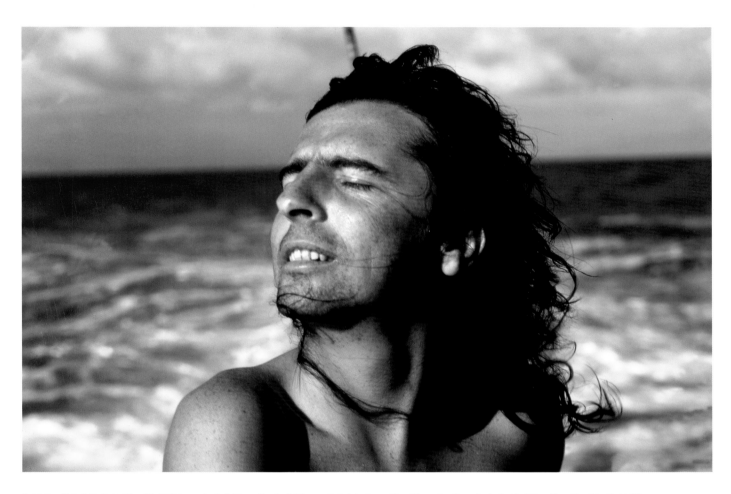

HE SHRUGGED AND SAID, "I'LL GO AS ALICE COOPER.

WHEN ALICE COOPER performed in Hawaii near the end of October in the '70s, his record company asked me to entertain him. They said, "Just take him around and do the things that he likes to do." So Alice and I went deep sea fishing and I arranged for him to play tennis and golf with some of my friends. One night I asked him, "Alice, do you want to go to a party?" He was like, "Yeah, sure." I said, "Alice, it's a Halloween party. What are you going to go as?" He shrugged and said, "I'll go as Alice Cooper." So he dressed in his usual stage costume, went to the party, and no one knew it was him. They just thought he made a really good Alice Cooper.

ALICE COOPER

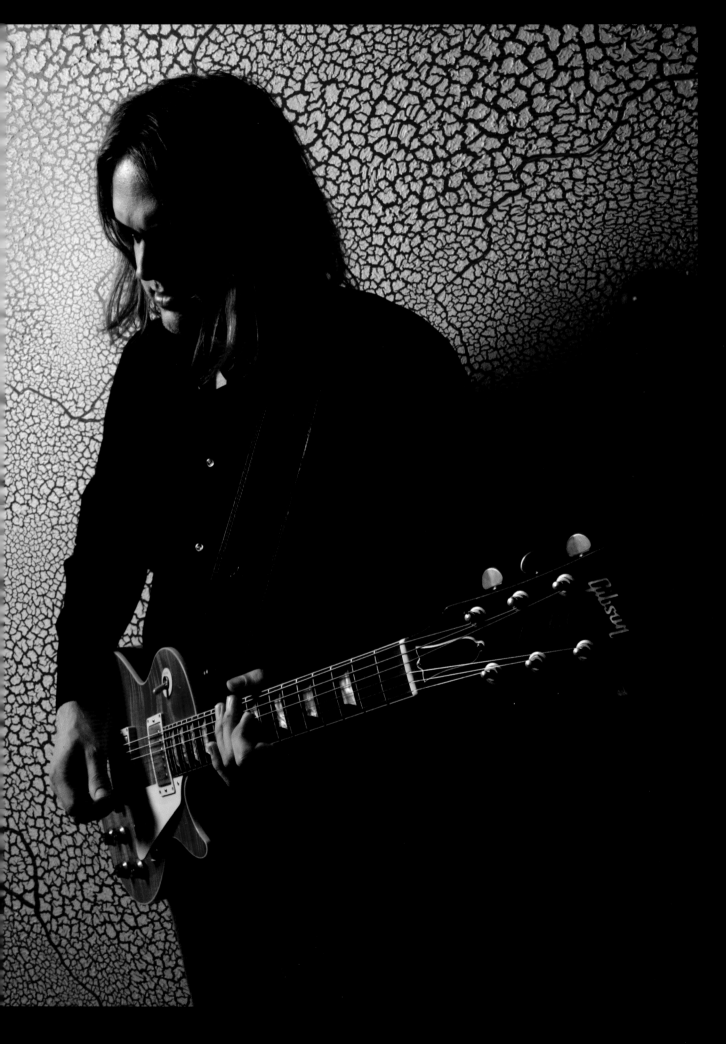

JOE BONAMASSA

ROBERT SMITH

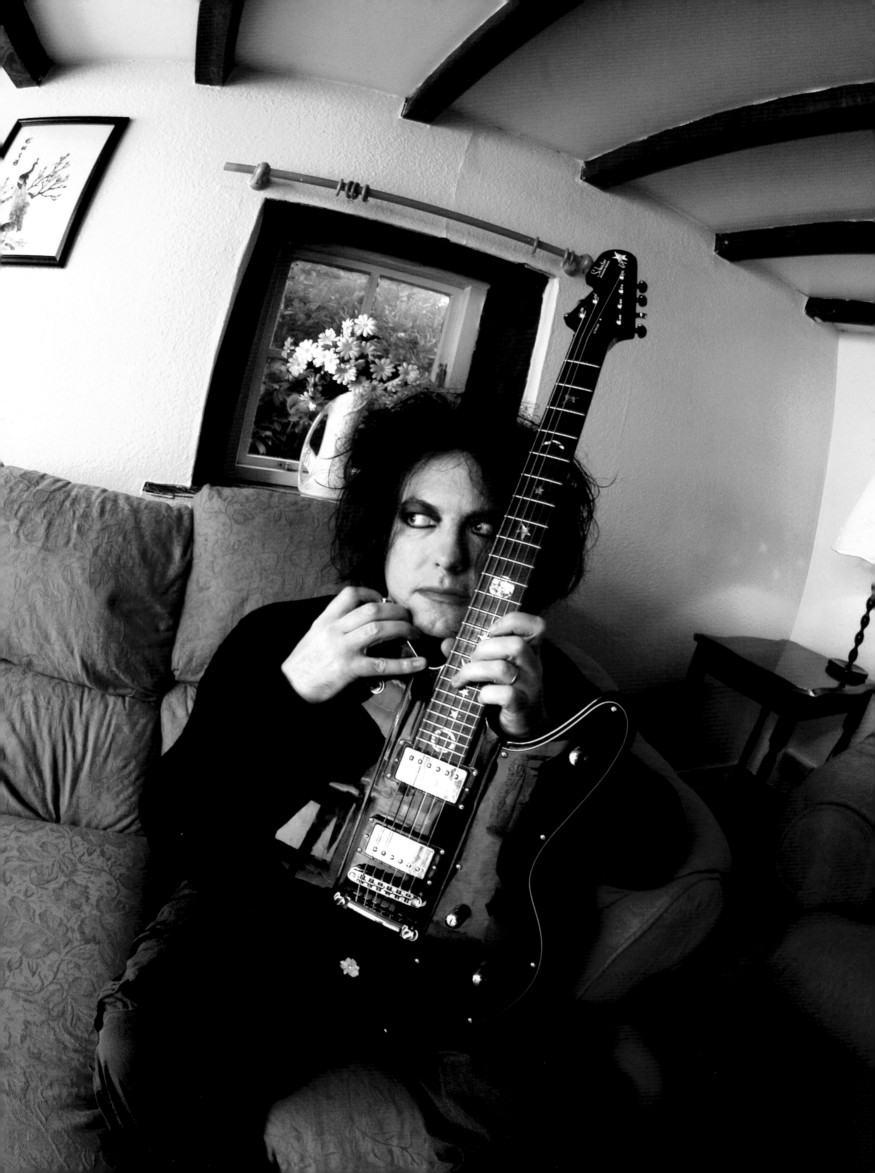

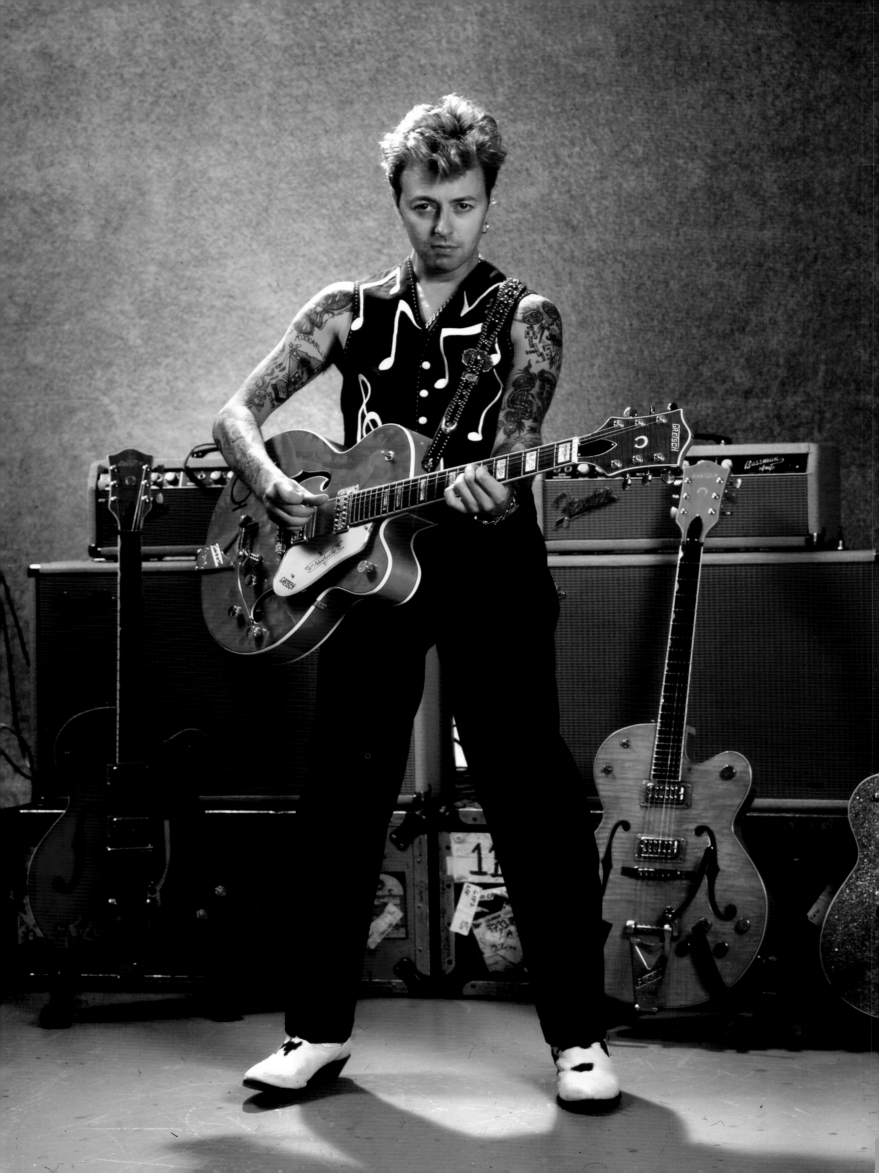

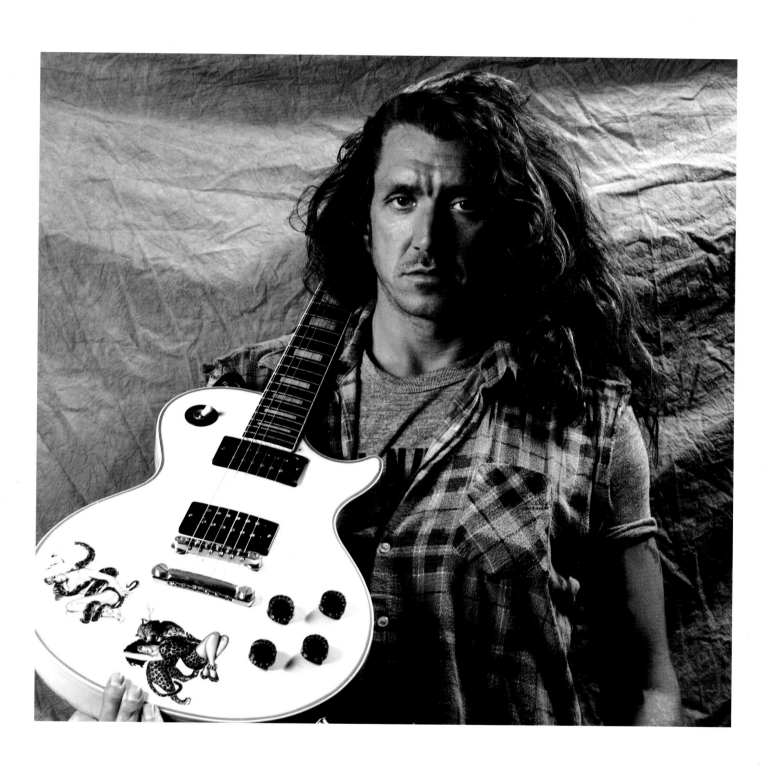

BRIAN SETZER

| Stray Cats | Los Angeles, California | 1995 |

STEVE JONES

| Sex Pistols | Los Angeles, California | 1985 |

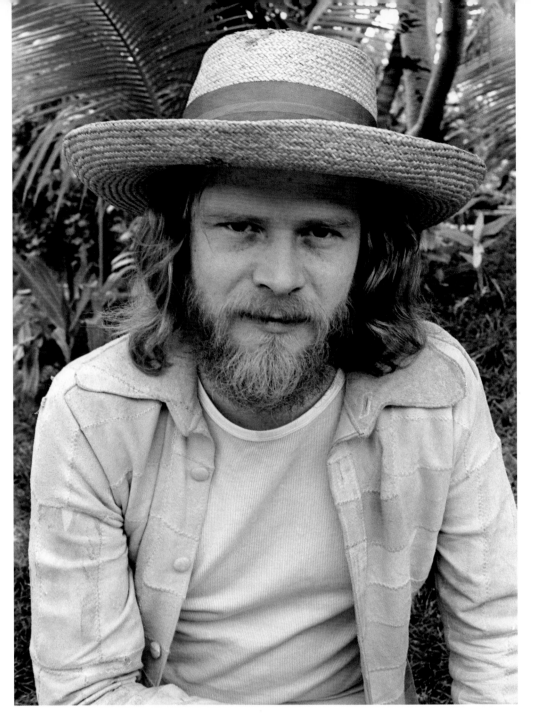

I BEFRIENDED LONG John Baldry, because I knew Elton John. There is a really cool story about how Elton was going to get married to this girl who playing in John Baldry's band and with Julie Driscoll and some of the other people in London. John Baldry talked Elton out of getting married.

JOHN BALDRY TALKED ELTON OUT OF GETTING MARRIED

wanted him to quit the music business and work at a bank instead. Elton, who was known as Reg at the time, had been around the music scene, Elton wrote a song, "Someone Saved My Life Tonight," changed his name to Elton John, with the "John" taken from Long John Baldry.

LONG JOHN BALDRY

		GEORGE CLINTON		
Honolulu, Hawaii	1973	RockWalk Induction	Los Angeles, California	1996

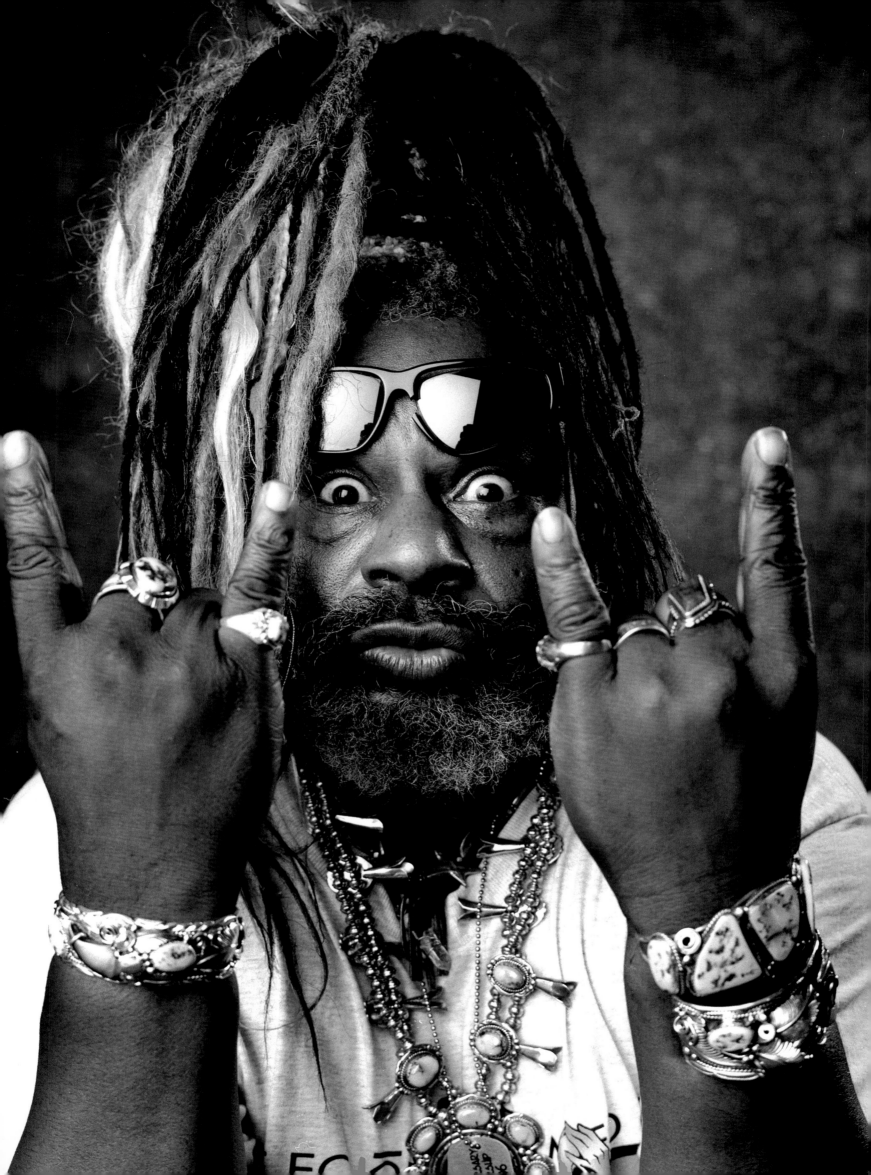

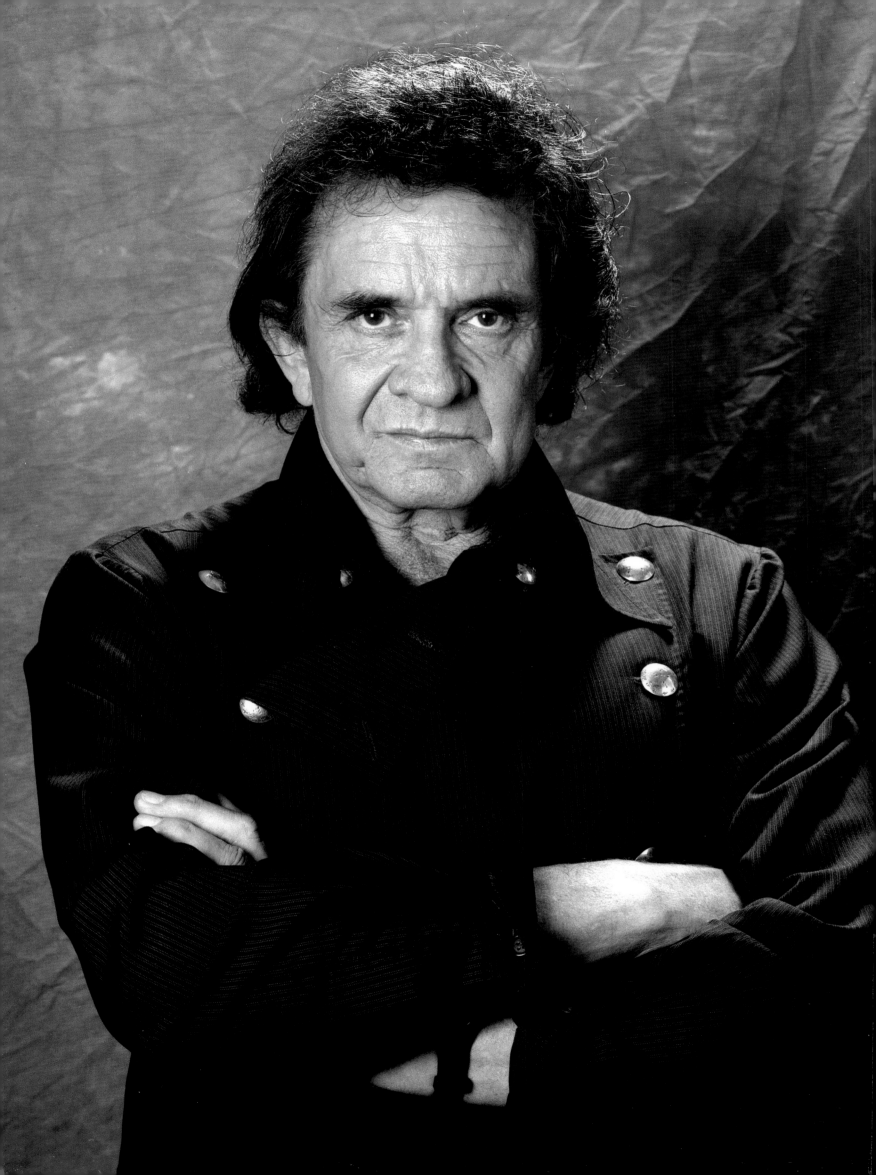

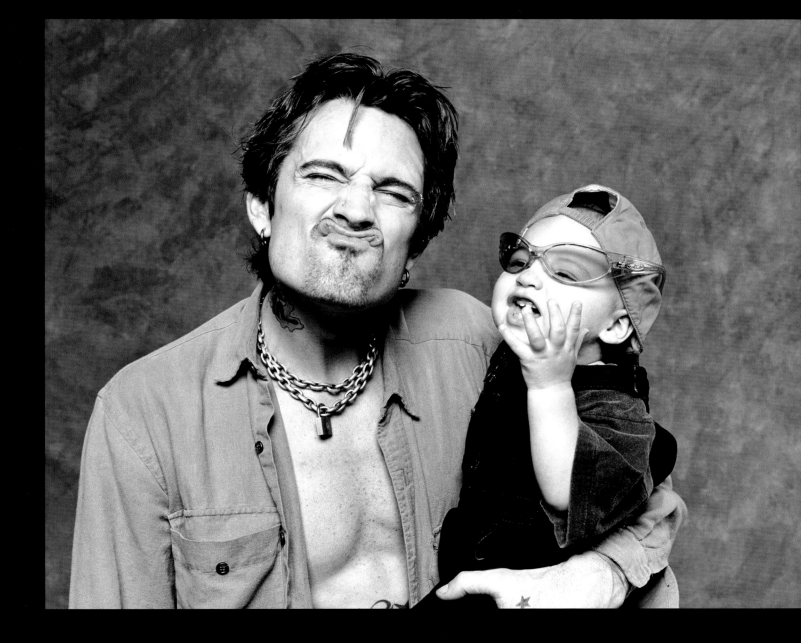

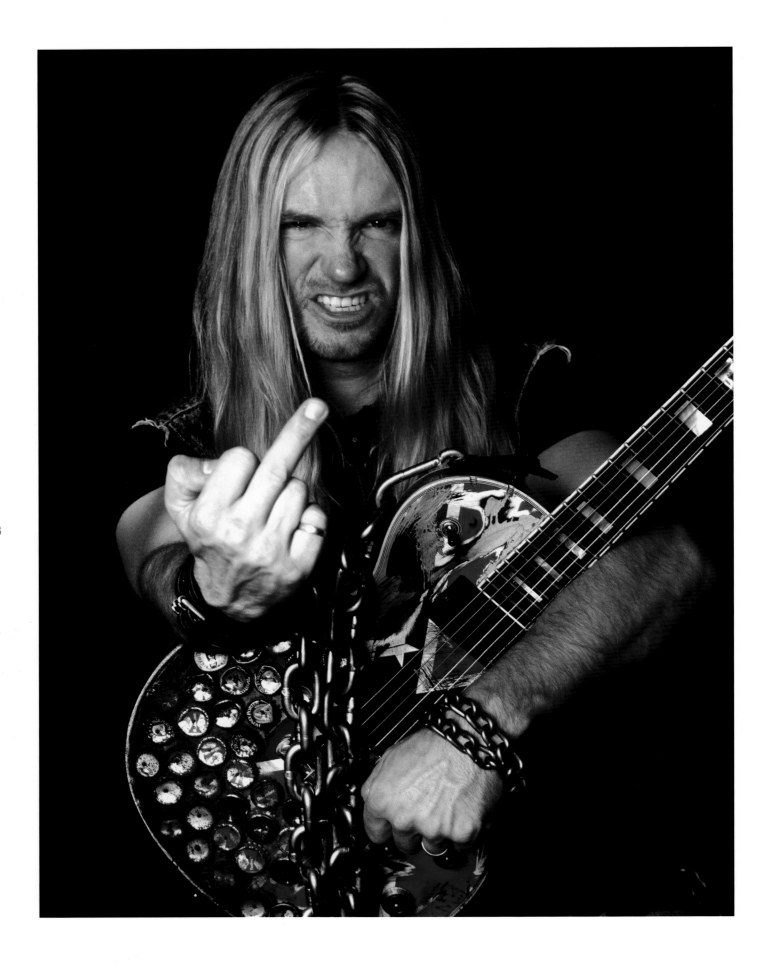

ZAKK WYLDE

Ozzy Osbourne/Black Label Society | Hollywood, CA | circa 2000

LOU REED

RockWalk Induction | Los Angeles, California | 2003

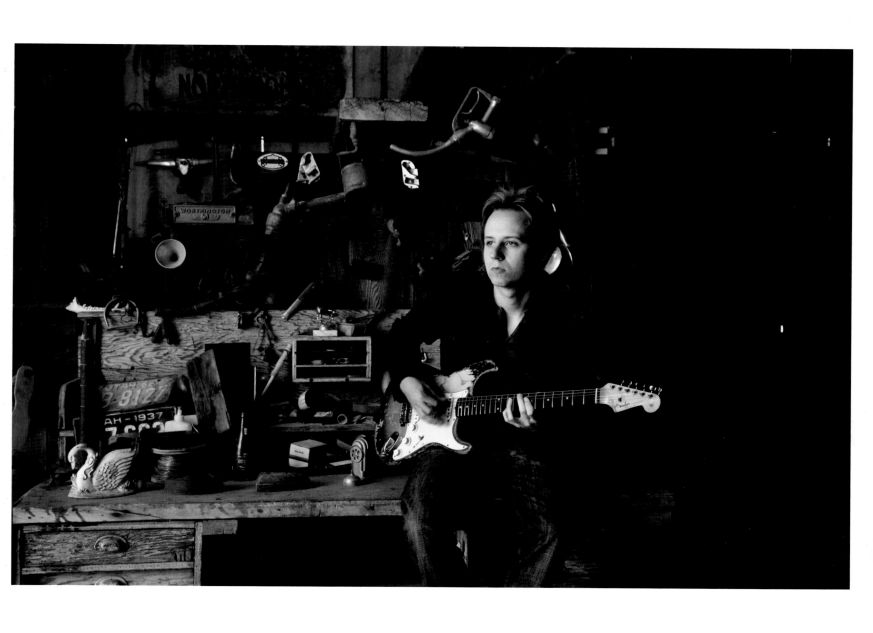

PANIC AT THE DISCO

SCOTT MCKEON

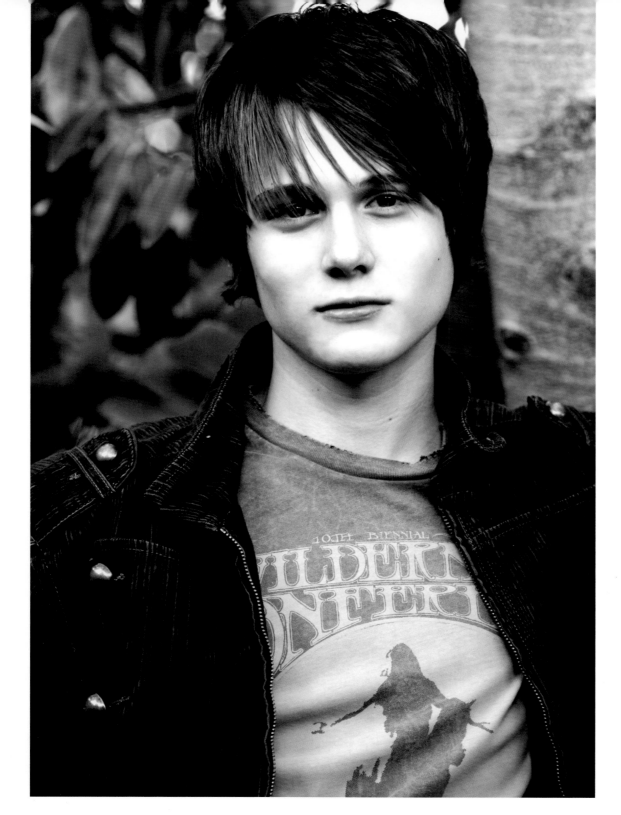

IN THE SPRING OF 2007 I received a Google notice about a young guitar player in Paris, Texas who won the Robert Johnson Blues Award as the best guitar player in America. I logged onto this kid's website, and I was blown away. He had the spirit of Stevie without mimicking him. I thought, "Okay, here we go again. I have got to

photograph this boy, and I have got to get to know him." I talked to Eric Clapton's Crossroads Festival about Tyler and they brought him in for the event. I met Tyler for the first time there while I was standing next to Jimi Hendrix's sister. Later, Albert Lee spotted Tyler's performance and introduced him to Eric Clapton, Jeff Beck, and John Mayer. This kid was

overwhelmed as he met some of the greatest guitar players in the world. The question with someone as young

HE HAD THE SPIRIT OF STEVIE WITHOUT MIMICKING HIM

and talented as Tyler is will he be able to handle success? He is pretty grounded, so I think he will do all right with the acclaim that is bound to come his way. Although, the girls love him. He'll have to learn how to handle that.

TYLER DOW BRYANT

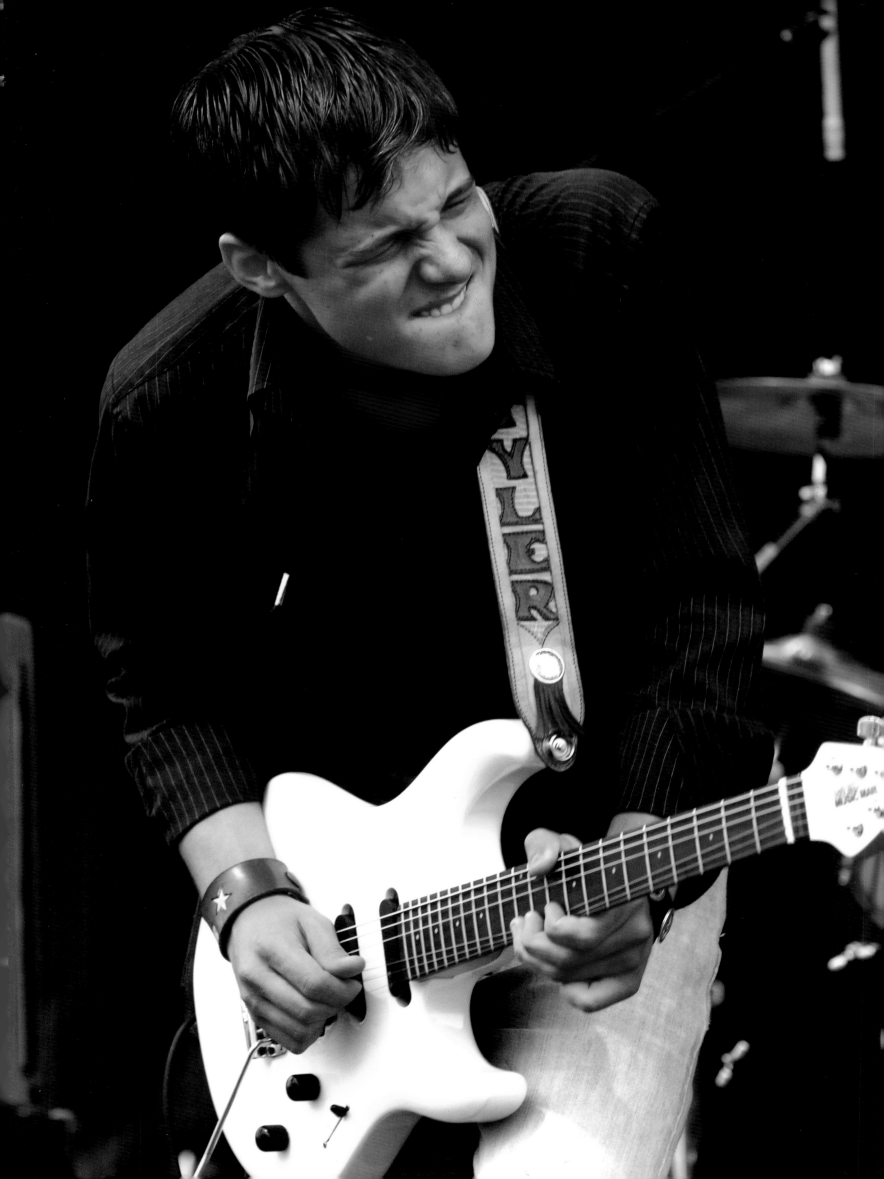

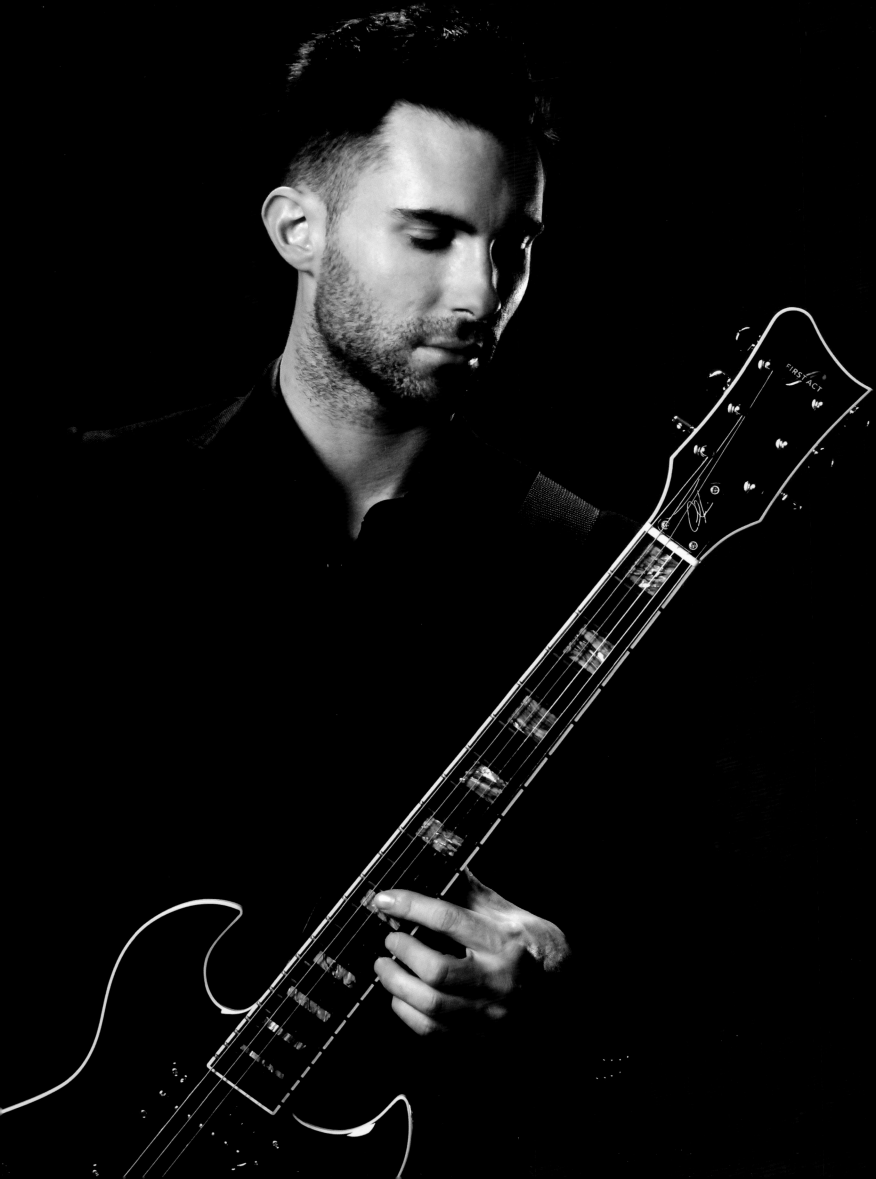

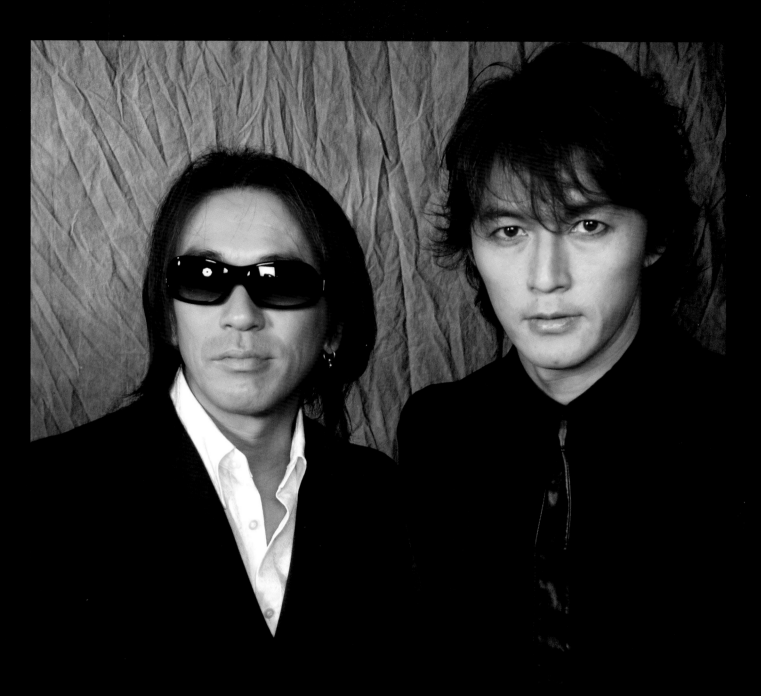

ADAM LEVINE

TAK MATSUMOTO & KOSHI INABA

| Maroon 5 | Hollywood, California | 2007 | B'z RockWalk Induction | Las Vegas, Nevada | 2007 |

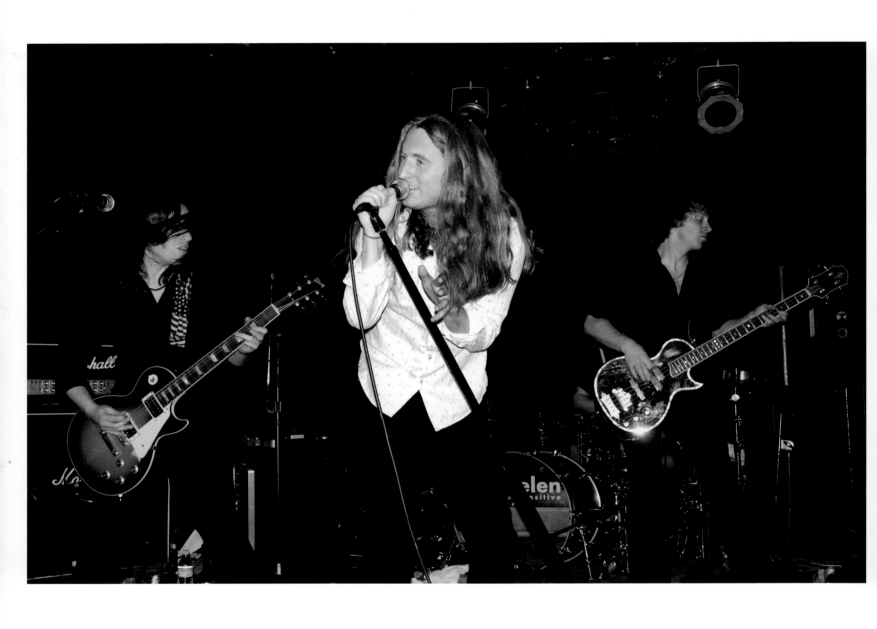

THE ANSWER

SICK PUPPIES

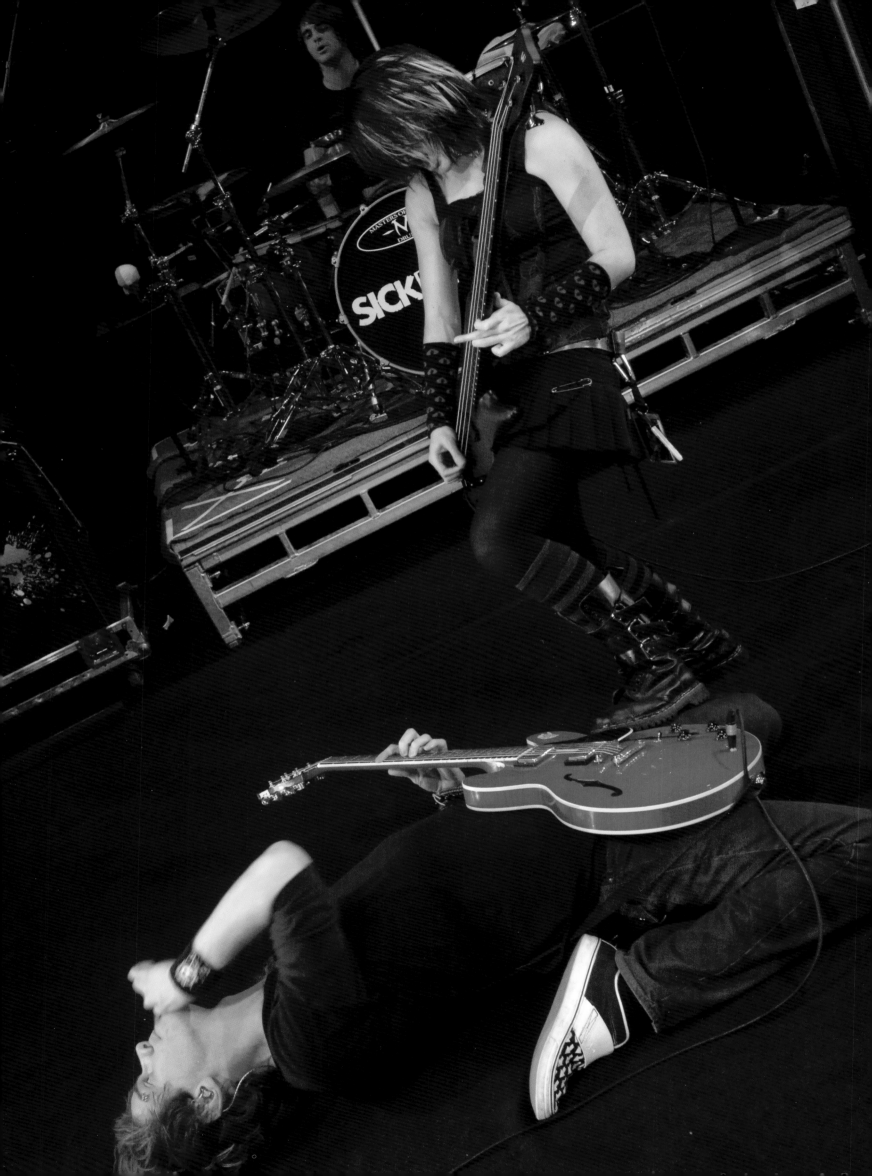

I WOULD LIKE TO THANK the following people who helped to make this book possible! Michael Jensen, Raoul Goff, Lisa Fitzpatrick and Barbara Genetin at Palace Press, Janie Hendrix, Divina Infusino for her words and Slash for always being there for me!

Funnel, Bruce Friedman, Marty Albertson and all my family at Guitar Center, Dave Weiderman, Daniel & Danny at The Limelight Agency, Michele at 319 Gallery, Gerard Marti-Celebrities Gallery Maui, Michael Dunn-Rockstar Gallery Scottsdale, Jim Evans, Warrick Stone, Nick Cook, Pam Moore,

ACKNOWLEDGMENTS

ROBERT M. KNIGHT

I also want to thank the film crew in the production of "Rock Prophecies," Tim Kaiser, John Chester and Thea Maichle. What a journey it has been!

I would like to say thanks to the following people for all that they bring to my life! Ray & Janet Scherr, Ingo Swann, Geoffery R. Murray, Jeff Beck, Billy Gibbons, Steve Vai, Ronnie Wood, Jed Leiber, Scott McKeon, Tyler Dow Bryant, Andrew & Sandra

Chris and Clare Vranian, Winston Smith, Lee Casey, Richard Upper, Jim Marshall and Doug Johnson.

Special thanks to Rod Gruendyke and his wonderful staff at my home away from home, "The Sunset Marquis Hotel and Villas," and Cheryl & Marilyn at Royal Order.

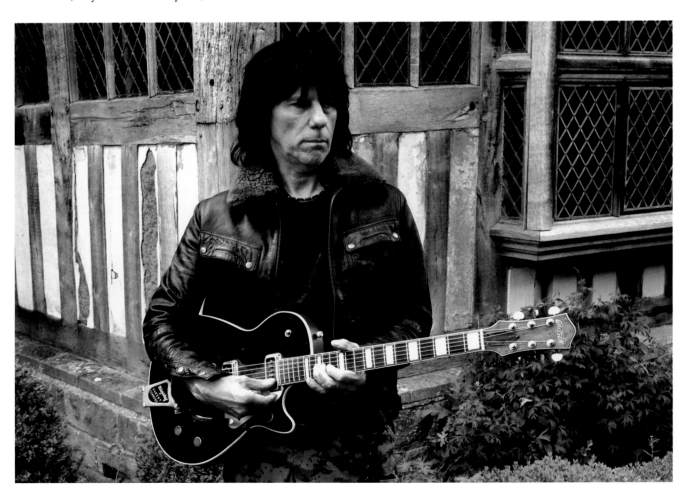

ROCK GODS
IMAGE CREDITS

Cover: Jimi Hendrix, circa 1969, *Honolulu, HI;*

Back Cover: Slash, circa 2000, *Los Angeles, CA;*

Page 1: Jimi Hendrix, 1969, *Honolulu, HI;*

Page 2: Stevie Ray Vaughan, 1989, *Minneapolis, MN;*

Page 4: Led Zeppelin, 1969, *Honolulu, HI,* second tour through Hawaii;

Page 6: Jeff Beck, 1985, *Los Angeles, CA;*

Page 8: Elton John, Mid '70s, *Honolulu, HI;*

Page 10: Slash, 1995-2005, *Los Angeles, CA;*

Page 12: Jimi Hendrix, 1970, *Sacramento, CA;*

Page 15: Jimi Hendrix, 1969, *Honolulu, HI;*

Page 16: Jeff Beck Group, 1968, *San Francisco, CA;*

Page 17: Jimmy Page, 1969, Honolulu, HI; John Bonham, Robert Plant, 1969, *Honolulu, HI;*

Page 18: Ronnie Wood, Rod Stewart, early '70's, *Honolulu, HI;*

Page 19: Jeff Beck, 1972, *Honolulu, HI;*

Page 20: Stevie Ray Vaughan, 1989, *Minneapolis, MI;*

Page 21: Stevie Ray Vaughan's last performance, August 26, 1990, *Alpine Valley, WI*—(left to right) Stevie Ray Vaughan, Andy Fairweather Low, Jimmy Vaughan, Buddy Guy, Eric Clapton;

Page 22: Sick Puppies, 2008; The Answer's lead singer, Cormac Neesan, 2008;

Page 23: Tyler Dow Bryant, 2007;

Page 24: Jimmy Page, 1972, *Seattle, WA;*

Page 26: Jimi Hendrix, circa 1968, *San Francisco, CA;*

Page 28: Jimi Hendrix, circa 1969, *Honolulu, HI;*

Page 32: Jimi Hendrix, 1970, *Sacramento, CA;*

Page 33: Hendrix's drummer, Mitch Mitchell, 1970, *Sacramento, CA;*

Page 34: Beck, Bogart Appice, 1973 *Honolulu, HI;*

Page 35: Jeff Beck, 1968, *San Francisco, CA;*

Page 36: Jeff Beck, circa 1970;

Page 38: Jeff on train, 1985;

Page 40: Jeff Beck;

Page 41: Jeff Beck, 2007, Crossroads Festival, *Chicago, IL;* Jeff Beck with Valerie Lee, Crossroads Festival;

Page 42: Rod Stewart, Mid '70's, *San Bernardino, CA;*

Page 43: Rod Stewart, 1973;

Page 44: Rod Stewart, 1968, *San Francisco, CA;*

Page 46: Mick Jagger, Rolling Stones, 1972, *Honolulu, HI;*

Page 48: Keith Richards, 1972, *Honolulu, HI;*

Page 50: Mick Jagger, 1973, *Honolulu, HI;*

Page 51: Mick Jagger, Keith Richards & Mick Taylor, 1973, *Los Angeles, CA;*

Page 52: Ron Wood, 1975, *Honolulu, HI;* Ron Wood with Jeff Beck Group, 1968, *San Francisco, CA;*

Page 53: Ron Wood, 1975, with the Rod Stewart Group, *Honolulu, HI;*

Page 54: Robert Plant, 1969, *Honolulu, HI;* Jimmy Page, 1969, *Honolulu, HI;*

Page 55: Robert Plant, 1969, *Honolulu, HI;*

Page 56: Jimmy Page, 1973, *Los Angeles, CA;*

Page 57: Led Zeppelin arriving in *Honolulu, HI,* 1969, carrying master tapes for Led Zeppelin II;

Page 59: Robert Plant and Jimmy Page, 1969, *Los Angeles, CA;*

Page 60: John Bonham, 1972, *Seattle, WA;*

Page 61: Robert Plant, 1969, *Honolulu, HI;*

Page 62: Steve Marriott performing with Humble Pie, early '70's, *Honolulu, HI;*

Page 64: Elton John, Mid '70's, *Honolulu, HI;*

Page 70: Eric Clapton, 1970, *Honolulu, HI;*

Page 72: Carlos Santana, early '70's. Crater Festival, *Honolulu, HI;*

Page 76: Carlos Santana, 1996, RockWalk Induction, *Los Angeles, CA;*

Page 77: Carlos Santana, 2004, Crossroads Festival, *Dallas, TX;*

Page 78: Steven Tyler, Aerosmith, 1974-75, *Honolulu, HI;*

Page 79: Aerosmith, RockWalk Induction, 1990, *Los Angeles, CA;*

Page 80: Joe Perry and Steven Tyler, mid '70's, *Honolulu, HI;*

Page 81: Aerosmith with Sam Kinison, 1990, Aerosmith's RockWalk Induction, *Los Angeles, CA;*

Page 82: Eddie Van Halen, 2000, recording studio;

Page 83: Eddie Van Halen, 1995, *Costa Mesa, CA;*

Page 84: Van Halen, 1995, *Costa Mesa, CA;*

Page 86: Eddie Van Halen, 1995, *Costa Mesa, CA;*

Page 87: Sammy Hagar and Eddie Van Halen, 1995, *Costa Mesa, CA;*

Page 88: Stevie Ray's last concert, August 26, 1970, *Alpine Valley, WI;*

Page 89: Steve Ray & brother Jimmie Vaughan, August 26, 1970, *Alpine Valley, WI;*

Page 90: Stevie Ray Vaughan, 1989, *Minneapolis, MI;*

Page 92: Stevie Ray Vaughan and Jeff Beck, 1989, *Minneapolis, MI;*

Page 93: Stevie Ray Vaughan, 1989, *Minneapolis, MI;*

Page 95: Slash, circa 2000, *Los Angeles, CA;*

Page 96: Slash, with Velvet Revolver, 2005, *Hollywood, CA;*

Page 97: Velvet Revolver, Duff McKagan and Scott Weiland, 2005, *Las Vegas, NV;*

Page 98: Slash, 2005, *Las Vegas, NV;*

Page 99-101: Slash, 2008, *Los Angeles, CA;*

Page 102: John Lee Hooker, Early '90s;

Page 104: B.B. King, 1992, B.B.'s club, *Hollywood, CA;*

Page 106: John Lee Hooker, 1995, Universal Amphitheater, *Los Angeles, CA;*

Page 107: John Lee Hooker, 1989, RockWalk Induction, *Los Angeles, CA;*

Page 108: Albert Collins, 1990, *Long Beach, CA;*

Page 109: Freddie King, 1972, *Honolulu, HI;*

Page 110: Buddy Guy, 1992, *Long Beach, CA;*

Page 111: Hubert Sumlin, 2004, *Dallas, TX;*

Page 112: Bo Diddley, 2004, Crossroads Festival, *Dallas, TX;*

Page 113: David "Honeyboy" Edwards, 2004, Crossroads Festival, *Dallas, TX;*

Page 114: Little Richard, Mid '90s;

Page 115: James Brown, 1992, RockWalk Induction, *Los Angeles, CA;*

Page 116: Ray Charles, *Honolulu, HI;*

Page 118: Willie Dixon, 1989, RockWalk Induction, *Los Angeles, CA;*

Page 119: Les Paul, 1990, *New York, NY;*

Page 120: Kenny Wayne Shepherd, Mid '90s;

Page 122: Steve Vai, mid '90's, *Hollywood, CA;*

Page 123: Steve Vai, 2005;

Page 124-125: Steve Vai, 2000;

Page 126: Kenny Wayne Shepherd, 2007;

Page 127: Kenny Wayne Shepherd, 2000;

Page 128: ZZ Top, Billy Gibbons, Dusty Hill, 2007, *Las Vegas, NV;*

Page 129: ZZ Top's Billy Gibbons, 2007, *Las Vegas, NV;*

Page 130: Cheap Trick's Rick Nielsen, 1992;

Page 131: Cheap Trick's Rick Nielsen, 2007;

Page 132: Kiss, early '90's, *Los Angeles, CA;*

Page 134: Nancy Wilson from Heart, 2007, *Las Vegas, NV;*

Page 135: Tom Petty, 2007, *Las Vegas, NV;*

Page 136: John Mayer, 2006, *Tampa, FL;*

Page 137: Sheryl Crow, 2006, *Tampa, FL;*

Page 138: Steve Stevens, 2005, *Las Vegas, NV;*

Page 139: Billy Idol, 2005, *Las Vegas, NV;*

Page 140: Green Day, 1992, *Phoenix, AZ;*

Page 142: Joni Mitchell, 1970, *Honolulu, HI;*

Page 143: Isaac Hayes, mid '70's, *Honolulu, HI;*

Page 144: Jim Keltner, RIngo Starr, Levon Helm, Alex Van Halen, 1990 *Los Angeles, CA;*

Page 145: Ringo Starr, 1990;

Page 146: Johnny Winter, 1998, *Hollywood, CA;*

Page 147: Bonnie Raitt, 1996, *Hollywood, CA;*

Page 148: Alice Cooper, 1991, RockWalk Induction, *Los Angeles, CA;*

Page 149: Alice Cooper, 1973, *Honolulu, HI;*

Page 150: Joe Bonamassa, 2007, *Las Vegas, NV;*

Page 151: Robert Smith, The Cure, 2005, *England;*

Page 152: Brian Setzer, 1995, *Los Angeles, CA;*

Page 153: Steve Jones, 1985, *Los Angeles, CA;*

Page 154: Long John Baldry, 1973, *Honolulu, HI;*

Page 155: George Clinton, 1996, RockWalk Induction, *Los Angeles, CA;*

Page 156: Johnny Cash, 1990, RockWalk Induction, *Los Angeles, CA;*

Page 157: Tommy & Brandon Lee, 1997, RockWalk Induction, *Los Angeles, CA;*

Page 158: Zach Wylde, 2000, *Hollywood, CA;*

Page 159: Lou Reed, 2003, RockWalk Induction, *Los Angeles, CA;*

Page 160: Panic at the Disco, 2008, *Las Vegas, NV;*

Page 161: Scott McKeon, 2008, *Las Vegas, NV;*

Page 162: Tyler Dow Bryant, 2008, *Los Angeles, CA;*

Page 163: Tyler Dow Bryant, 2007, Crossroads Festival, *Chicago, IL;*

Page 164: Adam Levine from Maroon 5, 2007, *Hollywood, CA;*

Page 165: Tak Matsumoto and Koshi Inaba from the B'z's, 2007, RockWalk Induction, *Los Angeles, CA,*

Page 166: The Answer, 2008, *Los Angeles, CA;*

Page 167: Sick Puppies, 2008, *Pennsylvania,* 2008;

Page 168: Jeff Beck, 2007, *Sussex, England;*

Page 170: Steve Vai, 2006, *Detroit, MI;*

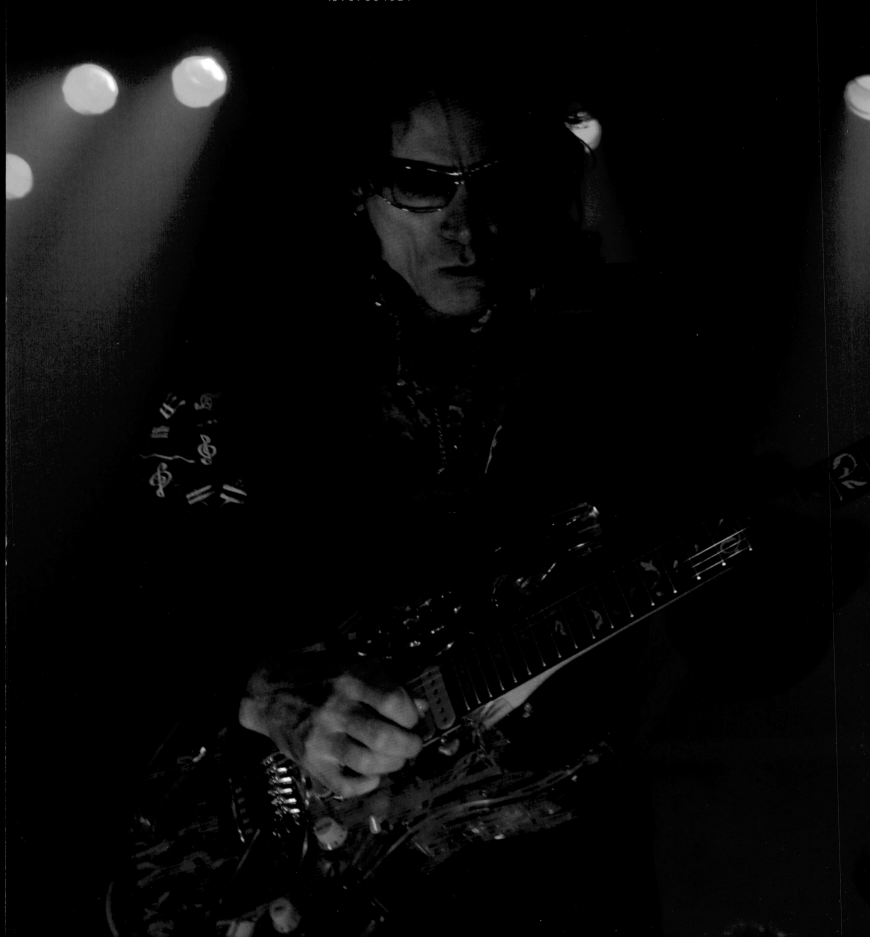

COLOPHON

Publisher & Creative Director: *Raoul Goff*

Art Director: *Iain R. Morris*

Designer: *Barbara Genetin*

Design Assistant: *Gabe Ely*

Managing Editor: *Lisa Fitzpatrick*

Editor: *Divina Infusino*

Production Managment: *Lina S. Palma-Temena*

Design and Production Coordinator: *Donna Lee*

17 Paul Drive : San Rafael : CA : 94903
phone 415.526.1370 • fax 415.526.1394
www.insighteditions.com

ISBN-13: 978-1-933784-71-7

10 9 8 7 6 5 4 3 2 1

Palace Press International, in association with Roots of Peace, will plant two trees for each tree used in the manufacturing of this book. Roots of Peace is an internationally renowned humanitarian organization dedicated to eradicating land mines worldwide and converting war-torn lands into productive farms and wildlife habitats. Together, we will plant two million fruit and nut trees in Afghanistan and provide farmers there with the skills and support necessary for sustainable land use.

Printed in China by Palace Press International
www.palacepress.com